THE STORY OF PHOTOGRAPHY

Focal Press
An imprint of Butterworth–Heinemann Ltd
Linacre House, Jordan Hill, Oxford OX2 8DP

 PART OF REED INTERNATIONAL BOOKS

OXFORD LONDON BOSTON
MUNICH NEW DELHI SINGAPORE SYDNEY
TOKYO TORONTO WELLINGTON

First published 1980
Reprinted 1992

British Library Cataloguing in Publication Data
Langford, Michael John
 The story of photography
 1. Photography – History
 I. Title
 770'.9'034 TR15

ISBN 0 240 51044 5

Printed and bound in Great Britain by Thomson Litho Ltd, East Kilbride
and bound by Hunter & Foulis Ltd, Edinburgh

THE STORY OF PHOTOGRAPHY

From its beginnings to the present day

Michael Langford

Senior Tutor in Photography, Royal College of Art, London

Focal Press

CONTENTS

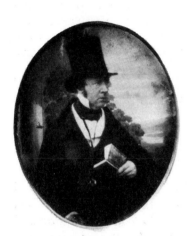

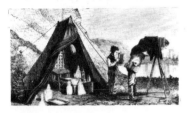

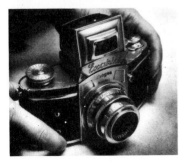

Part II–Subjects, Styles and Approaches

About this book

Thanks to photography it is possible to know what your great greatgrandparents really looked like. Photography's invention in the 1830s marks a great divide between one period of visual communication and another – you may feel that you know Abraham Lincoln or Queen Victoria (who were photographed) better than George Washington or Louis XIV (who were not). Photographic images not only seem very real, but combine a unique mixture of the technical and the visual. Its invention brought together people concerned with science and art, plus many colourful characters, from sharp businessmen to dreamy romantics, who tried to exploit the new discovery.

This book is an introductory guide to the history of photography written for students of photography, art history or communication studies; also for the general reader interested in tracing the beginning of the process used in so many ways today. It is presented in a form most helpful to learners – with regular summaries, projects, and questions – and covers the period from 1839 (when the first practical process was announced) to about 1970.

Photography began like a tree rooted in physics, chemistry and art, which grew two main shoots. One, the French Daguerreotype process, at first seemed overwhelmingly the strongest growth but eventually came to nothing. The other, a negative-positive system invented by Talbot in England, seemed inferior to begin with but was to form the main trunk. At first the processes were too difficult to allow more than professional portraits and views, but as more practical techniques and equipment developed the tree of photography grew faster and branched out. Stereo-pictures, press photography, amateur snapshotting, fashion, advertising, medical photography, and photographs as fine art – all became possible. These applications re-divided, and spread out like a pattern of twigs at the top of the tree. Over a period of 140 years photography has changed from a Victorian novelty to something accepted as an important part of modern life.

The story of photography has three equally important aspects:

1. *Technical developments*, controlling what could be recorded and how to do it. This influenced everything else, but became steadily easier as one improvement followed another. Technical progress is traced in chapters one to five.

2. *Styles and approaches* – what and why people photographed, the development of *types* of photographs as the range of possibilities became greater. Ways in which individual photographers chose to use the process. These are covered in chapters six to nine.

3. *The influences of photography* – how it affected the lives of ordinary people at different periods, and how photography itself was held back or advanced by social reactions. These influences are discussed towards the end of all the main chapters.

In dealing with each period a selection of important photographers are picked out and discussed. This seems more useful than trying to deal with a large number of photographers, which in a book of this size would only result in 'name dropping'. Hopefully this enables the main lines of development to be seen more clearly. Use the book as a structured overall history, then back this up by further reading on the photographers from each period suggested on page 151.

For school use The Story of Photography is complemented by three sound filmstrips in colour (EXP. 1–3) by the same author, produced by Visual Publications, London and New York.

Part 1—History of Process —

Obviously, before anyone can take photographs a workable process must exist. These first chapters tell how photography was discovered, put together, simplified and improved until it resembled today's processes and equipment. Part One of this book is concerned with how things worked – including what was just possible and what simply could not be done. The pictures included here show how technical limitations affected the style of photography. Later, in the second half of the book, the approaches of individual photographers are dis-

cussed in more detail. So having read this part through first you might decide to refer to both halves when looking at a chosen period or group of photographers. You may also find it helpful to look at *The Events by Date* information given at the end of book (pages 148– 150).

PRE-HISTORY AND DISCOVERY

The story of photography really begins in the 1830s, when light-sensitive materials were used in the camera for the first time. This chapter looks at the origins of both these vital components and sees how they came together at last to form a practical picture-making process.

The camera

If light from a brightly illuminated scene is allowed to enter a darkened room through a small hole (eg. in a blind or shutter covering a window) a dim image of the scene may appear on the opposite wall (see Fig. 1.1). The image is upside-down because light rays from the top part of objects only reach the lower part of the wall, and vice-versa. This *camera obscura* or darkened chamber effect has been known since ancient times. It was certainly mentioned by Leonardo da Vinci and in 1558 Giovanni Porta published a clear description of the device. At about this time too it was discovered that by enlarging the hole and fitting it with a suitable lens from a telescope a brighter, clearer image could be formed. Rooms modified to form camera obscuras were used as novelties in public buildings, parks etc, and a few even remain today.

By the 17th century smaller and more portable camera obscuras were in frequent use as artists' aids. Sedan chairs (a popular means of transport for short distances) were adapted into totally enclosed boxes with

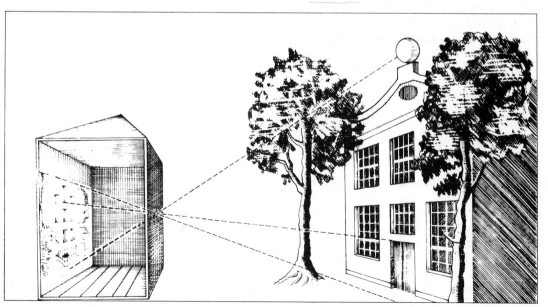

Fig. 1.1 The basic principle of the camera obscura. Because light travels in straight lines, a small hole forms a crude image of the sunlit landscape inside a darkened room.

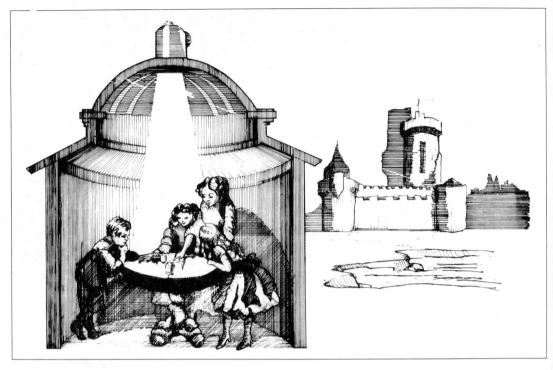

Fig. 1.2 Camera obscuras like this, fitted with a simple telescope lens and mirror, were designed to project scenes of the surrounding countryside onto a white-topped viewing table.

Fig. 1.3 18th century portable camera obscuras were often converted sedan chairs, left. Folding types could stand on any handy surface, right. They both projected images down on to paper so that they could be traced.

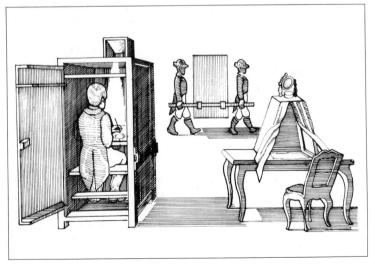

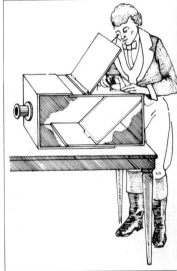

Fig. 1.4 A reflex camera obscura used by artists. The mirror reflected the image right way up onto ground glass for tracing.

a mirror and lens set into the roof (see Fig. 1.3). The mirror reflected the light down onto a drawing board inside and also made the image right way up. Folding camera obscuras were made to be set up on tables (Fig. 1.4), or could even be held in the hand. In all cases the image had to be traced onto paper, but these contrivances were extremely useful for accurately sketching perspective and scale in landscapes, architecture etc.

The light-sensitive material

It has also been known for centuries that certain materials are affected by the sun – either darkening or fading when left exposed for long periods. Often these changes were assumed to be due to *heat*, as in cooking, instead of the sun's *light*. Some compounds of silver are particularly responsive. As early as 1727 Professor J. Schulze proved that a whitish solution of silver nitrate and chalk placed in a glass bottle darkens on the side facing bright sunlight. He showed that heating alone has no such effect.

You might expect from this time that the two devices – the artist's camera and the scientist's light-responding chemical – might have been put together to create photography. In practice little seems to have been done. About 1800 Thomas Wedgwood, son of the famous Staffordshire potter, managed to make 'sun pictures' by placing opaque objects such as leaves (Fig. 1.5) in contact with leather which had been treated with silver nitrate. Left to expose in daylight the uncovered parts of the leather gradually darkened, so when the object was

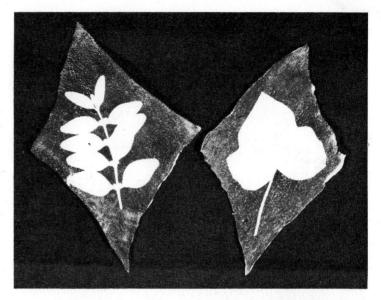

Fig. 1.5 'Sun pictures'. In 1800, Tom Wedgwood recorded leaf shapes by the action of light—contact printing them onto leather treated with silver nitrate. (Modern replicas by the same process.)

removed its white shape remained. Unfortunately Wedgwood could not prevent these still light-sensitive white areas from darkening too, unless results were viewed only by the dim illumination of a candle. Nor could he record the image formed in a camera obscura, as the light was apparently too faint. Wedgwood was unable to improve the process before he died in 1805.

The next stage of improvement was to occur nearly twenty years later in France. Here Nicéphore Niépce (pronounced 'Nee-eps') was trying to record a camera obscura image direct onto a chemically treated stone or metal surface. He hoped this could then be inked and printed by the newly invented process of lithography. According to Niépce's letters, by 1816 he had been able to record an impermanent form of result with reversed tones – whites reproduced as

black (a 'negative') – using silver chloride sensitized paper. But Niépce was looking for a picture with light parts in an acid-resisting material, on a metal base which could then be etched to absorb printer's ink. To do this he experimented with a varnish of white bitumen of Judea dissolved in oil and spread on a flat pewter plate. Prolonged exposure to light caused the bitumen to harden, so that when the plate was bathed in lavender oil unhardened parts of the white bitumen were washed away. It left bright parts of the image white against the dark metal. The plate therefore showed a picture with tones similar to the original scene (a 'positive' image.)

Niépce called his process 'heliography' meaning sun drawing, and used it for making contact prints from engravings on translucent paper. In 1826 he succeeded in using a plate in

9

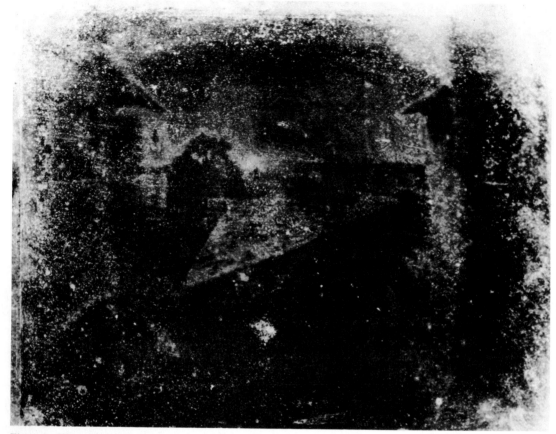

Fig. 1.6 The world's oldest surviving picture produced with a camera, about 1826. It shows the view from Niépce's window—the sloping barn roof, a pigeon house, left and part of his house, right.

a camera obscura to record the view from the window of his top floor workroom (Fig. 1.6). The exposure needed was about eight hours. This crude-looking image is the first permanent picture taken with the camera obscura which is still in existence. Niépce's light-hardening heliography process was eventually used in modified form for printing plates, but always remained too insensitive for direct practical use in the camera.

The daguerreotype process

One of the few people who heard of Niépce's experiments was the Parisian artist, scenic painter and showman Louis Daguerre (Fig. 1.7). Daguerre had already made his reputation staging 'dioramas'—entertainments in which large painted panoramas and specially controlled lighting effects produced a visual spectacle featuring unfamiliar parts of the world, famous buildings, etc. Daguerre used camera obscuras to make accurate sketches for his diorama shows and soon interested himself in trying to record the images chemically, using silver compounds.

Daguerre first cautiously corresponded with Niépce, then eventually went into partnership with him to pool the secrets (and profits) of heliography. The partnership proved barren. The bitumen process was not sensitive enough, and Niépce seemed unwilling to experiment further with silver salts, as urged by Daguerre. By the time Niépce died four years later little progress had been made. His son Isidore took over the partnership, but Daguerre was effectively on his own.

Daguerre continued using metal plates—this time they were copper, plated with silver and made light sensitive by iodine vapour which formed a

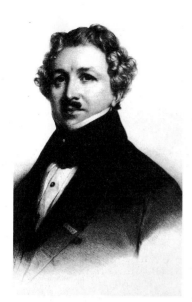

Fig. 1.7 Louis Daguerre, inventor of the first practical method of photography, drawn two years before the 1839 public announcement of his process.

coating of silver iodide. Even with the best available lenses the material was far too slow in its response to light. The turning point for Daguerre came when he discovered that by holding his exposed plate over warmed mercury the image became intensified or 'developed'. By 1837 he had a workable system (Fig. 1.9). A 30-minute exposure was needed for most brightly lit views, and the finished result was a detailed whitish image on a silvery background (Fig. 1.10).

Daguerre now called his system *the daguerreotype process.* Unfortunately he lacked the money to promote the process himself, but his discovery was considered so important by the French government that Daguerre (and Isidore Niépce) were awarded state pensions. In return they were to publicly reveal all the technical details and allow daguerreotyping to be freely practised in France.

A special meeting of the Academy of Science and the Academy of Art was arranged in August 1839, at which a friend of Daguerre was to explain in detail how the process could be worked. The whole of Paris seemed to wait in excited anticipation – at this time there were no illustrations in newspapers and books other than engravings like Fig. 2.6. Only the rich could afford paintings. Yet here was a magic process by which pictures could be drawn 'by the action of light itself'. Newspapers called the shiny metal picture 'a mirror with a memory'.

Here is one published report of the meeting: . . . Gradually I managed to push through the crowd after a long wait a door opens in the background and the first of the audience to come out rush into the vestibule. 'Silver iodide' cries one, 'Quicksilver' shouts another, while a third maintains that hyposulphite of soda is the name of the secret substance . . . An hour later, all the opticians' shops were beseiged, but could not rake together enough instru-

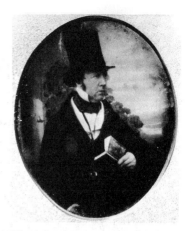

Fig. 1.8 A Daguerreotype portrait (1844), shown here almost actual size, The sitter is William Fox Talbot, British inventor of the rival Calotype process.

ments to satisfy the on-rushing army of would-be daguerreotypists; a few days later you could see in all the squares of Paris three-legged dark-boxes planted in front of churches and palaces . . .' Painters were extremely alarmed at this threat to their livelihoods. Paul Delaroche complained 'from today painting is dead'.

Once news of the process spread across Europe ideas for chemical improvements soon appeared (Table 1.1). Equally a new lens, designed specially

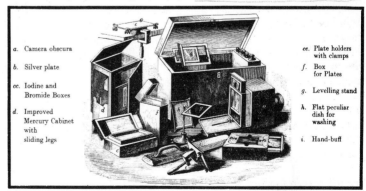

a. Camera obscura	ee. Plate holders with clamps
b. Silver plate	f. Box for Plates
cc. Iodine and Bromide Boxes	g. Levelling stand
d. Improved Mercury Cabinet with sliding legs	h. Flat peculiar dish for washing
	i. Hand-buff

Fig. 1.9 A complete Daguerreotype outfit, from an advertisement of 1843. To discover how all these bits and pieces were used see Table 1.1 overleaf.

Table 1.1 Daguerre's original process 1839

1 A sheet of silver-plated copper is well cleaned and polished.
2 The plate is sensitized by leaving it in a small sensitizing box with iodine solution at room temperature for 5–30 min until the silver surface has become golden yellow. (It can be viewed under a red lantern). The plate can then be inserted in a light-proof holder for taking to the camera.
3 Exposure in the camera for about 5–12 min (f11 lens).
4 The image is 'brought out' by supporting it face downwards above mercury heated to 75°C (167°F).
5 The remaining light-sensitive salts are removed by bathing with hyposulphite of soda.
6 Finally, the plate is washed in distilled water, and then dried.

1840 improvements: The following extra stages.
2a The plate is washed in silver halide solution. Then step 2 is repeated, briefly.
5a Bathing in gold chloride solution to strengthen the final result.

for daguerreotyping by Josef Petzval of Vienna, offered a wider aperture (f3.6 instead of about f11) and made the camera image ten times as bright. From 1841 onwards therefore exposure times were reduced to around one minute. Portraiture studios were soon set up and people flocked to them to 'have their likenesses taken'. Everyone marvelled at the detail and accuracy of daguerreotype images.

The calotype process

Meanwhile, in England, landowner and amateur scientist Henry Fox Talbot had been working on his own system of recording images in the camera obscura. In 1834 he experimented with writing paper dipped in silver chloride, which was dried and then exposed to sunlight under flat objects such as lace or leaves. As with Wedgwood's experiments the

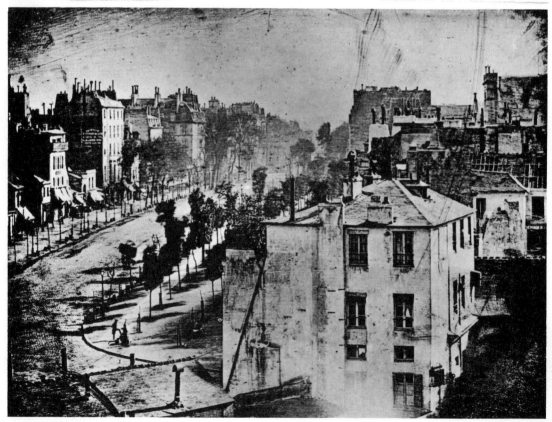

Fig. 1.10 Daguerreotype of Paris, 1838. As Daguerre gave about 15 mins exposure, moving carriages and figures failed to record.

12

silver salts darkened where uncovered by the object, but Talbot had discovered two important improvements. Firstly, the image could be prevented from darkening further by bathing the paper in a strong salt solution. And secondly, although the picture was a negative (blacks represented as whites, etc) he realized that it might be printed by light onto another sheet of sensitized paper which would then show correct tone values.

Small wooden cameras were built (Fig. 1.12) loaded with sensitized paper and left about his estate, Lacock Abbey in Wiltshire. Exposures needed to give a recognizable result ranged from 10 to 30 minutes. The oldest surviving Talbot picture of this period is dated 1835 (Fig. 1.11).

Talbot had many other interests and had made little further progress when in 1839 the first rumours of Daguerre's invention spread from Paris. Afraid they might both be using an identical process, he hurriedly decided to publish his work as far as it went, and prepared papers on 'photogenic drawing' which were read to learned societies in London.

This publicity resulted in

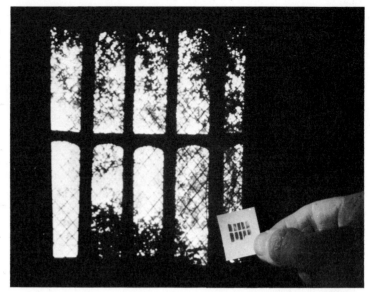

Fig. 1.11 Replica of an 1835 Talbot camera negative, given 1½ hours exposure. Behind it is the same Lacock Abbey window today.

several beneficial ideas. Sir John Herschel advised that hyposulphite of soda (today called sodium thiosulphate) would form a better arresting or fixing agent than salt. The terms 'negative' for Talbot's camera result, 'positive' for his final correctly toned print, and 'photography' (light drawing) as a general name for chemically recorded camera images were all suggested by Herschel.

By 1840 Talbot had improved his process by changing to

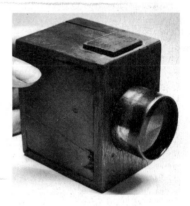

Fig. 1.12 A Talbot 'mousetrap' camera, by the Lacock carpenter.

Table 1.2 Talbot's calotype process in 1842

Negative
1 Under red lighting best quality writing paper is dipped in weak silver nitrate solution, followed by potassium iodide solution, and wiped dry.
2 One side is coated with an 'exciting' solution of gallic acid and silver nitrate, applied with a brush. The sensitized paper is then dried in front of the fire, and placed in a light-proof holder to take to the camera.
3 Exposure in the camera for about 1–3 min.
4 Development, in the same exciting solution as 2 but diluted to half strength.
5 Fixing in hyposulphite of soda, washing and drying.
Positive print
6 Another sheet of paper is soaked in salt solution and wiped dry.
7 Under red light it is brushed over with silver chloride solution, and dried.
8 Pressed in tight face contact with the negative in a printing frame, the paper is exposed to bright sunlight until it forms a strong brownish image (about 20 min).
9 The print is fixed, washed and dried.

silver iodide and also using a developer solution. Shorter exposure times could now be given and the image strengthened by this aftertreatment. The following year he patented his improved routine (Table 1.2) and named it the calotype process.

Within the space of three years the world had been presented with two rival systems of photography. Only one was to survive.

Summary – prehistory and discovery

– The invention of photography brought together the camera obscura, an optical novelty and artist's aid, and materials (such as silver compounds) which undergo changes when exposed to light.

– In 1800 Wedgwood managed to record the shadows of objects placed in direct contact with silver nitrate treated leather, but was unable to fix these results.

– Niépce succeeded in making the first permanent image with the camera obscura in about 1826. He used white bitumen on metal, giving a crude positive result he called a heliograph. Several hours exposure was needed.

– Daguerre devised the first practical process, the daguerreotype. It gave a direct positive image on a silvered metal plate. The process was publicly dis-

Fig. 1.13 Using a length of black cloth over your head, as in the figure, you can convert an overhead projector into a camera obscura and use it as a drawing aid. (See project 1.1). Compare this with Fig. 1.3.

closed in 1839 and created great excitement.

– Fox Talbot was also working on a light-sensitive process – one which formed a negative image, on paper. When printed by sunlight onto a further sheet this gave a positive, permanent picture. Talbot called his result a calotype, and patented it in 1841.

Projects

P1.1 Devise a camera obscura. Use for example a school overhead projector (Fig. 1.13)

switched off and with its lens pointed towards a bright outdoor scene. Place white paper over the light box. Use a coat or black cloth to prevent light reaching the paper other than through the lens. Focus the image onto the paper and trace its outlines.

P1.2 Experiment with 'sun pictures'. Place keys, a leaf, lace etc on photographic paper and leave it in sunlight for about 15 min, until the uncovered areas do not darken further. Kodak Bromesko paper works very well. Now fix, wash and dry your result. The image becomes much lighter during fixing. You can print this paper negative under glass in the same way as you contact print a film, developing and fixing as normal. Note: today's paper is less fibrous, more even and so able to print finer detail than in Talbot's day.

Questions

Q1.1 Outline the contribution to early photography of *two* of the following: Nicéphore Niépce, Louis Daguerre, Henry Fox Talbot.

Q1.2 Describe the main practical differences between the daguerreotype and calotype processes in 1841.

Q1.3 Explain the term *camera obscura* and describe how it was used prior to 1820.

EARLY PHOTOGRAPHY (1839–1850)

The news quickly spread that it was possible to record scenes by the direct action of light itself. Everybody wanted to see examples, or be recorded themselves – or even try taking such pictures. Both the Daguerre and Talbot processes had tremendous technical limitations by today's standards, but they seemed magical compared to the slow and costly business of drawing or painting. People at once began to explore how this novel idea could best be used. Some saw it as an important means of recording, some as a means of artistic expression, others as a method of making money.

Impact of the discovery

The idea of using light waves for picture making was as revolutionary as using radio waves to transmit sounds, more than sixty years later. Newspapers could not reproduce the results, nor of course were they easy to describe in words to anyone who had never seen a photograph. One reporter explained it was 'like holding up a mirror in the street, seeing the minutest details of your surroundings reflected in it, then carrying the mirror indoors and finding these details permanently imprinted'.

The description well fitted the shiny image of the daguerreotype – which was by far the most popular process. Most early pictures were about 13×18 cm (5×7 in), taken with a simple wooden camera (Fig. 2.2) (the word 'obscura' was generally dropped after the invention of photography). In 1839 photographers' subjects were landscapes, buildings and other still-life scenes which could be given exposures of 15 min or so.

Portraits were a special challenge. Iron rests were used to clamp the head, and subjects posed in brilliant sunlight until they almost melted. At first photographers even tried rubbing flour on people's faces! It was not until the American Wolcott camera, which used a curved mirror instead of a lens (Fig. 2.2), and eventually the

Fig. 2.1 Daguerreotype announcement, Morning Post (London) 1839.

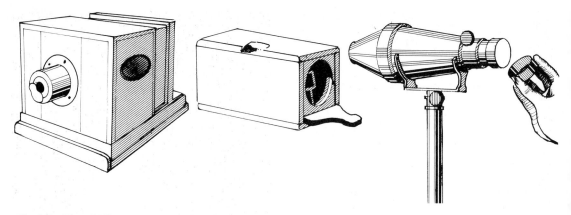

Fig. 2.2 (L to R) Daguerre camera by Giroux, Paris. Wolcott mirror camera 1840 (gave right way round images). 1841 Voigtländer camera.

Petzval lens Voigtländer camera from Germany became available that portraiture was really practical. These improved cameras gave much brighter images but pictures were relatively small – about 5 × 6 cm ($2 × 2\frac{1}{2}$ in).

For years cameras were either large with small aperture lenses 'for landscapes', or smaller but with wider aperture lenses 'for portraits'. Even with the best lenses exposures were still incredibly long. The Voigtländer camera instructions suggested 'For overcast dark skies in winter $3\frac{1}{2}$ min is sufficient; on a sunny day in the shade $1\frac{1}{2}$–2 min are enough; and in direct sunlight it requires no more than 40–45 sec . . .'

By 1841 daguerreotyping was demonstrated daily in London by a Mr Beard who was in business at the Polytechnic Institution in Regent Street, using the Wolcott camera, and by a Mr Claudet using one of Daguerre's cameras at the Adelaide Gallery. These halls were rival permanent exhibitions of popular science, similar to the Science Museum today. In America Samuel Morse taught daguerreotyping on the roof

of the University of the City of New York. An Irish reporter on a New York paper described it 'like fairy work'. Shops in most large cities sold camera equipment, sensitizing chemicals and silvered copper plates.

The popularity of the process varied from country to country according to the patents involved. In France and America anyone was allowed to make daguerreotypes, but in England a patent had been granted to Daguerre's invention, so that everyone taking pictures for money must purchase an annual licence. Talbot had patented all uses of the calotype process in France, America and England (but not Scotland). There is no doubt that this, plus its poorer rendering of fine detail, made it very little used. In America and France daguerreotypes dominated completely. Only in Scotland, and at Talbot's own establishment in England, were calotypes to be made in any quantity.

The 'daguerrean parlor'

Within five years of the announcement of the daguerreo-

type process in Paris, portrait studios were set up in principal cities in most European countries, and in America. Often they were known as 'Daguerrean Galleries' or 'Parlors'.

Being daguerreotyped was really quite an ordeal. You would first be advised what clothing it was best to come in, for the process was only sensitive to blue or white light, other colours mostly appearing black. Ladies had to avoid red or dark green satin; for men a dark grey suit was a better choice than black.

At the appointed hour, and subject to the weather (picture taking was cancelled in overcast conditions), you would climb several flights of stairs to the camera room. This was a glasshouse, usually constructed on the flat roof of the building (Fig. 2.5). Here you had to sit in an upright chair on a raised dais, a sheet of blue tinted glass above your head to help reduce the heat of the sun. The proprietor would adjust a metal clamp hidden behind your neck to hold your head still. Your forearms would rest on the arms of the chair, and you would be told to stare fixedly at

16

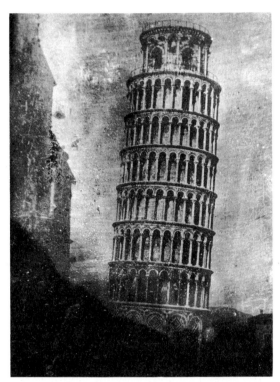

Fig. 2.3 Eight inch high daguerreotype of Pisa, 1841. Written on back is exposure time, 3.45–3.52 pm.

Fig. 2.4 Popular daguerreotype portraits were about this size, in pinchbeck frames (mid-1840s).

the camera, blinking as little as possible, and not on any account to twitch.

The camera was then loaded with the sensitized metal plate by an assistant and the $\frac{1}{2}$–1 min exposure begun. If you wanted two copies this procedure must take place twice (although sometimes two cameras were exposed together, side by side). Eventually you would receive your daguerreotype, set in a little frame mounted in a velvet lined case (Fig. 2.4).

Almost all daguerreotypes were given a final treatment in gold chloride which slightly darkened the appearance of the silver plate and made the white image stand out more clearly. For an extra charge results could be hand coloured. The

typical cost of a professionally made daguerreotype in London was about £1, putting them out of reach of ordinary working people, who barely earned this in a month. Of course they were still cheaper than portraits hand painted in oils, and a degree of snobbery grew up – painted images being called 'portraits' and camera images merely 'likenesses'.

For the painter of miniatures, which had been so popular before the invention of photography (Fig. 2.15), the new process was a disaster. Most of their customers preferred daguerreotypes instead. Many miniature painters turned over to daguerreotyping, carefully calling themselves artist-photographers. Inevitably, there was

friction between painters and photographers. The painters could see their skills being taken over by a machine, and they referred to photographers as 'technicians' or 'tradesmen'. Certainly some photographers deserved to be criticized as standards were often not that high. Such was the public demand that many daguerreotypists and their sitters were delighted with any recognizable result at all.

To be fair the photographer was so concerned with chemical and technical matters, and the need to avoid discomfort of the sitter, he had little time to consider the style of his pictures. People were portrayed seated with arms rested and generally flooded with light, because these

17

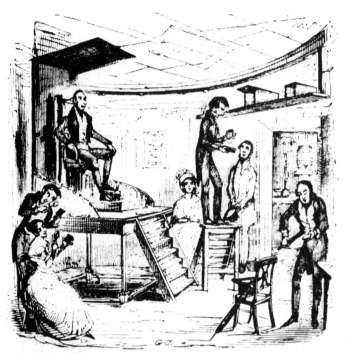

Fig. 2.5 Like many daguerreotype studios, Beard's camera room was located on the roof. Notice the sitter's head clamp, the Wolcott cameras and (foreground) an assistant polishing a silvered plate for sensitizing in the darkroom behind him.

were all technically essential. Results were judged mostly on their sharpness and clarity. Generally the approach was very simple and straightforward, using a plain darktoned background. In a few studios efforts were made to flatter their sitters by including a painted backdrop, or the corner of a good quality writing table or some suitable drapery, vaguely in the style of classical painting.

Travelling exhibitions of the best daguerreotypes from France helped to set standards in other countries, but in general it was a seller's market. People fell over themselves to be daguerreotyped. Vast fortunes were made in these early years by the proprietors of studio chains.

Whereas portraits were subjects mostly for the professional daguerreotypist, amateurs such

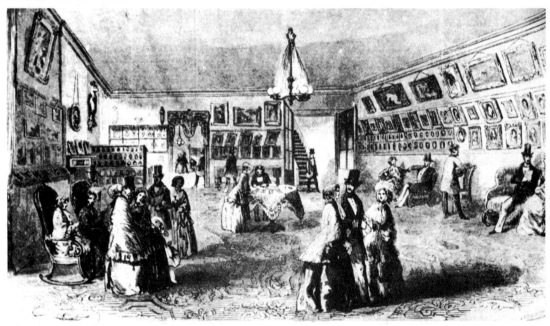

Fig. 2.6 This 1848 engraving shows the reception and waiting area of a 'Daguerrean Gallery' in New York. Daguerreotypes hang alongside paintings. Stairs lead up to the rooftop camera room.

as artists and tourists turned to views. Pictures of moving water and the tops of trees disturbed by the wind blurred over during the long time exposures, and white clouds against blue skies always disappeared, but other details were excellent. Some publishers sent out daguerreotypists to record landscapes in distant countries. These were then used as references for engravings made to illustrate travel books.

Calotype photography

While the daguerreotype grew and grew in popularity, the rival calotype process was used by only a few enthusiasts. Talbot himself took many pictures, mostly still life, character studies, and groups in the gardens of his stately home, Lacock Abbey. Often they look like spontaneous snapshots (Fig. 2.9) but were carefully posed to allow the long exposure times his camera lenses and material demanded.

Quite large cameras were best for calotypes. As described earlier, the process consisted of firstly producing a paper negative, which was then contact printed in turn by sunlight onto another sheet of paper to give a print. The larger the negative the less its pattern of paper fibres destroyed image detail in the final print. Talbot also found that by rubbing wax into the processed negative the paper was made more transparent. Despite this, the slight diffusion of detail and mottled overall pattern found in calotype prints was one of the main reasons people preferred daguerreotypes.

Other technical advantages

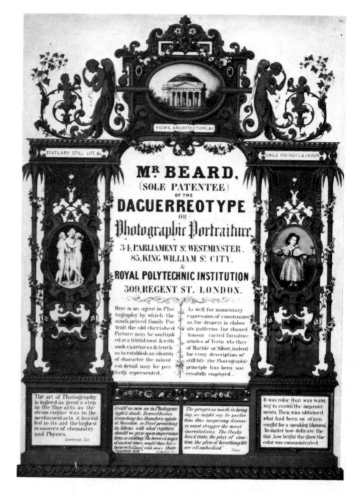

Fig. 2.7 An elaborate trade card sent to likely customers by Richard Beard, the first daguerreotypist to open a studio in Britain, May 1841. Portraiture was the biggest money-spinner. Within a few years Beard had made a large fortune.

and disadvantages between the two processes are shown in Table 2.1. The most valuable feature of the calotype, namely that having recorded one image in the camera almost unlimited numbers of prints could be run off cheaply, was rather overlooked. Daguerrean galleries could offer a while-you-wait service, and the image detail was unsurpassed. Talbot therefore had great difficulty persuading people to buy licences to use his process.

The London photographer Claudet took up calotyping for a few years but then returned exclusively to Daguerre's system which the public seemed to prefer. (No photographer in the early 1840s could have foreseen that Talbot's negative/positive process was the real road to the future of photography. The daguerreotype was to lead to nowhere, having practically reached the limit of improvements.)

Talbot was a resourceful

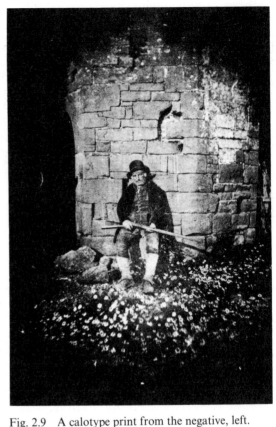

Fig. 2.8 One of the many calotype paper negatives taken at Lacock Abbey, about 1840. The subject here is Talbot's gamekeeper.

Fig. 2.9 A calotype print from the negative, left. The lens in Talbot's early $8\frac{1}{2} \times 6\frac{1}{2}$ in camera gave poor sharpness and illumination at picture corners.

and intelligent man. He decided he would publicize the main advantage of his process by making and selling large numbers of excellent quality prints. So in 1844 he rented premises in Reading and hired staff to mass produce calotype prints. Negatives were made of well-known buildings, landscapes, art objects such as statuettes, even copies of drawings and paint-

Table 2.1 The calotype–comparison with the daguerreotype

Calotype advantages	Calotype disadvantages
Unlimited numbers of relatively low cost prints could be made from each camera exposure.	Photographing onto paper gave results with poorer image detail; pictures were also often uneven.
The final picture was not reversed, left to right.	Calotype materials were less sensitive to light, requiring longer camera exposures.
Negatives could be retouched to remove wrinkles etc in portraits.	It also took longer to produce results–the negative had to be processed and dried, then printed, and finally the print processed and dried.
The process was cheaper and easier to use by the traveller.	
Pictures on paper were easier to view, and send through the post, mount in albums, etc.	There was a tendency for prints to fade.
Calotype photographs had warmer tones, and gave broad effects (rather than cold clinical detail), well suited to pictures having mood and atmosphere.	The process and equipment was less widely available, and more restricted by patents.

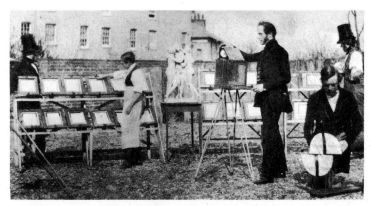

Fig. 2.10 Part of Talbot's works in the town of Reading, which he set up in 1844 to mass produce calotype prints. Assistants here are printing negatives by sunlight in glass-fronted frames, and also photographing statuary.

ings. Long racks of printing frames were set out in the sun (Fig. 2.10). Thousands of prints were sold, mostly in stationers' shops, at 5–25p (1–5 shillings) each according to size.

The Pencil of Nature

Talbot's most important project at Reading was to produce a book of calotypes–the first photographically illustrated book in the world. It was called *The Pencil of Nature* and the complete work contained 24 large pictures all by Talbot. Prints were individually stuck onto the pages (Fig. 2.11). In the accompanying text Talbot described the steps leading to his discovery, and explained its virtues and applications. *The Pencil of Nature* was published and sold in six parts between 1844 and 1846. The few still in existence today are now very valuable collector's items.

A similar work *Sun Pictures in Scotland* was published from Reading, and Talbot also made an enormous run of 7000 prints which were included in an art magazine special issue. All this activity helped to bring calotypes to the attention of the art world at least. In one respect the publicity was embarrassing, for some of these mass-produced prints began to fade after a few months. Naturally, the defect was gleefully seized upon by artists as yet another defect of photography.

Hill and Adamson

The calotype process had its most important success in Scotland. Here Talbot managed, through friends, to encourage a young chemist Robert Adamson to set up as a professional calotypist. He was soon approached by the Scottish portrait painter, David Octavius Hill who had been commissioned to produce an enormous historical painting portraying nearly 500 recognizable people –the ministers who had just rebelled and set up the Free Church of Scotland. Photography was ideal for recording these people, in small groups outdoors, and for providing work prints from which the huge mosaic of faces could be painted.

In fact Hill and Adamson became really enthusiastic about the new process for its own sake. Working in collaboration they not only produced the first outstanding calotype

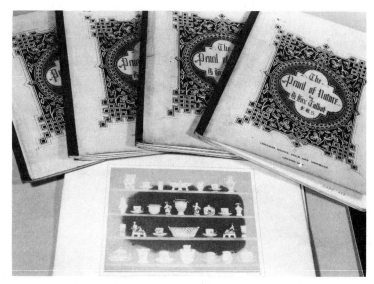

Fig. 2.11 'The Pencil of Nature', published in six separately bound parts, was the world's first book with photographic illustrations. It contained 24 gummed-in calotypes like the one shown, which are now fading with age.

portraits of celebrities, but took pictures to please themselves of Scottish fishing villages and their inhabitants. Hill seems to have posed the subjects and adjusted the composition, while Adamson handled all the technical aspects. Between 1843 and 1847 this collaboration of science and art produced hundreds of pictures which showed the artistic potential of Talbot's invention. Hill's knowledge of painting helped him compose in a broad and simple way which suited the detail limitations of paper negatives – in fact turned them to his advantage. David Hill is therefore recognized as one of the first artist photographers.

Sadly Robert Adamson died in 1848 aged 27, whereupon Hill effectively gave up photography and devoted all his time to painting. It is ironic that Hill's paintings are now mostly forgotten, whereas Hill/Adamson calotype prints are still admired and respected.

Use and influence of early photography

Although the daguerreotype and calotype remained in competition throughout the 1840s, only the daguerreotype process was well known to the public. People had their portraits taken to give to their loved ones; the results were considered cheaper, more accurate and more modern than miniature paintings. Of course, the process tended to record faces 'warts and all' (daguerreotypes could not really be retouched) but this was accepted along with the left-to-right reversed image unless a Wolcott camera was used. After all, most people

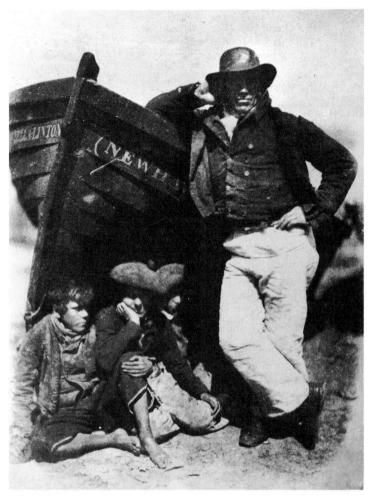

Fig. 2.12 'Jas Linton, His Boat and His Bairns', an 1845 photograph using the calotype process, taken by the Scots partners David Octavius Hill and Robert Adamson. Hill did most of the subject arrangement while Adamson handled the technical side.

only ever saw themselves reflected in a mirror.

This too was the time of the industrial revolution. The new invention of railways had been sweeping aside the stagecoach, providing transport at half the cost and twice the speed. Everyone became fascinated by travel and accurate records of far away places were extremely popular. Here daguerreotypes were at a disadvantage – you really had to hold them up to a

mirror to correct the rendering of buildings, landscapes etc. Calotypes were therefore a better alternative, and were taken by a few keen amateurs and professionals in Britain and France.

Both processes quickly became useful as sources of pictures which, like sketches, could be translated into steel engravings or woodcuts and printed in books, newspapers etc. So although the final results

clearly painting was not yet dead. In fact painters already sniggered at photographer's efforts to use the new medium artistically, while quietly using it themselves as a labour-saving device.

People were mostly put off photography as a hobby by its expense and difficulty – particularly the daguerreotype process, which required silvered metal plates. It was a skilled and messy business which only a real enthusiast with some knowledge of practical chemistry would ever take up.

By 1850 the mere ability to be able to record images was becoming less of a novelty. Would-be photographers were frustrated by the limitations of the processes, and people everywhere were experimenting to discover something better. The answer was to arrive in 1851, with a system which totally eclipsed both the Daguerre and Talbot processes.

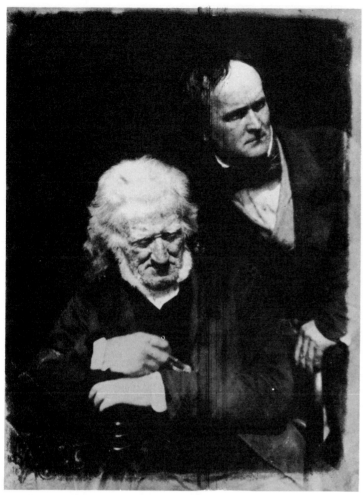

Fig. 2.13 Another Hill and Adamson portrait of similar date. It shows sculptors John Henning and Alex Ritchie. Note their natural appearance, despite an exposure several minutes long. The composition is outstanding for a time when most portraits looked wooden.

still looked like drawings, photography was already affecting the methods of communication. A few government departments and hospitals began to use daguerreotypes as a means of recording. Photographic likenesses formed splendid factual references for painters too and began influencing the way some portraits were painted – the posing of chin on hand, or arm on chair for example. At this time all cameras had to be used on stands and tripods. There was no question of taking action pictures, in fact it was to be 30 years before such things were possible.

Photographers could only measure their creative efforts (when they had time to consider them at all) against paintings of the period. After ten years of existence photography was a fine mechanical way of recording accurate information, but

Summary – early photography

– The two main applications for early photography were portraits and landscapes (including architecture). Daguerreotyping was far and away the most popular process for both, and was taught and demonstrated in most European countries and in America.

– Daguerrean galleries offering a portrait service soon appeared in most cities. They were set up in glasshouses alongside or on the roofs of buildings. The daguerreotype process was patented in England; and the calotype in England, France and America.

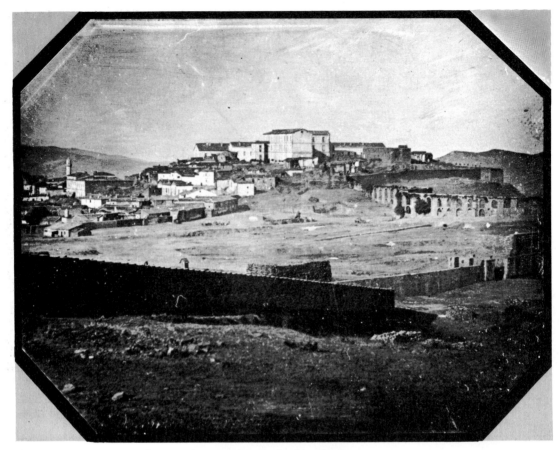

Fig. 2.14 Daguerreotype photographers took hundreds of scenic views
of far-away places as references for engravings in travel books. This one
shows Medea, Algeria about 1850. Like Fig. 2.3, the details are
reversed left to right.

–Being daguerreotyped be-
came very fashionable, despite
the discomfort, glare and heat.
Some of the first proprietors
made large fortunes. Miniature
painting declined.

–The trouble with calotypes
was their loss of fine detail,
slower (negative/positive) pro-
cessing and poorer sensitivity
to light. To promote his process
and demonstrate its multiprint
advantages Talbot set up a
calotype printing works and
published *The Pencil of Nature*.

–In Scotland the calotype
process was adopted by David
Hill and Robert Adamson, an

artist and a chemist working
in collaborration to produce
hundreds of fine portraits.

–Throughout the 1840s photo-
graphers worked under extreme
technical difficulties, due to the
long time exposures needed for
every subject. Both processes
were too complicated and too
expensive for more than a few
people to enjoy as a hobby.

Projects

P2.1 Try taking photographs
on paper negatives. Cut a
piece of grade 0 or 1 glossy
single-weight bromide paper to

fit within the film guides at the
back of your camera. Set the
meter to 32 ASA, then give
about 15 times the exposure
time indicated. Process in print
developer at half normal streng-
th. When fixed, washed and dry,
contact print this negative onto
another sheet of grade 0 or 1
paper. Experiment with waxing
or oiling your paper negative
to improve results.

P2.2 Check with your local
museum, art gallery or library
to see if they possess any
daguerreotypes. (Note: make
sure they are not the far more
common ambrotypes, see page
34). Examine their fine detail

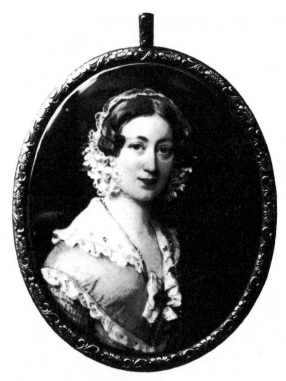

Fig. 2.15 Portrait miniatures, like this 1840 example by Sir William Ross, were mostly painted in watercolours on ivory. Set in narrow oval frames they were extremely popular before the coming of photography.

Fig. 2.16 Daguerreotype portraits, finished off in little gilt-framed cases, were in direct competition with painted miniatures. (Both pictures here are actual size). Photography was cheaper, more accurate, and much more modern.

and shiny difficult-to-view appearance. Using books find reproductions of painted portraits and landscapes of approximately the same date.

Questions

Q2.1 Why was the daguerreotype so much more popular than the calotype during the 1840s? Give your answer under three headings – Technical, Commercial, Artistic.

Q2.2 Write an account outlining the evolution of photography during the period 1825–45. Describe briefly the reaction of contemporary painters to the new medium.

Q2.3 Describe each of the following:
The Pencil of Nature
The photography of David Octavius Hill and Robert Adamson.

THE 'WET' PLATE ERA (1851–1870)

Photography underwent an important change in the early 1850s. A new process called collodion or 'wet plate' was, in various forms, to sweep the world. The manipulations required were, if anything, worse than the daguerreotype or calotype. However, it offered very important advantages. Through the collodion process far more people were brought into contact with photography, and photographs were used for many more purposes. For a long period – almost a whole generation – wet collodion remained the only practical process.

The search for a binder

Ideally, photographers wanted a process which offered the image clarity and detail given by the daguerreotype, *plus* the ability to quickly and cheaply run off prints on paper like the calotype. A better form of negative was needed – on a clear transparent base instead of paper. Film as it is known today did not exist. The obvious choice was to use a sheet of clear glass, but whereas the light-sensitive chemicals could be absorbed into paper they were much more difficult to stick to a smooth glass surface.

Sir John Herschel had experimented along these lines back in 1839, using a sheet of glass at the bottom of a dish of silver chloride solution and allowing the chemical to gradually settle onto its surface. This was slow and impractical, and of course processing solutions quite easily floated the coating off again. Some sort of 'binder' was essential.

People searched about for a sticky clear substance which would attach light-sensitive salts to glass, yet still allow them to be chemically affected by processing and washing solutions. At first albumen (the clear liquid in a hen's egg) seemed the best possible binder. By 1847 Niépce de Saint-Victor, a nephew of Nicephore, had patented an albumen-on-glass process. But the amount of light-sensitive chemical you could mix in with the sticky albumen was so limited that plates were extremely slow – too impractical to use for subjects such as portraits.

Albumen was more successful for printing paper, which did

Fig. 3.1 An early 12 × 10 in collodion negative. The new process gave excellent quality negatives on glass sheets. These printed without the usual mottle and image diffusion of paper negatives.

not have to be nearly so responsive to light. Albumenized paper gave a good quality image, less prone to fading than Talbot's salted paper, and with an attractive glossy surface. You could also print onto albumen-coated glass to form a lantern slide. This could be projected using a 'magic lantern', a device long used for showing images painted on glass, and now to become really popular thanks to photography.

Collodion

1851 was an important year for Britain, then at the height of her achievements in the industrial revolution. The Great Exhibition was staged in London showing progress in science, arts and manufacturing. Articles were published, papers read to meetings, information exchanged. Out of this melting

pot of ideas came news of experimental work by an obscure London sculptor, Frederick Scott Archer. Like so many others he had been trying to improve detail in his photography by using glass plates. But Archer had discovered that a sticky liquid called *collodion* formed a good binder. Collodion is nitrated cotton (gun cotton) dissolved in ether and alcohol. It had been used a few years earlier for dressing wounds–painted over an open cut it dries to form a hard clear protective membrane. (You can still buy this kind of paint-on sealer at chemists today.)

Archer's method, shown in Table 3.1, was to pour a mixture of collodion and chemical over a sheet of glass, then sensitize this and expose it in the camera while still damp (the plate would not work after the collodion dried hard.) The image was immediately developed, fixed and washed. This odd requirement meant that collodion negative making quickly became known as the 'wet plate' process.

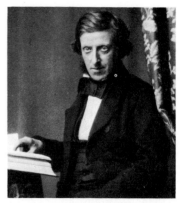

Fig. 3.2 Frederick Scott Archer, sculptor and photographer, who invented the revolutionary collodion or 'wet plate' process in 1851.

The new process had four main advantages:
1 Negatives gave great clarity of detail. Look at Figs 3.1 and 3.5. You could make unlimited numbers of permanent prints (eg. on albumen paper) revealing outstandingly sharp subject information. This made them very attractive to buy and sell.
2 It was cheap. People could buy about 12 paper prints for the same price as one daguerreotype.

Table 3.1 Wet plate photography process

Negative
1 A sticky solution of collodion in which potassium iodide had been dissolved is flowed over the surface of a cleaned and polished sheet of glass. It is a skilled job to form a smooth even coating–particularly over large plates.
2 Under red lighting the still-tacky plate is soaked for several minutes in silver nitrate solution. Then it is drained and placed immediately in a light-proof holder to take to the camera.
3 Exposure in the camera, typically between 30 sec to 2 min at $f11$.
4 Back in the darkroom a developing solution of pyrogallic acid is immediately poured over the plate. You wait until the image looks fully developed, then rinse it in water.
5 The negative is fixed in hyposulphite of soda, washed, dried (over a gentle flame) and finally varnished.

Print
6 In the darkroom a sheet of paper coated with albumen and common salt (as sold to the trade) is floated coated side downwards in a tray of silver nitrate sensitizing solution. It is then allowed to dry and used as soon as possible.
7 The paper is pressed behind the negative in a printing frame and left in sunlight until a strong purple black image has formed.
8 The exposed print is rinsed, usually toned in gold chloride to turn its image dark brown, fixed in hypo, washed and dried.

3 Archer never patented his idea, so anyone could practise collodion photography without fee.

4 It was more sensitive to light than the calotype or albumen-on-glass processes.

Collodion also shared all the advantages of neg/pos photography over the daguerreotype, discussed on page 20. Understandably, it became the main photographic process almost at once in England, and within a few years in Europe and America too. (Americans preferred the ambrotype form of collodion photography, page 34.)

Thousands more people, artists, scientists, travellers, now looked at photography seriously. It was practically re-born: the first negative/positive system able to give a really satisfactory image. Most people compared these new paper pictures with the detailed but unreproduceable daguerreotype. Within five years hardly anyone made daguerreotypes or calotypes any more.

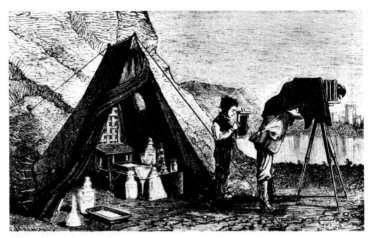

Fig. 3.3 Collodion was awkward because plates had to be coated, exposed and processed all within minutes. Away from the studio photographers needed a darkroom tent and chest of chemicals.

Wet-plate negatives in practice

Despite the excellence of results, no-one would claim that the collodion process was easy to use. Working at home or in a professional studio, it was a skilful job to flow the thick sticky collodion evenly over the entire glass surface. Then the plate had to be sensitized, exposed and processed (see Table 3.1)–all within the 10–20 minutes collodion took to dry.

This procedure was difficult when your darkroom was just next door to your studio, or wherever the subject was set up. Photography of country landscapes, or foreign lands would seem impossibly difficult. And yet the prospect of bringing back detailed, reproduceable records of places no-one had photographed before was such a lure that most technical problems were somehow overcome.

People took out with them complete darkroom tents (Fig. 3.3) and as from about 1853 a darkroom unit was made which folded out of a kind of suit-case, supported at a convenient height on a tripod (Fig. 3.4). The wet-plate photographer first used the darkroom device for preparing the plate, then carried it in a light-tight holder to the camera, exposed it to the image and returned to develop, fix and wash the result. Pictures were often taken near lakes or streams, for unless you were prepared to carry your own water barrel some handy local supply was essential to process and wash each plate.

When you see a collodion photograph, like Fig. 3.5, just consider the darkroom and camera which had to be set up, water fetched and chemicals

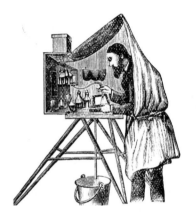

Fig. 3.4 This portable darkroom folded out of a large box. You filled the top tank from any handy water supply.

mixed. Remember too that enlarging was not yet possible–the only way to get a large print was by using a large heavy camera. Most of the time the photographer's upper half would be hidden under some form of cloth, so it was not surprising village children sometimes jeered and threw stones. Frequently the mysterious stranger was chased off by local inhabitants convinced he was up to no good.

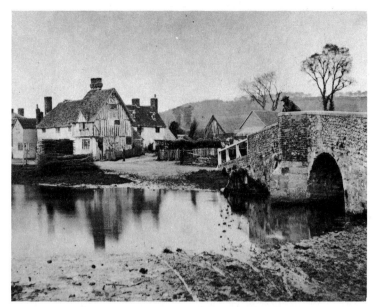

Fig. 3.5 An 1850's English landscape taken on a collodion negative contact printed on albumen paper. Details are as good as a daguerreotype but the process was cheaper and allowed prints.

Despite problems of this kind the collodion negative was considered so versatile, so sensitive to light and of such excellent quality, that a whole range of applications of photography were opened up. Some of these are shown in the photographs on pages 30–34, all taken during the 1850s.

Record photographs of new engineering or building constructions, (or old buildings before demolition) could now be made and filed for reference. This sort of information previously needed laborious sketches and thousands of words to describe. Philip Delamotte for example took regular progress pictures of the rebuilding of the Crystal Palace at Sydenham, London from 1851 to 1854 for the directors of the project. As well as acting as records, many of his photographs are well composed pictures in their own right (Fig. 3.6).

Roger Fenton, already well known as a landscape photographer, was sent from London to take *documentary pictures* of the Crimean War. Action pictures were technically impossible so most of his photographs are still-life views of supplies (Fig. 3.8), also the front line before or after battles, and carefully posed groups of officers in camp. Fenton's pictures were later exhibited and sold in album sets by the print publisher who financed his trip.

Another photographer prepared to work under appalling conditions was Francis Frith. Frith was one of the earliest *travel photographers* to use the collodion process. Between 1856 and 1860 he made no less than three trips up the Nile, and took hundreds of views of Egypt (Fig. 3.7), Syria, and the Holy Lands. Imagine the problems of working in the presence of sand and flies, at temperatures which made the collodion almost dry as it was coated!

Scenic views by Frith and others were bulk printed in thousands on albumen paper – their production became a minor industry in England and France. So many printing frames would be laid out on racks to face the sun that print establishments looked like greenhouses. Assistants walked up and down the rows checking progress as prints darkened, changing paper, washing and toning results. Finished albumen prints were mostly sold direct in print shops, or pasted into travel books.

The first major exhibition of photography was held in London in late 1852, and the following year the Photographic Society (now the Royal Photographic Society) came into being. Roger Fenton was its first secretary. Other societies formed in several big cities. One of their most important functions was the organization of exhibitions. These gave free publicity to the professional, allowed amateurs to vie with each other, and the public and press to comment on the current state of the new art.

Perhaps because of the remarks of art critics assigned to the new medium, or a general feeling that the most acceptable approach to '*artistic*' *photography* would be to ape popular painting of the period, many serious photographers chose lofty, sentimental or historical themes for their exhibition prints. Having decided a title such as 'Tis Dark Without,

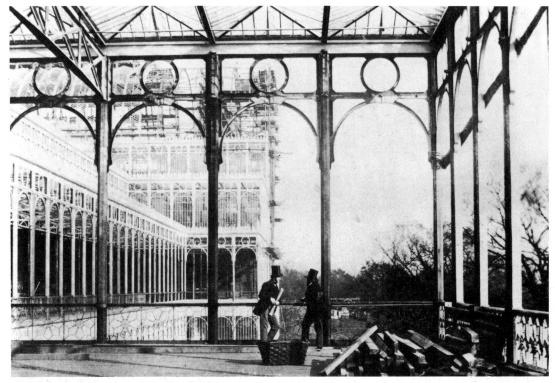

Fig. 3.6 An early 1853 collodion record photograph by Philip
Delamotte. It was one of a series showing reconstruction of the Crystal
Palace in South London after removal from Hyde Park.

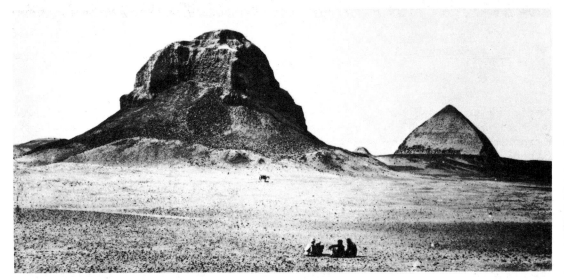

Fig. 3.7 Francis Frith, the travel photographer, took this collodion
view of the pyramids of Dahshoor during a Nile trip in 1856. Frith's
albumen prints of distant places sold in thousands.

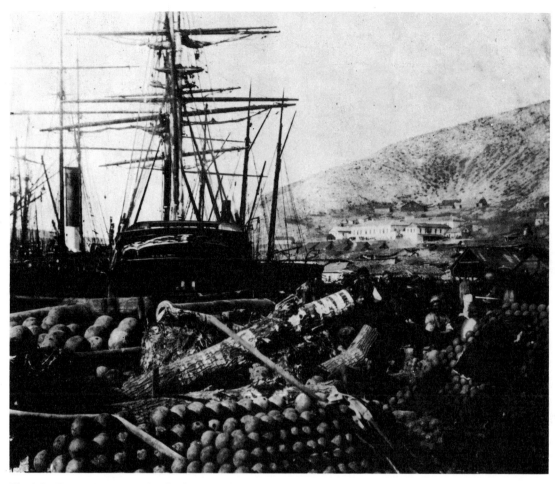

Fig. 3.8 Roger Fenton used collodion to document the Crimean War. Action shots were impossible but pictures like this Balaclava harbour scene 1855 at least proved that supplies were reaching the troops.

Tis Light Within' or 'Don Quixote in His Study' (page 103) they would construct the whole picture like a stage set. In 'Play' for example (Fig. 3.10), Oscar Rejlander chose suitable models for the child and old man and dressed them accordingly. Books and a stuffed dog were positioned in the foreground and the two figures drilled and rehearsed to adopt the most appropriate positions and expressions which had to be held, unmoving, while the time exposure was given.

Rejlander and other British 'High Art' photographers of the 1850s became expert at stage managing everything the camera saw. Painters of course often pose models to sketch and interpret in compositions, but the use of the detail-revealing camera to make fake photographs frequently gave ridiculous artificial results. This approach is discussed in Chapter 7.

Another way of working made possible by collodion negatives was combination printing. This meant planning and photographing the various parts of a composition – figures or groups of figures, background, foreground objects, etc – on separate negatives. They were then all combined onto one final print.

The idea stemmed from the problem of recording skies in landscapes. Collodion plates were much more sensitive to blue than green, so by the time

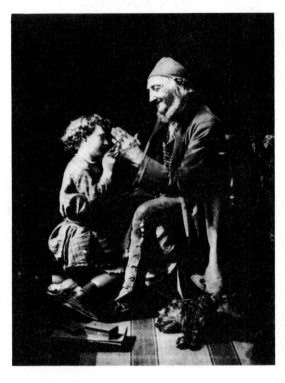

Fig. 3.9 Part of The Illustrated London News review of London's first major photographic exhibition (1852).

Fig. 3.10 'Play' by Oscar Rejlander, 1855. Sentimental staged studio compositions were considered artistic, and greatly admired.

you had exposed correctly for grass and trees, the sky and clouds appeared burnt out white. Photographers therefore often took two negatives, one a short exposure to record sky detail, the other longer for ground detail. These were contact printed one at a time onto the same sheet of paper, carefully shading the printing frame so that only the wanted area was exposed to light in each case. You could also use the technique to avoid bad expressions or moved figures in a group of people, taking several negatives and then picking and combining the best heads from each.

Rejlander patiently used combination printing to build up elaborate compositions such as 'Two Ways of Life', page 102. His fellow member of the Photographic Society and rival exhibitor H. P. Robinson also constructed pictures from various negatives (but by making separate prints which he cut out, pasted onto a background print, and re-photographed). Fig. 3.12 shows how the composition 'Fading Away' was put together in this way. The final work appeared on a mount carrying tasteful verse by Shelley and when exhibited in 1858 it received great admiration. 'High Art' photographs were bought regularly by important people including Queen Victoria and Prince Albert.

The early collodion period also brought a slightly freer approach to *portraiture*. This was probably due to the talents of some of the people now attracted to photography as much as any technical improvements. Look at the work of Nadar (real name Felix Toumachon). He opened a portrait studio in Paris in 1853 and during the next twenty years became the best-known photographer in France. Most of the important writers, artists, and actors of this period sat for Nadar's camera. He had a gift for understanding and being in sympathy with his subject—despite the need for time ex-

32

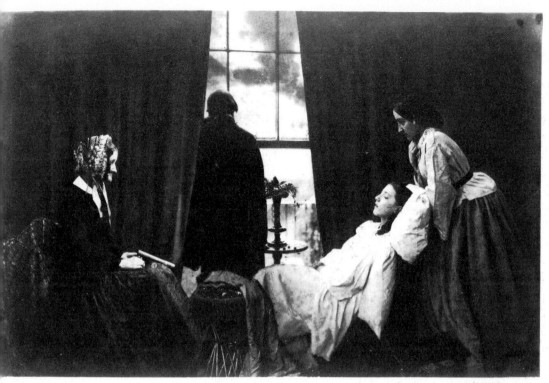

Fig. 3.11 'Fading Away' by H. Peach Robinson, 1858, was a smash hit at photography exhibitions. The dying girl and grieving family gave a strong narrative theme, like characters in Victorian novels of the period.

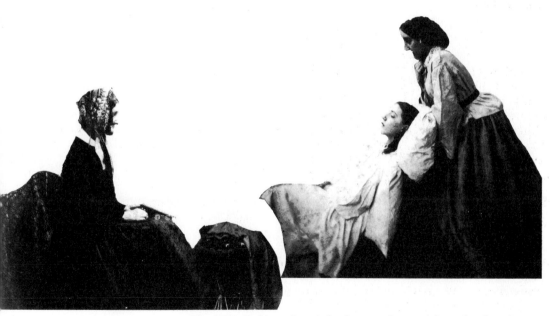

Fig. 3.12 Robinson's artistic photographs were planned and made up from several negatives. Figures or groups of figures were photographed separately in the studio, then prints cut out and pasted on a background print, retouched and copied.

posures his portraits manage to show personalities rather than the usual cardboard likenesses (Figs. 3.13 and 14).

Nadar was an adventurous man: he was the first to take photographs from the air (sensitizing his collodion plates in a balloon basket) and underground in the catacombs of Paris (using primitive battery-powered electric lamps). But Nadar and other photographers producing high quality work were soon concerned about the way the patent-free collodion process was being used in cheap studios to turn out second rate portraiture. People could pick up the basic techniques of taking photographs without possessing any interest or feeling for pictures. Nadar's concern was to prove well founded.

Ambrotype and tintype versions

Whereas collodion was at first intended as a negative/positive process, Scott-Archer also discovered how the glass plate exposed in the camera could itself show a positive image. You may have noticed with modern film how a very underexposed (weak) negative viewed against a dark background takes on a positive appearance. Fig. 3.15 shows how the dark silver image reflects some light, whereas the clear areas look black. In the same way an underexposed collodion negative could be backed up with black velvet in a little case to form a direct positive picture. (For best results the processed plate was bathed in a chemical which gave the black silver a strong grey-white appearance.)

This form of result was known as an 'Ambrotype' after the Greek word signifying 'imperishable'. Table 3.2 summarizes its good and bad points. Ambrotypes were rarely used for subjects other than portraits. In America between 1855 and 1857 more portraits were taken by ambrotype than any other process. This is largely because they looked similar to the very popular daguerreotype – in fact they were often wrongly called 'daguerreotypes on glass.'

The advent of the ambrotype

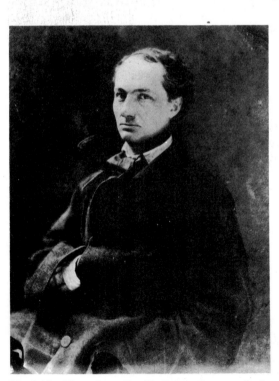

Fig. 3.13 The painter Camille Corot, photographed by his friend Felix Nadar in Paris 1858. Despite the need for time exposures, Nadar's portraits captured the character and personality of his sitters.

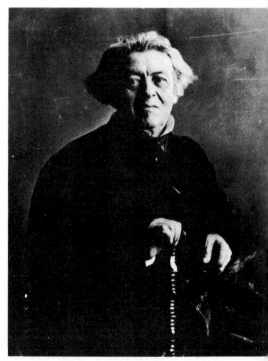

Fig. 3.14 Nadar was an ex-painter and writer who collodion photographed many leading figures in Paris of the 50s and 60s. This striking and direct portrait is of writer Baudelaire, 1856.

Fig. 3.15 How ambrotypes work. A very underexposed black-and-white negative appears as a positive if you view it dull side upward against a black background.

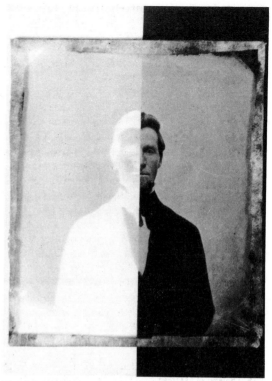

Fig. 3.16 A typical low cost ambrotype portrait of the late 1850s. The left half has had its black velvet backing removed, showing that it is really an underexposed glass negative.

meant that people previously unable to afford daguerreotypes could now have portraits which looked almost as good. In fact, to cut costs further and give a less breakable result which could be mounted in an album, American photographer Hamilton Smith patented a version using black-painted metal instead of glass. These became known as 'tintypes' (or 'ferrotypes') (Fig. 3.20). Thousands and thousands of tintypes were produced, particularly in cheap portrait studios and by street photographers, from 1856 until well into

Table 3.2 The ambrotype–comparison with collodion negatives printed onto paper

Ambrotype advantages	Ambrotype disadvantages
Results could be produced more quickly. No printing stage required.	You could not make paper prints off ambrotypes. Each picture was unique.
They cost less in materials and time.	Results had a poorer tone range than a paper print or daguerreotype; in particular the image had little detail in dark parts of the picture.
Less exposure was needed.	
They resembled daguerreotypes, which had been popular for years although much more expensive.	
They were easier to view (less reflective) than daguerreotypes.	
By mounting the plate with its collodion surface towards the black backing material the picture appeared correct left-to-right, unlike a dageuerreotype.	

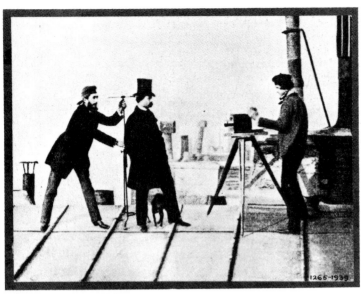

the present century. Tintypes, ambrotypes, and daguerreotypes were all frequently coloured by hand.

The tintype did not reach Britain and Europe generally until the late 1860s, where it became a 'While-U-Wait' camera gimmick used by street and beach photographers. In fact the most important aspect of ambrotype and tintype collodion photographs was that they were both very cheap forms of portraiture. 'Studios' offering sixpenny ($2\frac{1}{2}$p) and shilling (5p) likenesses sprung up everywhere. This meant that portraiture had at last reached the working man's family, but every tradesman and every charlatan who could get together camera equipment and a few chemicals now offered to take your pic

Fig. 3.17 Although this 1860 picture was probably staged as a joke, it shows the cheapjack kind of ambrotype studio set up among the chimney pots.

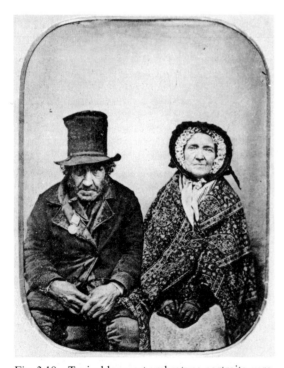

Fig. 3.18 Typical low cost ambrotype portraits were about this size, roughly similar to a daguerreotype at one tenth its cost. There is no painted backdrop, props, or much attempt at arrangement.

Fig. 3.19 An 1857 advertisement for a humble but respectable studio, warning people against charlatans.

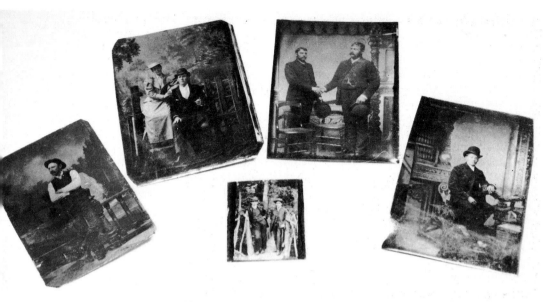

Fig. 3.20 Various unmounted tintypes, produced about 1870. Note their small size. All but the smallest were taken in the studio. These roughly cut metal shapes were not seen when finally slipped into oval or square frames.

ure. The average standard was ppalling–'cheapjack like-nesses' became a music hall oke. In the poorer areas of owns customers were fobbed ·ff with blackened, blurred and ınrecognizable results which they were assured would 'im-prove after exposure to the air'. Ordinary people were overawed by the process. There were tales of friends 'who never had a day's health after being photo-graphed'.

The stereoscopic photograph

The collodion process also hastened the growth of a 19th century equivalent to television, the family stereoscope. By using a double camera with lenses

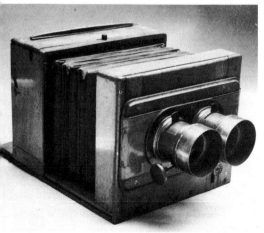

'ig. 3.21 A double lens collodion plate camera √hich took pairs of photographs for stereoscopes.

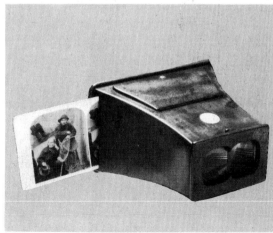

Fig. 3.22 A hand viewer for stereoscopic pictures either on card (shown partly inserted) or on glass.

about 65 mm (2·5 in) apart two pictures could be exposed side-by-side on a collodion plate, giving the equivalents of left and right eye views of a scene. Prints made from these negatives were set up in a viewer so your left eye only saw the left hand camera's photograph and the right eye only saw the right hand image. When this was properly adjusted your eyes fused the pictures into a three-dimensional image – foreground objects 'standing out' and things in the background seeming to be spaced much further back.

Collodion stereo negatives therefore allowed the making of unlimited quantities of stereo prints on albumen-coated paper or glass. Their quality and detail could be excellent (Fig. 3.23). As from about 1855 shops everywhere sold a wide range of cheap stereo pictures. They included travel views taken all over the world, portraits of famous personalities, events of the day, even story-telling sequences. 'No home complete without a stereoscope' ran the advertisement for the London Stereoscope Co., which listed over one hundred thousand titles in their 1858 catalogue.

It was true hardly a parlour was without some form of stereo viewer – either a low cost hand device (Fig. 3.22) or a cabinet type which might accept up to 50 pairs of pictures. People would buy and collect stereophotographs as they might today purchase pop records. On Sundays when relatives visited each other it would be a great treat to peep through the stereoscope and see the latest additions to their picture collection.

You could buy stereo cameras, and stereo-pairs were accepted and shown in all the photographic exhibitions, but for the most part these pictures were taken by professional photographers for sale. The main publishers were in London and Paris, and they were sold in stores the world over. The stereo boom which really began in 1852 rose to peaks in 1860 and 1870, and at other times declined (particularly during the 1860s carte-de-visite craze, see below). However it remained fairly popular throughout various new photographic processes, until films and then radio competed for family interests. Even today clubs and competitions exist for photographers taking stereo pictures on colour slide film.

The carte-de-visite craze

The mass-production of prints, made possible by the collodion process, led to a fashionable new way of using photographic

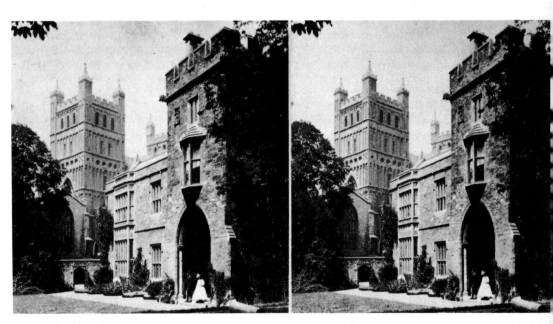

Fig. 3.23 A stereo pair of photographs. If you look through magnifying glasses so that each eye sees a different picture the effect is a single 3D image.

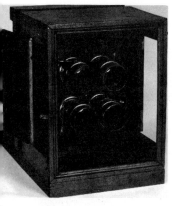

Fig. 3.24 A four lens carte de visite studio camera. Lenses were either opened one at a time, or all together.

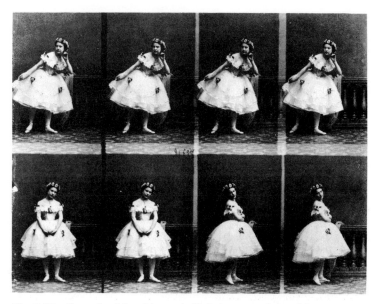

Fig. 3.25 Carte de visites (shown half size) contact printed from a negative exposed in a four lens camera. The plate shifted sideways to expose the second set of pictures.

portraits as visiting cards. In the nineteenth century most people –or at least those in 'polite society'–carried calling cards. They were rather like business cards today, neatly printed with your name, rank or qualifications, and address. When visiting you would hand a card to the maid who opened the door. The card was either carried to her employer or, if no-one was in, left on a plate in the hall to show who had called.

In 1854 the French portrait photographer Adolphe Disderi devised a camera giving pictures of the size of visiting cards. It had four lenses (Fig. 3.24) and by exposing through each in turn you could take four poses of the sitter filling one half of a $6\frac{1}{2} \times 8\frac{1}{2}$ in (16·5 × 21·5 cm) 'whole plate' size collodion plate. Then the plate was turned around and another four pictures taken, recording eight poses in all. Contact prints from the negative could be cut up and pasted on small card mounts printed with your name to form a novel photographic visiting card (Fig. 3.26).

Disderi skilfully publicized his visiting card or *Carte-de-Visite* photography, and the novelty began to grow. Disderi flourished. Even Napoleon III, marching to a war at the head of his troops, stopped off at Disderi's studio to have carte de visites taken while the army waited for him out in the street. By 1860 the idea had spread from Paris to London and then New York, sweeping away the last remnants of the American daguerreotype trade. Carte de visites became a craze–newspapers called it 'cardomania'.

The main reasons for such success were probably:

1 Cheapness. In Britain they were about five shillings (25p) a dozen including the photography–you could have four finished cards for about the price of one whole-plate photograph.

2 They were only $2\frac{1}{2} \times 4$ in (6 × 10 cm), light-weight, and highly collectable. Albums soon appeared which you could fill with several portraits to a page (Fig. 3.29). These became fashionable objects to leave in the Victorian parlour.

3 Cartes of celebrities were quickly on sale in the shops. You could therefore collect pictures of people in the public eye as well as friends and relations.

The craze grew to really enormous proportions. In 1855 there had been only 66 portrait photography studios in London, but six years later there were over 200 (35 in Regent street alone.) Some carte-de-visite printing establishments turned out over 3000 celebrity cards daily. Well-known people were paid to allow themselves to be photographed and published in this way. Royalty, politicians, prize-fighters, actresses, freaks–they all appeared in the catalogues. The London Stereoscope and Photographic Co. 'scooped' Tennyson, Dis-

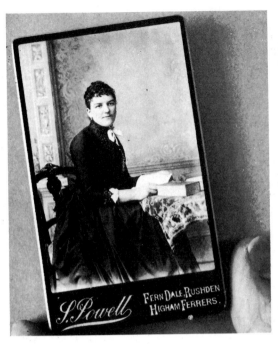

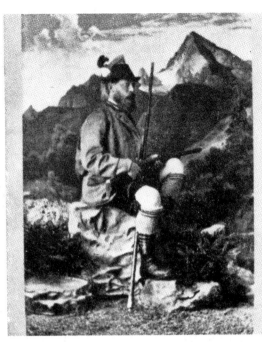

Fig. 3.26 Each finished carte de visite portrait was neatly pasted on a white or tinted card, about four inches high. Often the photographer's name and address appeared underneath.

Fig. 3.27 Some photographers went to ridiculous lengths to show sportsmen and others in realistic settings for their carte de visites. The rocks used in this German studio are papier mâché.

raeli and Holman Hunt; Marion & Co. signed up Charles Dickens. Seventy thousand cartes of Prince Albert were sold during the week following his death. Unscrupulous firms rephotographed some cards and issued pirated copies.

In all directions business boomed – sales of albumen-coated paper to the trade reached such a level that in 1866 half a million eggs were needed each month in Britain alone. As for the actual photography, this was so mechanized and cut-price the results were all rather similar. Usually the person was shown full-length, standing beside a table with books or a plaster column. The background was draped or, increasingly, consisted of painted scenery (Fig. 3.26).

The carte-de-visite craze was too intensely popular to last for long. It was the height of fashion between 1861 and 1866 but then began to die away almost as quickly as it had come in. Many photographers who had made fortunes producing these little prints now began to lose money, for by the 1870s the public considered carte de visites quite old fashioned and dull. The market for stereo pictures revived again and cheap portrait studios returned to ambrotypes or tintypes.

Most better quality establishments now concentrated on cabinet-size prints instead. Cabinet photographs were rather like scaled up carte de visites – larger prints on $4\frac{1}{2} \times 6\frac{1}{2}$ in (11×16 cm) mounts. As the name suggests these could be displayed on a bureau or cabinet. They grew especially

popular for photographs of stars of the theatre, who were posed in the studio rather than on stage (Fig. 3.30). The cabinet print also became the size most used for family group portraits. Here much play was made of the fact that the camera, unlike the painter, could 'draw' groups with the same speed as single figures. (In fact the photographer often charged slightly more because of the time and plates wasted trying to keep several people still.) Notice too how people at that time loved dressing up and appearing in apparently 'outdoor' settings (Fig. 3.27 and 3.31).

Amateur collodion portraiture

The wet plate process created a great expansion in professional

40

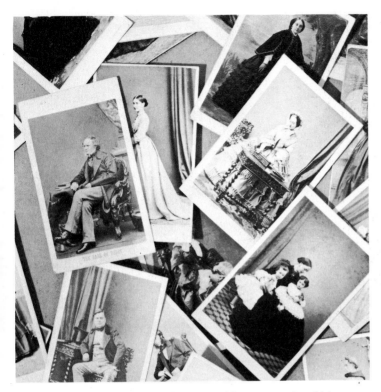

Fig. 3.28 Carte de visite albumen prints of famous people sold in millions during the 1860s. Basketfuls of pictures like these were on sale in all the main stores.

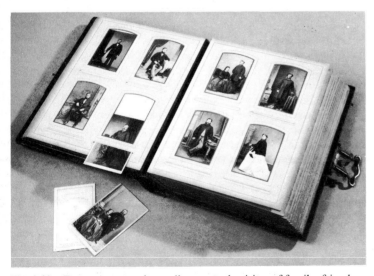

Fig. 3.29 Everyone seemed to collect carte de visites of family, friends and important people. Because they were uniform in size, cards could be displayed in slip-in albums like this one, designed and sold for the purpose.

photography, but amateur photographers had to struggle to produce results of a reasonable standard. You certainly needed to be an enthusiast to prepare all your materials, focus and compose the dim upside-down image in the camera, guess the exposure time, and mix and use the processing chemicals. Most would-be photographers must have been deterred. Others possibly pro-produced interesting important work which has long since been lost or destroyed.

Lewis Carroll–the Reverent Charles Dodgson, author of 'Alice in Wonderland'–was a keen amateur collodion photographer. Not much of his work has survived, but pictures such as Fig. 3.32 show his lightness of touch and dreamy romantic approach, particularly to portraits of children. The photograph of Alice Liddell may seem a rather ordinary pose today, but most portraits were dull artificial 'set pieces', and by comparison Carroll's pictures were original. He managed to get natural casual-looking poses from children despite the need for long time exposures, and took great care over his compositions.

Julia Margaret Cameron was a totally different personality working with the collodion process. Today she is thought of as the most famous British amateur portraitist of the late 1860s–although very few photographers recognized this at the time. Wealthy, strong-minded, and eccentric, she took up photography in 1864 at the age of 49, when she and her family had settled in the Isle of Wight.

She was lucky in having contacts with some of the

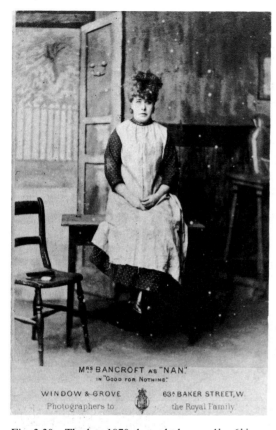

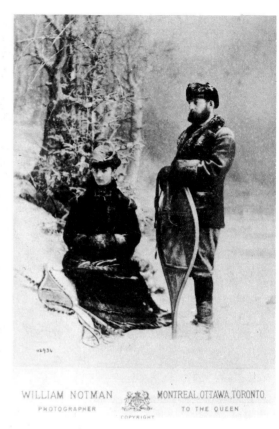

Fig. 3.30 The late 1870s brought larger, $4\frac{1}{2} \times 6\frac{1}{2}$ in 'cabinet' prints. Portraits of theatrical stars in famous roles sold well.

Fig. 3.31 High quality studios specialized in cabinet portraits, offering scenic backgrounds. This couple have chosen Notman's snowstorm treatment.

famous names of her day. Alfred, Lord Tennyson was a neighbour; Sir John Herschel an old family friend. Darwin, Longfellow, Browning and Carlyle were all persuaded to sit for her camera. These people were her heroes, and with immense energy and zeal Mrs Cameron set out to show their 'inner greatness' as much as actual features. So she concentrated on head shots, using a 8×10 in or 12×15 in camera to get big imposing pictures, and restricted the way daylight reached her subject, to give dramatic effect.

You can see how Charles Darwin's massive domed head is picked out by allowing light to reach him only from above (Fig. 3.33). Sir John Herschel's face and rim of hair are emphasized by daylight directed from the right. The results did not conform in any way to accepted photographic portraiture of that time and were generally disliked by fellow members of the Royal Photographic Society. Mrs Cameron's work was accepted and hung at RPS exhibitions but critics called it 'artistically inferior', 'wilfully imperfect', and 'original at

the expense of all photographic qualities'.

Certainly she made things difficult for herself – the limited lighting and use of a large camera with its small aperture lens meant that long exposure times were needed, often up to 5 minutes. Obviously, the sitter was usually slightly blurred by movement. She was also careless about really accurate focusing and her plates were mostly spotty and marked. Even the final prints were poorly mounted. In short she blundered her way through technique at a time when photographs were

42

judged by their clarity and accuracy. The great strength of Mrs Cameron's work was the way she used photography to *interpret* the great personalities she admired. In this she was well ahead of her time.

Compare Cameron portraits with those of Nadar (on page 34) who also used plain backgrounds and the minimum of extra 'props'. Mrs Cameron imposed her own will on the sitter, with dramatic results; Nadar's sitters seem to respond to him. Strangely enough, when Mrs Cameron was not photographing personalities and indulged instead in constructed 'artistic' pictures the results look sickly and false (judged by today's standards). See page 103. This is discussed further in Chapter 7.

Social influences of the collodion process

The invention and use of wet plates is an important milestone in the growth of photography. For one thing, photographs now became really numerous – almost everyone seemed to come into contact with them in one form or another, so people became used to 'reading' this new form of picture information. Unlike today, photography's popularity was due hardly at all to people taking pictures themselves, but more in *being* photographed, and buying, collecting, looking at and discussing photographs of various kinds.

When you look at old pictures try to see them in the context of how people lived and behaved in the mid-nineteenth century rather than in our own time. You can see signs of the social

Fig. 3.32 Lewis Carroll took this portrait of Alice Liddell, the original 'Alice in Wonderland', 1859.

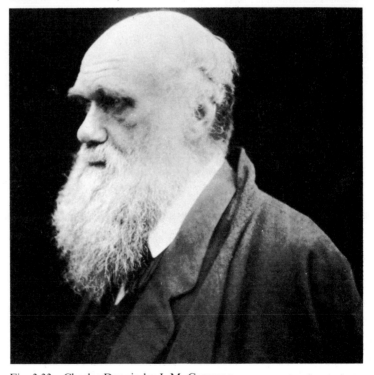

Fig. 3.33 Charles Darwin by J. M. Cameron.

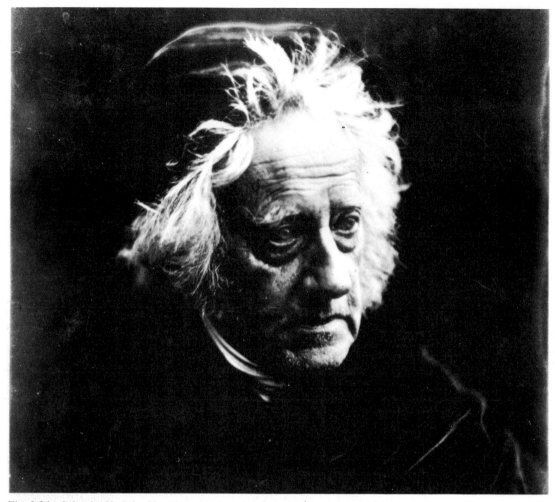

Fig. 3.34 Scientist Sir John Herschel photographed by Julia Margaret Cameron, 1869.

conventions and attitudes to life that existed—what was considered *respectable* or *artistic*, and the way photographs were arranged to express *taste* or present the viewer with a moral lesson, like a Victorian sermon. The popularity of photographs also created its own conventions. For example 'being photographed' was a modern wonder which most people tried to afford in some form or another. The same was true of collecting photographic prints. So the custom of having a family album quickly developed; it could be added to and passed down from one generation to the next, just like the family bible.

The carte-de-visite album was an even quicker way of collecting photographs, because you could just go out and buy a complete assortment. It was therefore necessary to demonstrate your taste by purchasing pictures of the 'right people'. These albums were left out on parlour tables where visitors might flip through them –and were often useful conversation pieces when visitors had run out of things to say. So it was important to demonstrate your cultural interests by possessing, say, several pages of poets and painters, a composer or two, even a few politicians. Royalty was very safe and respectable, whereas music hall stars gave you a daring, if vulgar, image.

Photographs were commodities which you purchased, collected, gave to people. Portraits of loved ones were carried in

44

lockets and other jewellery. Hardly anyone wanted pictures of bad housing conditions, the tough life of the poor and similar documentary themes. On the other hand photography opened up a 'window on the world' at a time when travel was suddenly within reach of many more people. Foreign places became of general interest and albumen prints could show all the sights with great accuracy and detail. In fact they often proved how wrong earlier traveller's drawings had been.

Relatively few photographs appeared in books (because of the high cost of pasted-in prints) but albumen-on-glass lantern slides allowed excellent quality photographs to be shown to large groups. Magic lantern lectures, on subjects such as 'Life in America' or 'Scenes from the Swiss Alps', became very popular. Pay-at-the-door shows were held both in city institutions and village halls, the lecturers travelling from place to place with their gas-powered equipment.

The value of recording works of art by means of photography was also quickly realized. Albert, the Prince Consort, arranged to have photographs taken of Raphael drawings in the royal collection at Windsor Castle. Prints were sent to art museums in other parts of Britain; in return they were encouraged to circulate prints of their important possessions too. (Coloured objects were generally avoided as the collodion process made them turn out rather dark.)

In many ways photography had a strange, levelling effect. It made the world seem smaller

Fig. 3.35 J. Croil and His Ladies. People used photographs to impress others with their social position. These Canadians, back from a Grand Tour of Europe, include labelled luggage to prove it.

and more commonplace. Kings and Queens, poets and politicians, were revealed as flesh-and-blood people looking much like anyone else, instead of distant Gods. Some people in Britain were concerned that this might damage rigid class distinctions. After all, there had previously been clear divisions between society people who were painted, and those who were not . . . On the other hand exhibitions of photographs were patronized by royalty and given lengthy reviews in newspapers. The photographic societies and groups were considered highly respectable, and even professional photographers, with their mass-produced pictures of celebrities and far away places, fulfilled a valuable need.

It was the cheapjack, tradesmen photographers fleecing the poor and taking advantage of the gullible who brought the craft into disrepute. The whole procedure of collodion photography – the conspicuous figure outdoors under a darkcloth, the use of fake artistic settings in the studio – was also something of a joke.

Most collodion portraits look wooden, stilted and pompous by today's standards. Of course, this is partly due to the long drawn out process of being photographed. The setting, the suitable pose and then freezing for the exposure were bound to make people self-aware. But sitters were also very concerned about conveying, or suggesting, their social position. The professional portrait photographer pandered to this need by offering a wide range of picturesque backdrops. (In a typical high quality studio the customer could choose from a variety of painted scenes, pulled down one

at a time for his inspection.)

There was practically no scope for original approaches – the photographer seemingly had to remain timid and conventional in order to sell. As a would-be artist he was limited to shallow ideas, like for example offering a new woodland setting, going for a new size of print or a different form of mounting or packaging.

Visually talented but non-technically minded people were still generally deterred from attempting photography. Even if you knew what you were doing, the silver chemical stained your fingers and clothes, and the ether had an overpowering smell . . . Wet collodion was really too impractical for the casual hobbyist. People needed an easier system of photography, with materials which could be bought already manufactured and usable in the camera at any time.

Summary – Wet plate era

– Collodion, used to bind light-sensitive salts to glass plates, made possible a negative/positive process with results free of paper fibre pattern. Scott Archer discovered this method in 1851. But plates had to be prepared, exposed and developed before the collodion dried out.

– Finished collodion negatives were contact printed on albumen-coated paper which the photographer bought and sensitized before use. Similarly prints could be made onto glass to form lantern slides.

– Archer's process gave excellent detail, allowed unlimited prints, and was cheaper than

the daguerreotype. Since it was not patented, anyone could use collodion without fee.

– Location photography was difficult. You needed a portable darkroom, set up near the camera. Here and in the studio long time exposures were still essential.

– Despite all this complexity, record, travel, and of course portrait photography flourished. Serious workers aimed at 'high art' exhibition prints often using compositions constructed from several negatives.

– Important names: Delamotte (Crystal Palace record photography); Fenton (landscapes, and Crimean War); Frith (views of Middle East Countries); Rejlander, and Robinson (high art compositions); Nadar (French personality portraits); Lewis Carroll (child portraits) and Julia Margaret Cameron (portraits of famous men).

– Ambrotype and tintype versions of the process give a direct positive result on glass or metal. They were quicker, cheaper and needed less exposure. Results were especially popular in America, long used to the similar looking daguerreotype. In Europe these versions were used in cut-price studios which almost everyone could afford to use.

– Stereoscopic pictures, taken with a double camera, became popular from 1855. Most homes had a stereoscope and you could choose from thousands of views, portraits, events, etc.

– The Carte-de-Visite craze (peak years 1861–66) was a marketing idea for small low cost portrait prints. Special cameras made eight images on

one plate. People bought cartes of personalities; they were collected in albums everywhere.

– The collodion process greatly expanded photography and brought everyone into contact with its results. Photographs were used to express taste and suggest status, to remind you of loved ones, to reveal people and places, to educate. Professional photographers however often proved to be more tradesmen than artists and the process was too technical for everyone to join in.

Projects

P3.1 Using your local museum or library seek out examples of albumen prints, and ambrotypes or tintypes. Note: albumen-coated paper is generally thin, curls easily and has a yellowish delicate glazed sheen. The image is black or dark brown. Ambrotypes look like daguerreotypes but are less reflective, and have a darker less detailed image.

P3.2 Experience what it was like to pose for a collodion portrait. Settle yourself in a chair, brace your head, and stare at a clock or watch trying to keep absolutely still for 40 seconds. Now try one of Mrs Cameron's four minute exposure times.

P3.3 Try making a modern version of an ambrotype portrait. Photograph (preferably using a roll-film or larger camera) giving only one eighth correct exposure. Process the negative normally, then soak it in chromium intensifier* to turn the image white. Wash, dry, and press the film against black card. Cover with glass. *Note: chromium intensifier is poisonous and must be handled with care.

Questions

Q3.1 Imagine that you were a photographer during the 1860s. Describe the equipment, materials and processes which you would be likely to use, together with some of the technical problems that might face you during a day's work. What sort of subjects would you probably tackle?

Q3.2 Seek out and discuss critically work by *one* of the following:

Julia Margaret Cameron
Oscar Rejlander
Roger Fenton
Nadar

Q3.3 Describe the wet collodion process, stating its advantages and disadvantages over earlier photographic processes. Why were ambrotype or tintype forms of the process used mostly for portraits, but glass negatives for views?

Q3.4 Discuss changes and developments in the *uses* of photography during the period 1851–71.

Q3.5 Seen today, mid-nineteenth century photographic portraits often appear pompous and 'wooden'. Suggest some reasons for this, including both technical and social influences.

Q3.6 During the 1850s and 1860s two extremely popular forms of photograph appeared – the carte de visite and the stereo-pair. Explain each of these, describe typical subject matter, and discuss why they were so attractive to ordinary people at the time.

Q3.7 Discuss the limitations of the photographic medium prior to 1870, and explain how these limitations conditioned photographic techniques and consequently the photographs produced up to that date.

'DRY' PLATES, ROLLFILMS (1870–1900)

The 1870s brought another sweeping change to the process of photography. By using gelatine instead of collodion it was possible to do away with the need to prepare your own materials before taking each picture. Plates, and soon films, could be bought in the shops. New materials and equipment allowed much briefer exposures to be given, so cameras could be used in the hand. Manufacturers soon stepped in with simplified cameras and a back-up service of processing. The overall result was that photography became something ordinary people could now practise themselves, and the range of pictures taken became much more varied. Gelatine materials mark the beginnings of the photographic process as it is known today.

Gelatine
Almost from the discovery of the collodion process people had been searching for a better binder – one which allowed plates to be used *dry*. Various substances were suggested but all had practical drawbacks, such as greatly reducing the light sensitivity of the silver salts they carried. Then in 1871 an English doctor, Richard Leach Maddox described in the *British Journal of Photography* how gelatine (as used in jellies) seemed a promising substitute.

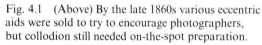

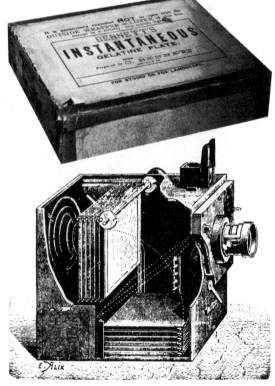

Fig. 4.1 (Above) By the late 1860s various eccentric aids were sold to try to encourage photographers, but collodion still needed on-the-spot preparation.

Fig. 4.2 (Right, top) Some of the first manufactured gelatine dry plates, 1878. (Right) This 1888 magazine camera allowed you to go out and take up to twelve pictures. A handle lowered each exposed plate to the bottom of the camera.

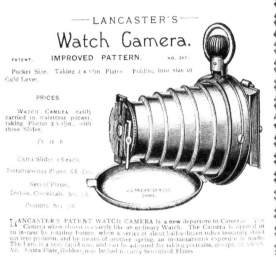
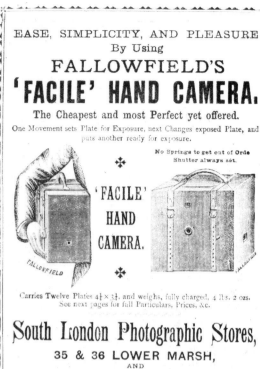

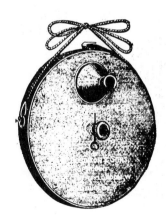
An 'emulsion' of gelatine containing silver bromide could be prepared and flowed as a warm solution over a sheet of glass. When the gelatine emulsion dried the chemicals did not crystallize out, as with collodion. At the processing stage it swelled sufficiently for developing and fixing solutions to act easily.

Other experimenters took up Maddox's idea, making the happy discovery that the new emulsion became very much more sensitive to light by prolonged heating (called 'ripening') during its preparation. By

Fig. 4.3 Advertisements for various so-called 'detective' hand-held plate cameras in the mid 1880s. The Facile worked well (fig. 6.8) but others were just novelties and gave poor results.

1879 the complexities of emulsion making and coating had been taken out of the hands of the photographer; instead he bought ready-to-use manufactured plates, in boxes.

Dry plates gave the same excellent image quality as collodion, but with three important practical advantages:

1 You no longer had to carry a tent, chemicals, etc., when working on location. All that was needed apart from the camera, was a number of loaded plate-holders. Exposed negatives could be processed later at home – or this could even be done by someone else.

2 Gelatine dry plates were so sensitive to light that exposures as brief as 1/25 sec could be given outdoors. A tripod was no longer essential.

3 Factory manufactured plates were much more consistent and of better quality than the home-made kind.

Gelatine emulsions could also be coated onto printing paper, and by the mid 1870s you could purchase ready-made 'bromide paper' which was sensitive enough to make enlargements using a gas-lit enlarger. (A few early enlargers had been built for use with albumen paper. But since only sunlight was powerful enough for this print-out material the back of the enlarger was fitted over an opening in the darkroom wall, the sun's rays being directed through the device by an angled mirror fixed outside the building.)

The sensitivity of dry plates to light meant that cameras now had to have something better than the lens cap used to give time exposures. You needed a mechanical shutter to give consistent, 'instantaneous'

exposures. People also wanted to be able to take several pictures without having to keep changing plateholders. One solution was a magazine camera (Fig. 4.2).

In fact dry plates unlocked a whole range of new camera designs. Just being able to use a camera hand-held instead of setting up all the earlier paraphernalia was a great novelty. It lead to many so called 'detective' cameras during the 1880s, which allowed pictures to be taken while the subject was unaware. The camera was made to look like a parcel or a walking stick . . . or even a hat (Fig. 4.3). When used carefully one or two expensive types gave good results, like Paul Martin's 'parcel' camera pictured on page 84. Most detective cameras however were little more than toys, with poor lenses and unreliable mechanisms.

You press the button . . .

The most revolutionary new camera for amateur photography – in fact a complete system – was to appear first in America. George Eastman, a 24-year-old bank clerk and amateur photographer, had read about British developments in emulsion preparation and manufacture of dry-plates. After experimenting he invented a plate-coating machine and in 1880 set up as the Eastman Dry Plate Company in a rented loft in Rochester, New York. But Eastman's real genius was in recognizing that the new materials made possible really simplified photography – he therefore set out to remove all the irksome technical stages preventing ordinary people from taking their own snapshots.

The result was the first (1888) Kodak camera (Fig. 4.4). Eastman made up the word *Kodak*

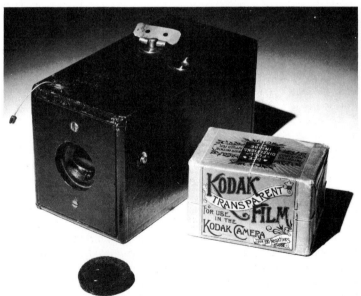

Fig. 4.4 The first 1888 Kodak camera was $6\frac{1}{2}$ in long, $3\frac{3}{4}$ in high and gave 100 pictures. You pull the cord to set the shutter and press the button to release it. A viewfinder was not thought necessary. It used paper rolls, but by 1899 Eastman introduced celluloid roll-film, (right).

Fig. 4.5 Each Kodak contact print, $2\frac{1}{2}''$ dia, was returned mounted on card. Eastman himself took this snapshot of Nadar's son Paul in Paris, 1890.

Fig. 4.6 Here they reversed roles and Paul Nadar took this portrait of George Eastman on a studio camera. Eastman was 36 years old.

as a trademark – it was pronounceable in most languages, easily spelt and distinctive. For years all cameras of this type were called Kodaks, just as people called all vacuum cleaners 'Hoovers'. Look at some of the Kodak camera's unique features:

1 It was small enough to carry and use in the hand, yet the negatives were big enough to give album size low-cost contact prints (Fig. 4.5) as well as enlargements.

2 It contained a 20 ft (6 m) roll of light-sensitive material, enough to take 100 circular pictures $2\frac{1}{2}$ in (6 cm) in diameter. (At first this was a roll of paper, negatives being transferred after processing onto transparent supports for printing. A year later Eastman used emulsion-coated film – the world's first rollfilm.)

3 The camera had a fixed focus, $f9$ good quality lens which sharply rendered subjects at all distances beyond 8 ft (2.5 m). The shutter worked at one speed, 1/25 sec, which suited most scenes in bright sunlight and was instantaneous enough not to blur, provided you held the camera still.

4 The roll of film came ready loaded in the camera. When you had taken all 100 pictures the camera was sent back to Eastman's factory. Here the film was removed, processed and printed, and the camera returned reloaded.

5 Its price of $25 (5 guineas in Britain) plus $10 for the service of processing and reloading was reasonable.

So for the first time the photographer need know nothing of chemicals and processing. Just pulling a string set the

shutter; pressing a button made the exposure; winding a key transported the sensitive material. It was as simple as that. Eastman's Kodak system was an immediate success and sold worldwide. Most of the profits were ploughed back into research and the development of more cameras such as a range of folding types, and (in 1891) rollfilms which could be user-loaded.

The Eastman Kodak Company went from strength to strength. Its founder became a multi-millionaire. But Eastman's great contribution was to simplify and popularize photography. (Within 12 years simple mass-produced cameras sold for only $1, and films 15 cents each.) His slogan 'You press the button, we do the rest' was really true, and changed amateur photography

51

from a process full of technicalities to the start of 'snapshooting' anyone felt they could attempt.

Movement and action

The shorter exposure times now possible and the 'frozen' records these gave of moving subjects produced interesting – sometimes unexpected – results.

Instantaneous pictures really date from stereoscopic cameras of the 1860s. These often had mechanical shutters to ensure that left and right hand photographs were exposed to-gether. (Also by taking small pictures, they used lenses which admitted more light and allowed short exposures.) Stereo street scenes showed how photographs could capture traffic and passers-by in frozen detail missed by the ordinary observer.

One of the earliest and certainly the best-known photographer to record action detail was Eadweard Muybridge. Born in England as Edward Muggridge he was working as a scenic photographer for the US Government when he be-came involved in a dispute between San Fransisco race-horse owners. The argument centred on whether a fast trotting horse ever had all four feet off the ground at one time. Muybridge reckoned he could check this out by photography. After some promising experiments using wet plates he persuaded railroad million-naire Leland Stanford to provide finance and allow the use of his stock farm.

By 1877 the photographer had devised a line of cameras set up beside a specially built

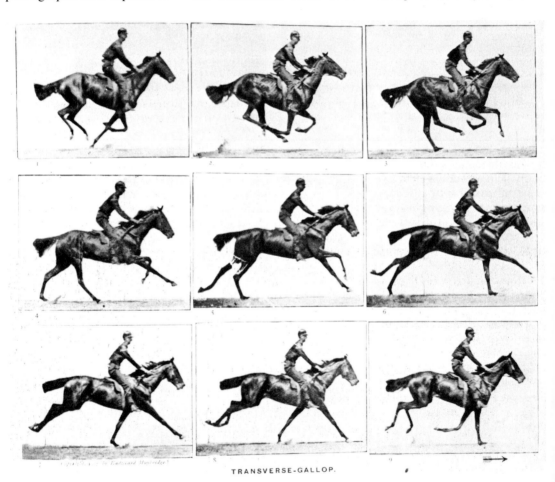

TRANSVERSE-GALLOP.

Fig. 4.7 Using the row of cameras shown opposite Eadweard Muybridge could record animal movements too fast for the eye to perceive clearly. This horse was travelling at about 35 mph.

section of race track (Fig. 4.8). Here a series of threads stretched across the track were broken by the horse – each thread electrically firing a 1/1000 sec shutter on one camera at a time. Results (Fig. 4.7) were technically underexposed but showed how the animal's feet all leave the ground only when bunched under the belly.

More than this, Muybridge proved that if each photograph were presented rapidly in sequence to the eye like a flicker book (or viewed in a zoetrope, Fig. 4.10) the horse appeared to move. It was a first important step towards moving pictures. Between 1883 and 1885 Muybridge went on to record hundreds more sequences, using improved equipment and the faster dry plates. These were mostly made for the University of Pennsylvania and analysed the movements of animals, humans, birds etc.

In France the physiologist Professor Etienne Marey heard of Muybridge's photographic work and devised his own single camera systems, recording a

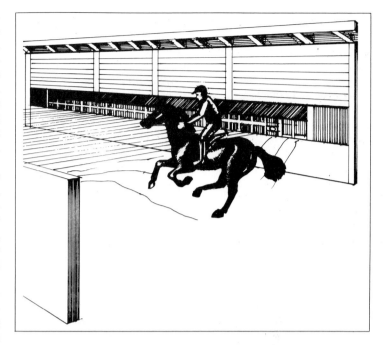

Fig. 4.8 Muybridge's camera arrangement devised for photographic studies of animal locomotion, 1879. Shutters fired when the animal broke threads, or carriage wheels touched electric wires on the ground.

whole sequence of brief exposures on one plate. Images either overlapped like Fig. 4.9 to show movement *flow*, or appeared spaced out around a circular plate. All these pic-

ture sequence records (named 'chronographs') created great interest among scientists and naturalists. As for artists, who mostly aimed at drawing accuracy, they were shaken to real-

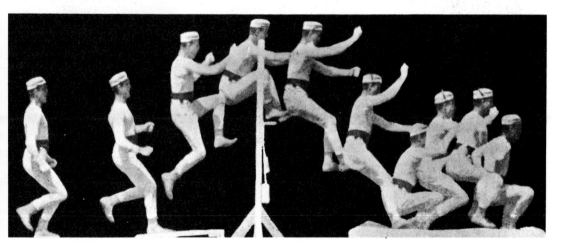

Fig. 4.9 A 'chronograph' sequence of a leaping man, all exposed by a repeating shutter onto one plate. One of many produced by Etienne Marey about 1885.

Fig. 4.10 Revolving this zoetrope drum, and looking through the slits, makes pictures appear to move.

ize that many famous paintings portrayed action incorrectly – see page 60.

Meanwhile it is interesting to note that Thomas Edison, working on equipment which might photograph and reproduce moving pictures, approached George Eastman in 1889 for some of his new flexible film. The $2\frac{3}{4}$ in (70 mm) wide Kodak rollfilm was slit down the centre, making it $1\frac{3}{8}$ in (35 mm) wide, and Edison's assistant punched transport perforations down each edge. Later 35 mm became an international standard for motion pictures and eventually still cameras were designed to suit this film width.

Film sensitivity improvements

Collodion, albumen, and early gelatin emulsions were basically only sensitive to blue light. When used to photograph coloured subjects, greens and reds reproduce unnaturally dark (Fig. 4.11). But in 1873 Professor Herman Vogel of Berlin discovered that by adding a small quantity of suitable dye when making an emulsion, the plates would also respond to green light. By 1882 manufacturers had 'orthochromatic' (blue and green sensitive) plates on sale. Further research by German chemists resulted in 1906 in the first 'panchromatic' (all-colour sensitive) films and plates. These gave much better detail and tones in coloured objects (Fig. 4.12), and soon became the most generally used form of black and white camera material.

By the late 1880s dozens of manufacturers produced plates, constantly improving them as they gained experience. Materials were always being advertised as 'extra fast', or at least more light-sensitive than anything offered by their rivals. Of course, in the days of collodion, it was not too important to know the exact sensitivity of your plates. Results were always processed on the spot, so like today's instant pictures it was possible to just take another one until you got the result you wanted. The new dry plates and films however were processed elsewhere, so accurate exposure had to be guessed, and for this it was helpful to know how the various types differed in light sensitivity.

Rival advertising claims were so confusing that two scientists in Britain, F Hurter and V C Driffield, devised the first independent system to give emulsions speed numbers. As from 1890 materials could be given reliable 'H and D numbers', a system which allowed exposure tables and meters to be prepared (page 72). This essentially led to the system of ASA and DIN numbers marked on all film boxes today to show their light sensitivity or 'speed'.

Camera and lens developments

As you can see from Fig. 4.13, many serious amateurs as well as professionals still favoured plate cameras in the 1890s. Optical glass developed in Germany now allowed new lens

Fig. 4.11 Purple and (large) orange flowers recorded on material insensitive to green and red.

Fig. 4.12 From 1906 new panchromatic sensitivity emulsions gave much truer colour tones.

54

designs, like the first anastigmat made by Zeiss in 1889. These lenses gave brighter and less distorted images than earlier types. In fact for the next 50 years Germany was to remain the World leader in photographic optics.

Lenses however, like emulsions, also lacked clear descriptions. At first manufacturers marked their own preferred series of f numbers on the lens aperture control. It was not until 1900, at a conference in Paris, that the present series of aperture settings ($f2$, $f2.8$, $f4$, $f5.6$ etc) was internationally agreed.

The original Kodak box-like cameras were soon followed by very popular new folding roll-film cameras. These gave quite big $2\frac{1}{4} \times 3\frac{1}{4}$ in (6×8 cm) pictures, but still folded up small enough to fit into a large pocket. For the first time also twin lens reflex cameras appeared, made for plates (see Fig 4.16).

Lighting

Light sources other than daylight were still unusual in photo-

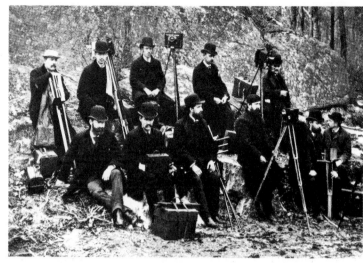

Fig. 4.13 Hand cameras popularized photography, but 'serious' amateurs preferred plate cameras on tripods. A typically male-dominated camera club 1890.

graphy. And yet the short hours of winter daylight meant that the working day for portrait studios was ridiculously brief. Nadar and others had used battery-operated lamps, but these were awkward and not really powerful enough for portraits. Gas lighting roasted the sitter when sufficient gas jets were put together to give brilliant illumination. (From about

The Folding 'Montauk.'

AMERICA'S IDEAL HAND CAMERA.

An exceedingly compact, light, and strongly-made Hand Camera, having all modern improvements, which, being made from the finest material by the most skilled workmen, even to the leather work—by far handsomer than any of similar construction—it may be looked upon as the *beau idéal*.

Fig. 4.14 (Above, centre) The folding Pocket Kodak, 1897. Fig. 4.15 (Above) Typical hand-held plate camera with instantaneous shutter, 1903.

The 'Albion' Twin Lens Camera.
THE ALBION ALBUMENISING COMPANY.

As will be seen from the illustration, this camera is of the double pattern-with twin lenses and a full-sized finder with shading hood and strap to sling round the neck. It is provided with a pair of rectilinear lenses, with iris diaphragm, a roller-blind shutter, for time and instantaneous, with speed indicator, and three double dark slides which are carried inside the camera.

Price 4*l*. 15*s*.

Fig. 4.16 Twin lens reflex, 1890s. The top lens gave an image for viewing, like Fig. 1.4. The bottom one exposed onto plates pre-loaded into darkslides.

Figs 4.17–18 Adverts, 1888.

homes today, first appeared in 1880. But few towns had a regular electricity supply, and the early lamps gave such a weak orange illumination they were not much used for photography until after the turn of the century.

Photographs on the printed page

As if to complete the technical revolution which was occurring in photography, the 1880s and 1890s at last brought a solution to the problems of reproducing photographs on the printed pages of books, magazines and newspapers. Up until then photographers could only show their work to the public through direct sales of photographic prints in print shops, or prints pasted into books, or shown in exhibitions. To appear alongside text on the printed page all photographs had first to be redrawn by hand onto a wooden block. A wood engraver next cut away the wood in the spaces between the drawn lines, leaving the design in relief like a lino cut. When inked up and pressed onto paper the result looked like Fig. 4.20. (In practice the engraved wood was used to form a mould for a *metal* relief block which withstood greater wear on the printing press.)

In a sense then the photo-

1885 however gas lamps were used for contact printing.) Gradually dynamo-powered arc lamps were brought into use by the bigger establishments. In 1877 the world's first exclusively electric light studio opened in Regent Street, London. Using 6000 candle power the exposures needed ranged from 3 to 10 sec.

As you can see from Fig 4.17, the main rival to electric light was pyrotechnic flashpowder. This was introduced in the 1880s and consisted of ground magnesium and other chemicals which you blew into a flame or ignited by a spark from a flint. It produced a brilliant flash lasting about 1/10 sec– plus a great deal of smoke, smell and fallout of white ash. Flashpowder was less dangerous and unpleasant used outdoors, provided you avoided wind or rain. But unlike flashbulbs (which were invented in 1925) it was not practical to make flashpowder go off at the same instant as the shutter of a hand camera. So flash pictures had to be taken by mounting the camera on a tripod, opening the shutter, igniting the flash and then reclosing the shutter.

Tungsten filament lamps, forerunners of the type used in

graph only provided a *reference* for the skilled engraver, who added or subtracted his own details. Notice too how the picture consists only of black ink lines–intermediate grey tones between black and white (ie. 'half-tones') are suggested by varying the spacing and thickness of the lines engraved.

The search for a means of converting photographs direct to a metal surface which could be inked and printed *without* intermediate drawing was as old as photography itself (see Niépce's experiments, page 9). By 1866 a process known as Woodburytype allowed negatives to be printed on a gelatin layer which could be converted to shallow impressions in a lead plate. When these hollows were filled with ink a whole range of tones could be reproduced on paper. Results were excellent, but Woodburytype plates wore down quickly; the process was also so costly it was no cheaper than making actual albumen prints. It was therefore only practical for hand-mounted illustrations in expensive books.

The big challenge was to make photographic blocks which withstood the enormous wear of magazine and newspaper presses. By the late 1870s photographic negatives could be printed onto light-sensitized metal which was then acid etched into a relief, but this could only give pure blacks and whites.

Eventually, following an idea by Talbot 20 years earlier, it was found that by copying a photograph using a camera containing a glass screen with a grid pattern of fine lines, all the grey tones turned into tiny dots of different sizes. When these dots are etched into metal, then printed by ink onto paper, they appear (from normal reading distance) just like the various half-tones of a photograph. The dot differences act like the engravers lines of different spacings. (Check the grey part of any photograph in this book through a magnifier.)

The first half-tone photograph in a daily newspaper appeared in the *New York Graphic* in 1880. But there were still problems to solve. New steam-driven rotary presses were coming into use; ways had to be found to bend the new half-tone plates onto cylinders along with type, to allow high speed printing. Wood engravers understandably objected to the threat to their jobs. Some cautious newspaper owners even feared that photographic illustration would 'cheapen' their publications.

However, by the late 1890s newspapers were already using more photographs than wood-cuts. Within 10 years most newspapers and many magazines and books were exclusively illustrated by half-tone photographs. See Fig. 6.16 on page 90. Thanks to this technical breakthrough the new century

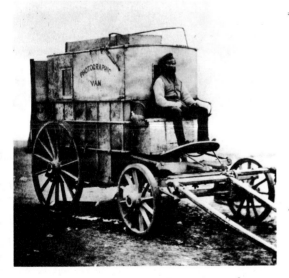

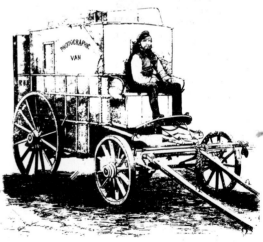

Fig. 4.19 Photograph of Roger Fenton's van, from which he documented the Crimean war. (See also Fig. 3.8).

Fig. 4.20 Before the 1880s newspaper photographs were hand-drawn and engraved. The same picture, as left, in Illustrated London News, 1855.

held a bright future for new branches of professional photography – press, photojournalism, advertising and fashion.

Influences of the new materials

Some people argue that practical photography really began in the 1880s. The four most far-reaching effects of all these new materials and equipment were:

1 Everyone could now be his own photographer.

2 The photographic industry was born – factories to manufacture reliable materials and equipment, and for developing and printing.

3 The expansion of photography gave rise to quite new kinds of pictures, of interest to both artists and scientists. People began to realize how versatile photography could be.

4 It made movies possible, and contributed to the printing press reproduction of half-tone pictures of all kinds.

Snapshots had replaced the old ritual of tripod and focusing cloth in the public mind. There was no need to be technically minded or wealthy. For many having a camera was like being given a time machine which preserved for ever the people and scenes they chose – something no previous generation had been able to do. Often snaps were ordinary and dull, but at least people now took them to please *themselves* rather than flatter a customer or satisfy a stuffy exhibition judge.

Some results had a freshness of approach which overturned conventional 'rules of composition'. Again, the hand-held camera encouraged people to try viewpoints other than tripod height. Instantaneous shutters meant that the exact moment chosen to expose moving subjects made a big difference to their composition.

People also tended to photograph *actuality* – casual pictures of ordinary life as it was really lived, like Fig. 4.21. Such subjects had been taboo among artists because they were considered unpicturesque and therefore unfashionable. (Equally they were technically difficult for earlier photographers, because of the need to set up for time exposures.) Some professional photographers documented city life, and one or two reformers began to take pictures showing the conditions of the poor. Like the novels of Charles Dickens, photography was to reveal dramatically the lives of unfortunates most people chose to forget. The documentary work of Paul Martin, Jacob Riis and others is discussed in Chapter 6.

With all this new spontaneous picture making, society had to re-think what photography was all about. Was it art ... or a recording medium? A scientific tool ... or a popular but passing novelty? It was easy to foresee that photography on the printed page could powerfully communicate news, help campaign for better working and living conditions, educate and entertain.

Few painters of the time could afford not to examine carefully the images the camera was producing (although most tried not to admit being in photography's debt). Contemporary artists such as Degas took great interest in the way photographs often 'cropped off' figures near the picture's edges, and the steep perspective given by the camera. Both devices can be seen used in Fig. 4.22; also in several of Degas's ballet paintings. It is strange to think that in the 1870s this was

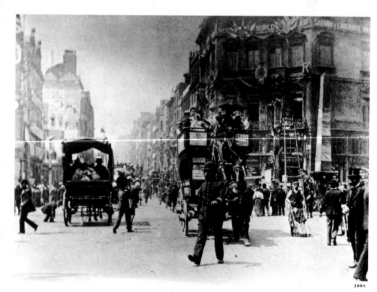

Fig. 4.21 Hand cameras and faster materials allowed pictures of everyday events, as if you were actually there. Ludgate Circus 1897.

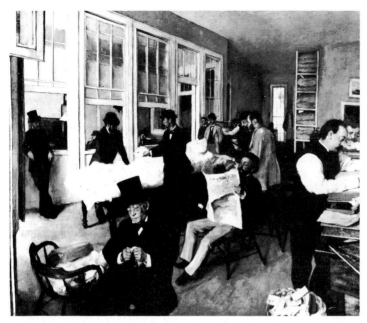

Fig. 4.22 The Degas painting 'Cotton Bureau' 1873. Look at the strong perspective, particularly in the foreground. Both this and abrupt cropping (figures on the right) were unusual in painting. Degas was influenced by the way photographic cameras recorded such scenes.

considered quite shocking.

Photography's emphasis of light and shade, and even 'mistakes' – such as movement recorded as blur – interested artists. Corot, Monet, and other impressionists often conveyed movement of figures, trees etc by painting them as the camera would have recorded them during a brief time exposure (Fig. 4.23).

We have also seen how Muybridge's analytical photographs created a sensation. Twice during the 1880s he visited Europe, talking to painters and sculptors and scientists in Paris, lecturing to a crowded Royal Academy and similar institutions in London. His sequences of animal and human figure locomotion published in 1887 were enormously comprehensive. They analyzed thousands of movements, from simple walking or lifting, or sports activities, to the jump of a kangaroo and the flight of birds. These were photographed with such precision that direct measurements could be made. The pictures formed a major reference encyclopaedia of artists' studies, and were bought and used by leading figures in many countries. Muybridge's sequences became standards against which the errors of earlier painters (Fig. 4.24) were endlessly compared.

If all this fuss seems strange today, remember that the gallop of a horse and similar actions the eye could not follow had been puzzled over for centuries, until frozen on film. Much the same applied to photographs taken through microscopes, telescopes etc. These were all areas in which the camera gave new, essentially *photographic* pictures. In contrast, the photography of subjects like landscapes and portraits was (and still is) influenced by the way painters had seen them. But

Fig. 4.23 'Poplars at Giverny, Sunrise', painted by Claude Monet in 1888. Several Impressionist painters chose to represent movement in their subjects by use of blur – a visual effect discovered from the time-exposures early photographers were forced to give.

59

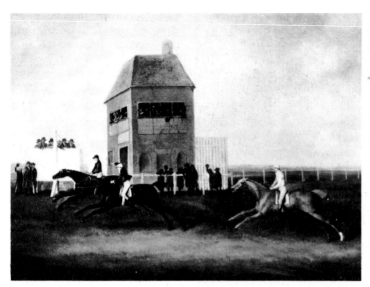

Fig. 4.24 Detail from 'First Spring Meeting, Newmarket 1793'. Painters generally showed gallopping horses spreadeagled like rocking horses until Muybridge's photographs proved them wrong. (See page 52.)

– There was great interest in the action-freezing effect of short exposures. Eadweard Muybridge (USA) made a special study of animal and human locomotion in photosequences. Together with similar work by Marey (France) these could be 'played back' through a viewing device which recreated the subject's movement. Detailed analysis of action too fast for the eye to follow was of special interest to artists, at a time when realism and accuracy was considered very important. It was also a vital first step towards moving pictures.

– Further technical improvements included ortho- and panchromatic films, agreed systems of emulsion speed ratings and lens f numbers; better lenses; and smaller cameras.

– Studios began to use generators and electric lamps. Magnesium powder formed the first practical flash-light source, although rather dangerous and unpleasant.

– At last magazines and newspapers found a direct method of reproducing photographs alongside text. The half-tone dot system meant that photographs no longer had to be turned into woodcuts and etchings.

– Hand cameras used by ordinary people allowed a freer choice of subject; pictures were more natural, less restricted by current art. The scope of photography was immeasurably widened. Artists were influenced by some of the new images the camera produced – sometimes excessively so.

there were many examples of artists overusing reference photographs too. So many works sent to major art exhibitions in the 1880s and 1890s resembled coloured photographs it was clear they were being slavishly copied from this new source rather than sketches from nature. (This was an odd reversal of the artistic photographer who was still striving to make his work appear less mechanical, more like fashionable painting of the time. Compare Fig. 4.25 with Fig. 7.8 on page 107.)

These and other influences of photography on art, and of art on photography were fiercely argued in both camps, and brought up in practically every exhibition review published in the press. This is discussed further in Chapter 7.

Summary – Dry plates and rollfilm

– Maddox's idea to replace collodion by gelatin led to 'dry'

light-sensitive materials which could be manufactured and sold ready for use. They were also much faster and more convenient, and could be processed at any time after exposure.

– The sensitivity of gelatin made 'instantaneous' shutter speeds possible. Coated on paper they allowed enlargements to be made with an artificial light source enlarger.

– Various hand-held cameras were designed for use with the new dry materials. They included detective camera novelties and the Kodak – the first simplified camera with a back-up processing service.

– Eastman's Kodak system expanded into a range of simple cheap cameras which allowed anyone to get results under good conditions. People could at last take their own snapshots without special technical knowledge.

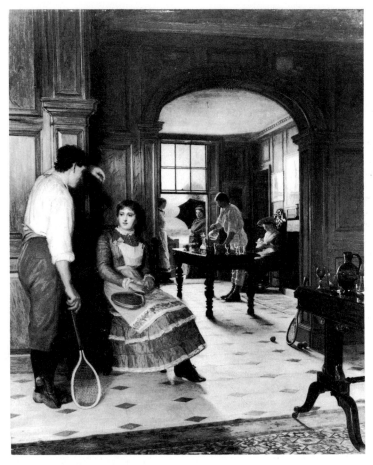

Fig. 4.25 Haylier: 'A Summer Shower' 1883. English and French academy painting of the 1880s frequently resembled coloured photographs.

Projects

P4.1 Using a photocopying machine make two copies of the Muybridge sequence (Fig. 4.8). Carefully cut up the copies, sort them into two repeating the Muybridge sequence (Fig. 4.8.) Carefully cut up the copies, sort them into two repeating sequences and staple them at one end to form a flick book. Flick the pages to see if the photographs truly represent movement.

P4.2 Try disguising your own camera as a package or bag and take pictures of people unaware. (As you will not be able to aim the camera very accurately do not approach too close – instead enlarge up wanted parts of the negative later.)

P4.3 Seek out illustrated books, magazines and newspapers published at about the turn of the century. (Some libraries keep microfilm copies of newspapers. Look also for books on market stalls and secondhand shops.) What is the earliest date you can discover half-tone photographs on the printed page? Look out too for woodburytype or collotype reproductions separately printed and inserted into books.

Questions

Q4.1 In what way do you consider advances made in photographic technology towards the end of the nineteenth century affected (*a*) practical photography, and (*b*) the ways photographs were used?

Q4.2 Describe the contribution made to photography by *two* of the following: George Eastman, Dr Richard Maddox, Eadweard Muybridge.

Q4.3 Discuss some of the inter-influences between painting and photography during the nineteenth century.

Q4.4 How and why did the introduction of the Kodak camera popularize the taking of photographs in the late 1880s and 1890s?

Q4.5 Briefly explain each of the following terms – detective cameras, orthochromatic, half-tone reproduction of photographs, chronographs.

COLOUR AND OTHER TECHNICAL IMPROVEMENTS, 1900–1970

It is often said that photography is a nineteenth century invention. To a large extent this is true, for the *principles* by which all today's materials and equipment work were known by 1900. Gelatine emulsions, handcameras, flash, even the ideas behind colour photography all existed. But what modern technology has done is to enormously improve the performance of these things and make their practical use easier and more automatic. Today almost every one has colour prints of their last holiday, yet 40 years ago a skilled photographer would take several days to get one colour image on to paper.

This part of the story of photography therefore highlights some of the technological improvements this century.

They include thousand-fold increases in film speed, miniaturized cameras, exposure automation, instant pictures and above all *colour*. This chapter also looks at the expanding applications of photography and its acceptance as an important aspect of modern society.

Black and white materials

As mentioned in Chapter 4, the same basic nineteenth century light-sensitive material—gelatine emulsion containing silver salts—is still used for photography today. The principle has not changed but performance has improved enormously. Glass plates were not immediately replaced by film and plenty of professionals still continued using glass well

into the 1950s. But plates are more expensive to make than film, and the processed negatives much more difficult to handle and store. Also modern colour materials are only made on film, so that glass eventually went out of use. Instead, plateholders were adapted to take sheets of film of the same dimensions.

Film itself has undergone subtle changes—in 1930 cellulose acetate replaced the old nitrocellulose film base which was very inflammable, and cracked and discoloured after a few years. This in turn gave way to tougher non-stretch plastics in the 1970s. Also, from this date most photographic printing papers were plastic coated to allow faster processing and washing.

Back at the turn of the

Table 5.1 Improvements in film speed

Material	H & D (twice the number = double the speed)	ASA†
1902 fastest B & W	**650**	20
1907 Autochrome	**6**	0.2
1925 fastest B & W	**1000**	30
1934 Dufaycolor	**125**	4
1935 Kodachrome	**320**	10
1942 Kodacolor	800	**25**
1942 fastest B & W	3200	**100**
1946 Ektachrome	320	**10**
1954 fastest B & W	13 000	**400**
1965 fastest B & W*	100 000	**3000**
1976 fastest Colour	13 000	**400**

*Approx. 20 million times more sensitive to light than the original daguerreotype.
† ASA speed numbers, introduced in 1942, soon replaced earlier rating systems.

century fast black and white camera materials needed exposure times one hundred and sixty times as long as their equivalents in the 1970s, (Table 5.1.) Equally most films and plates used in 1900 were insensitive to colours other than blue (page 54) although you could bathe them in a special dye bath before exposure to make them orthochromatic (blue and green sensitive.)

One improvement not shown in the film speed figures of Table 5.1 was the way modern materials were so much more able to record fine detail. By coating emulsions more thinly and using silver chemicals and developers designed to prevent grains clumping together, films gave better than ever image resolution. This allowed bigger enlargements without loss of detail, so cameras could gradually become smaller and handier, and the cost of photography relatively less expensive.

Black and white film processing was often handled personally by chemists until the late 1940s when factory-size laboratories took over the work from shops. (This explains the tradition in most countries of *chemists* selling films rather than, say, artists' suppliers.)

The most important and original new black and white camera material invented since 1945 was the Polaroid instant picture process. It was invented in 1947 by Dr Edwin Land (and first called the *Polaroid Land* process.) Although still using the gelatin and silver halide principle, Land devised a camera which sandwiched the exposed negative with a receiving positive paper and spread jellied processing chemical between the two. When peeled apart the paper carried a finished print. For the first time since the daguerreotype and collodion processes you could see results on the spot— and reshoot if the picture was not quite right.

Colour photography

Of all technical changes, the one which most clearly separates twentieth from nineteenth century photography was the conquest of colour. Of course, even the earliest cameras and lenses formed images in full colour. It must have been tantalizing to see so much coloured detail on the focusing screen yet be unable to capture it in other than tones of light and dark grey. Photographers had been trying to solve this problem by colouring pictures by hand, but everyone wanted films which would record 'natural' colour.

As early as 1860 experiments by British scientist James Clark Maxwell had shown that *three* black and white photographs might be taken of a subject through each of red, green and blue coloured filters. Lantern slides printed from these negatives could then be projected by three lanterns, fitted with the

Fig. 5.1 Until the 1940s you needed three B & W negatives to make a colour print. This one-shot camera contained mirrors and separately filtered plate holders.

Fig. 5.2 1895 Viewer. You saw a coloured image formed by mirrors and filters when lantern slides from three separation negatives were placed on top.

same filters. If the pictures were made to exactly overlap on one screen all the colours in the original subject would be re-created.

In 1868, Ducas du Hauron, a French scientist, published a brilliant book suggesting how a whole range of colour photography methods might work. Unfortunately none of these ideas could really be tested or put into practice. No photographic materials in the 1860s were sensitive to red – so a red filter used on the camera gave little or no result. Vogel's discovery of sensitizing dyes, 1873, was therefore of great importance in 'unlocking' colour photography.

As soon as panchromatic plates became available in 1906 professsionals and advanced amateurs were able to take their three 'separation negatives' of still-life subjects. In fact a few special one-shot cameras were made which exposed all three plates with one click of the shutter (Fig. 5.1). These could be used for portraits and scenes containing moving subjects. Results were mostly viewed in a device like Fig. 5.2, containing mirrors which allowed you to see the three lantern slides superimposed as one coloured image. This was colour photography of a sort, but much too complicated and expensive for the average photographer.

The first colour plates as such to go on sale (1907) used a rather different system. Made by the Lumière brothers in France, the *Autochrome* plate contained a layer of tiny mixed starch grains, dyed red, green and blue (Fig. 5.4). Behind this transparent colour mosaic was coated a layer of panchro-

matic emulsion. When you exposed the plate the coloured grains acted like microscopic size filters. Special processing was needed to form a black and white *positive* image in the emulsion, whereupon the filters gave it a correctly coloured appearance when you held the plate up to the light. Results had delicate colours and were quite attractive, like Fig. 5.3, provided you did not magnify them too much and reveal the mosaic pattern.

Autochrome was the first practical colour photography process, and in the years that followed many other European filter mosaic materials appeared, on plates and then film. They included Paget, Thames, Agfa and Finlay. The most famous of these was Dufaycolor, made in sheet film, rollfilm and movie film from 1935 until the 1950s.

• The main disadvantage with all colour films of this kind was the long exposures needed because of the presence of filters. Results too were dark looking and difficult to project, and it was impossible to make colour prints on paper.

Another approach, already suggested in du Hauron's book, was to have film coated with three thin layers of emulsion – sensitive to blue, green and red. Then in some way during processing each layer is turned into a positive picture, each of its own distinct colour dye, so that it gave a fully coloured slide. The whole idea was a tremendous challenge to film manufacturers.

By 1912 German chemists had shown how dyes could be formed when a colourless colour developer chemical united with a colourless coupler

chemical. The colour of the dye formed depended upon the chemical nature of the coupler.
• But it was very difficult to get the whole system to work reliably within the three layer film structure. After extensive research Kodak produced the first film of this tripack type in 1936 as *Kodachrome*. The following year Agfa brought out their own similar colour film, called *Agfacolor*. The quality and brilliance of the colour slides these films gave were excellent; they were also more sensitive to light. Both are still made in improved forms today.

A photographer working in colour in 1936 would therefore have used slide film of the Dufaycolor or Kodachrome type. (From the mid-1930s onwards no colour materials were made on *glass*). To obtain colour prints was still very difficult. Dozens of inventors and small-time manufacturers came forward with patented processes. Many of them ended up bankrupt. The only colour print methods giving good results still needed a set of separation negatives. One complicated process was called *Wash-off Relief*, making enlargements on three sheets of film coated with thick gelatin, each dyed in the appropriate colour and pressed in turn onto white paper.
• Colour prints were just possible but took enormous care and skill. They were so expensive that few were made, even by professional photographers. It was not until World War II that Agfa and then Kodak produced colour *negative* films, designed to be enlarged onto tripack colour paper. Neither Agfacolor nor Kodacolor col-

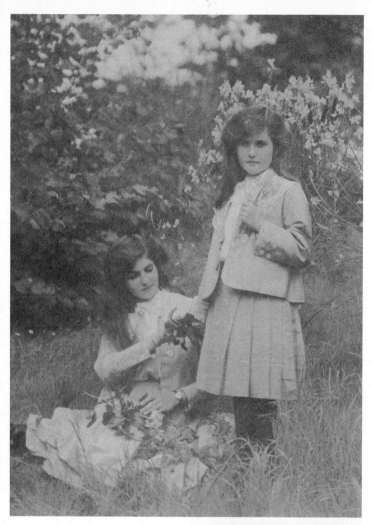

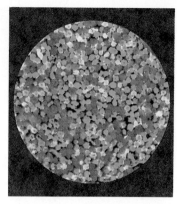

Fig. 5.4 Enlarged part of Autochrome, left, shows its mosaic of dyed starch grains.

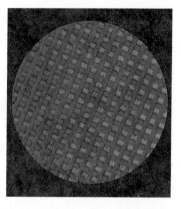

Fig. 5.5 Enlargement of the mechanically ruled filter mosaic used in Dufacolor films until 1950.

Fig. 5.3 (Above) A $6\frac{1}{2} \times 4\frac{3}{4}$ in Autochrome colour plate, about 1914. Autochrome transparencies gave delicate colours but results always looked very dark. The plates needed several seconds exposure even in bright daylight.

Fig. 5.6 (Right) A Kodachrome transparency taken in 1939. Kodachrome, invented 1936, was the first colour film free of a mosaic pattern. Images were more brilliant and sharp than any other process. In a faster, improved form the same process is still used for slides today.

Fig. 5.7 Polacolor peel-apart colour print material arrived in 1963. It used entirely new dye technology. You pulled a paper sandwich from the special camera, then about a minute later peeled them apart to get this finished colour print.

Fig. 5.8 Single sheet instant colour print material appears from the camera as a white card on which the image gradually builds up. This is the Polaroid version (1972). Kodak instant colour prints (1976) appear through the back of the card.

Table 5.2 Trends in amateur photography (UK)

	1965 (%)	1976 (%)
Households with cameras	48	61
Black and white films sold	66	8
Colour films sold	33	92

our negative films were generally available until about 1950.

Germany had been defeated in the war, so Agfa's patented processes could be freely used by other manufacturers. A great number of firms–Ansco, Sakura, Fuji, Ilford, Ferrania– now offered their own brands of slide films. A few made negative colour films. All these were based on pre-war principles, which in turn had been suggested by du Hauron. Even Cibachrome (1963) a multi-layer material containing ready-formed dyes and designed for printing direct from slides, was based on patents filed in 1918.

Instant colour picture material (Polaroid, and Kodak versions) follows the basic three colour principle, but carries it through with entirely original chemistry. Dr Edwin Land's Polaroid Corporation research team pioneered the first colour print material in 1963. Like black and white instant pictures you pulled the exposed material from the camera as a sandwich of negative and print, which were held for about one minute, then peeled apart. In 1972 (Polaroid) and 1976 (Kodak) invented single sheet materials which eject from the camera as a white card on which a colour picture gradually appears.

These instant picture materials took immense skill and technology to produce in a reliable form, you require some

processing skills on the part of the user. In fact all colour materials have progressed in this general direction–from relatively crude triple exposures on black and white plates with the photographer doing all the work, to one of the most advanced of manufactured products. (In 1928 Kodak spent $1 million a year on research; by 1976 this same sum was spent *every day*.)

During the first 50 years of this century photographers were lucky if they could achieve any natural colour image at all. Many creative workers preferred black and white because

colour processes were such a technical struggle; snapshotters regarded it as too expensive. In fact the amateur use of colour films did not overtake black and white until the early 1970s (Table 5.2). Colour TV also became general by this time– an important influence. Relatively cheaper equipment and faster processing made do-it-yourself colour printing a practical proposition for anyone with a simple darkroom. From this time onwards only the most popular black and white materials and processes continued to be made and used.

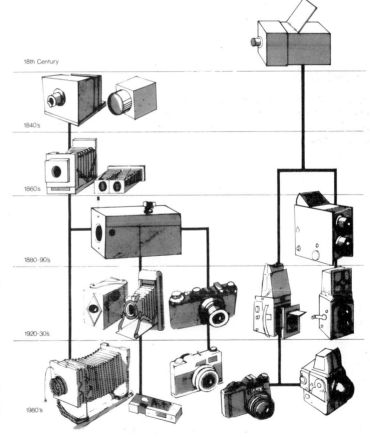

Fig. 5.9 The evolution of camera designs (see overleaf). Simple Talbot and Daguerre type cameras, left, led through box and folding cameras to professional and compact amateur cameras today. Reflex camera designs inspired twin lens, then single lens reflex designs.

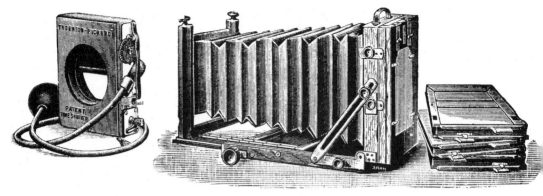

Fig. 5.10 Folding half-plate wooden camera with leather bellows, 1900.
A roller blind shutter, left, pushed on over the lens. Plate holders, right,
replaced the focusing screen to take pictures.

Cameras and lenses

To begin with consider the way photographers had to work at the turn of the century. Professionals were using folding view cameras, like Fig. 5.1, not greatly advanced over the old daguerreotype cameras (Fig. 2.2) used sixty years earlier. Plates (still greatly preferred to sheets of film) were carried around in wooden plateholders, the most popular size being 'half-plate' $4\frac{3}{4} \times 6\frac{1}{2}$ in (12×17 cm). You focused the dim image seen upside-down on the ground glass at the back of the camera, using a black cloth over your head. Next the glass was replaced with a plate-holder, and a 'time or instantaneous' blind shutter device fitted over the front of the lens (Fig. 5.10). A tasselled cord was pulled to set the shutter and when you pressed the rubber bulb a small bladder inflated to fire the blind.

Some photographers, particularly portraitists, preferred the newer reflex cameras mostly made for quarter plates (Fig. 5.12). These were designed along the same lines as the early reflex camera obscura (page 8) and contained a mirror allowing the picture to be seen and focused right way up on the ground glass screen. When you pressed the shutter lever the mirror hinged out of the way and a large blind just in front of the light-sensitive plate exposed the image. Various instantaneous speeds or a time exposure could be selected.

Most view cameras were used

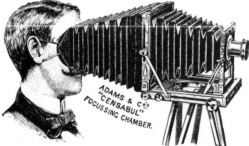

The 'Censabul' Focussing Chamber.
Adams & Co.

This consists of a bellows body with, at one end, an elastic gusset which is slipped over the back of the camera, and, at the other, cords which can be adjusted to the ears, thus allowing plenty of breathing space, and yet does not disarrange the head gear. The focussing screen is completely shielded from all light, and there is no chance of its blowing away.
Prices: Quarter plate, 6s.; half plate, 7s. 6d.; whole plate, 8s. 6d.

Fig. 5.11 To see the dim image on a plate camera's focusing screen you covered your head with a cloth, or even bought this eccentric device.

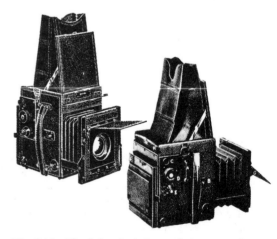

Fig. 5.12 The Soho single lens reflex quarter-plate camera, popular for portraiture and general hand-held professional photography throughout the 1920–30s.

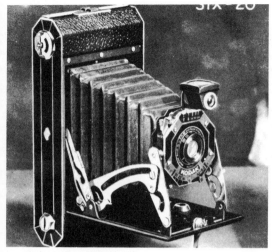

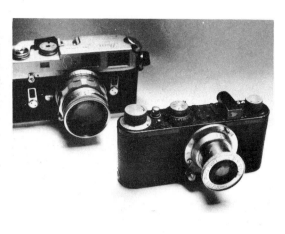

Fig. 5.13 The Kodak 6–20 took 8 pictures $3\frac{1}{4} \times 2\frac{1}{4}$ in on rollfilm. In the early 1930s most amateurs either used folding cameras like this or box cameras.

Fig. 5.14 The 1924 Leica, world's first precision 35 mm camera. In the background is a 1960s model of the same camera.

with lenses such as a 'Rapid Rectilinear' or an anastigmat Dagor. Their widest apertures were only about $f8$, which meant they let in less than one-tenth of the light passed by a good lens today. The portrait reflex might be fitted with a Cooke Triplet lens which worked at a much brighter $f3$, but gave rather fuzzy detail in the corners of the photograph unless used at smaller apertures. In fact the Ilford Manual of 1902, which regarded quarter plates as small, advised 'When small negatives are taken for the purpose of making enlargements or lantern slides, it is scarcely ever advisable to use a stop larger than $f32$'.

Amateurs, if they were beginners, were mostly happy to use rollfilm box cameras now sold by several manufacturers. More expensive folding cameras took rollfilm pictures up to $3\frac{1}{2} \times 5\frac{1}{2}$ in (9×14 cm), the most popular size being $3\frac{1}{4} \times 2\frac{1}{4}$ in (8×6 cm) like Fig. 5.13. They had black folding leather bellows and a little reflective viewfinder, and

were sold in millions in Europe and America. Most offered a choice of several instantaneous shutter speeds and lens apertures from about $f8$ to $f32$. You could therefore take pictures under a wider range of lighting conditions than a box camera, although having these various controls made the camera less simple to use.

People were torn between having a camera which gave contact prints big enough for an album or small frame, and something smaller and easily carried but still able to give good enlarged prints. The trouble with enlarging, apart from the cost, was that neither lenses nor films were good enough to give results with the same detail as a contact print (or enlargements made today.)

Of course the growth of photography encouraged manufacturers to produce better lenses, but first they needed to research designs using newly devised types of glass. Photographic lenses consist of several glass elements of various

shapes, grouped together and working as one. By making the best choice of element shape, glass type, spacing etc, natural optical errors (aberrations) are corrected and image sharpness improved. The problem is that errors are magnified the larger the lens aperture, yet photographers need the widest possible apertures to let in more light and reduce exposure times. Again, the designer could correct errors by adding still more elements, but the image gradually became grey (low contrast) and lifeless – like looking through many sheets of glass.

In 1914 a designer called Oscar Barnack, working for the German microscope makers Leitz, constructed a small camera for himself. It took pictures $1 \times 1\frac{1}{2}$ in (24×36 mm), on lengths of the 35 mm wide film made for movie cameras (page 54). Ten years later Leitz put an improved form of this camera on sale as the Leica (a name made up from LEItz CAmera). This was the first *precision* miniature camera. It

69

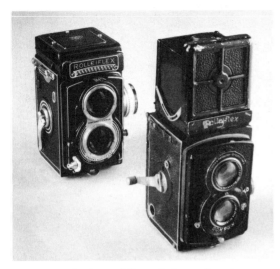

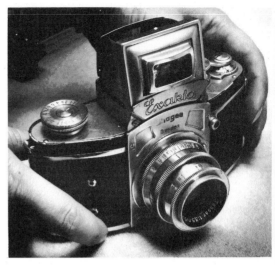

Fig. 5.15 The first rollfilm twin-lens reflex, the 1928 Rolleiflex, shown with its 1960s model. Compare these cameras with Fig. 4.16.

Fig. 5.16 This 1937 German-made Exakta was the first 35 mm single lens reflex camera. It had a small ground-glass focusing screen on top.

VOIGTLANDER " SUPERB "

(2¼ in. × 2¼ in.)

A soundly constructed twin lens reflex, with unique "parallax-compensation." This movement is operated by the focussing lever automatically causing the focusing screen, mirror, and finder-lens to incline downwards on near distances.

The Superb takes twelve pictures 2¼ in. square on standard 8-exposure 3¼ in. × 2¼ in. film.

		24 Monthly
Skopar f/3.5	Cash Price	Payments of
Compur D.A. ...	£19 7 6	17/4
Heliar f/3.5		
Compur D.A. ...	£21 7 6	19/2

Size : 5⅝ in. × 3⅞ in. × 3⅞ in. Weight : 31 oz.

ZEISS-IKON CONTAX

GENERAL SPECIFICATION

Finish : Dull chromium.

All-Metal Focal Plane Shutter—speeds, ½ to 1/1,250 sec., set before or after winding.

Film Wind interconnected with shutter. Impossible to take two pictures on one film.

Contax Model II.

View-finder : Direct vision eye level.

Range-finder : Accurate (long base), coupled to focussing mount of lens. Using this it is only necessary to bring two images into coincidence, and picture may be taken with the definite knowledge that the result will be perfectly sharp.

Daylight Loading films are used, with or without separate spool-boxes.

The Optical Equipment : Genuine Carl Zeiss Jena Tessar or Sonnar lens, 2 in. focus in adjustable mount, scaled for distances down to 3 ft.

ZEISS IKON NETTAR

With release on body

This is the series for the user who covets a genuine Zeiss camera, but who can only spend a limited amount. The Nettar is basically similar to the Zeiss Ikon Ikonta and only by minor constructional differences has its amazing low price been made possible.

Self erecting — rigid — handy and well finished it is truly amazing value.

All Nettars use 3¼ × 2¼ in. roll films. 8 exposures. Models marked * take 16 pictures 4¼ × 6 cm.

Lens and Shutter	No. 510 *	No. 510/2	No. 515 *	No. 515/2
Nettar f/6.3, Derval ...	£3 7 6	—	—	£3 12 6
Nettar f/6.3, Telma ...	£4 0 0	—	—	£4 2 6
Nettar f/7.7, Automat ...	—	£3 12 6	—	—
Nettar f/7.7, Automat D.A.	—	£3 5 0	—	—
Nettar f/6.3, Klio ...	—	—	—	—
Nettar f/4.5, Klio ...	—	—	£5 12 6	£6 5 0
Nettar f/4.5, Telma ...	—	—	£5 0 0	£5 10 0
Nettar f/4.5, Compur ...	—	—	—	£7 5 0
Nettar f/3.5, Compur-rapid	—	—	—	£9 10 0
Tessar f/4.5, Compur-rapid	—	—	—	£9 17 6

For Easy Payment Terms, see page 3.

ZEISS-IKON 6 × 6 cm. IKONTA

A handy pocket model built to the usual Zeiss Ikon constructional standards—easy to load, rigid and light, with D.V. finder and release on camera body.

Fig. 5.17 Popular cameras advertised in a catalogue for 1938. All are German made. Leica-type view-finder cameras and twin lens reflexes were usually chosen for serious amateur photography.

had an excellent specially designed f3.5 lens, but the limiting factor for quality was the coarse grain pattern which appeared when small film of that time was enlarged to normal print size. This lack of image resolving power in film itself was a major factor against all 35 mm cameras until emulsion improvements in the 1930s and 1940s.

Press photographers and other professional hand camera users therefore kept to equipment like the 1925 Ermanox 6×9 cm ($2\frac{1}{2} \times 3\frac{1}{2}$ in) plate camera with its (then world's fastest) f1.8 lens. Using the Ermanox with the most sensitive plates available you could often give instantaneous exposures using existing lighting indoors, instead of burning flashpowder. 'Candid' photography was possible. This and other small eye-level plate cameras greatly improved newspaper and news magazine photography in the 1930s.

During the years just before World War II advanced amateurs used a Leica or similar camera, or a Rolleiflex, (Fig. 5.15). This rollfilm twinlens reflex appeared in Germany in 1928. It was less bulky than a plate camera, gave a reasonable size $2\frac{1}{4}$ in (6 cm) square negative, and allowed composing and focusing on a screen on top of the camera. It also had the excellent f3.5 Tessar lens, designed back in 1902 by Zeiss and steadily improved. Many lenses are still based on the Tessar design.

For snapshooters mass production of box and simple folding cameras brought photography within the reach of everyone. Allowing for inflation the cheapest box camera was now about one-hundredth the price of the first Kodak, 50 years earlier.

A few single-lens reflex rollfilm or 35 mm cameras had appeared before 1939. They work like scaled down plate reflexes, but people found it difficult to see and focus on the small screen when the lens was set to a small aperture. Some were mechanically unreliable. World War II stopped the export of German made equipment, forcing individual countries to rely on their own cameras, lenses and film, now mostly directed to Air Force and military needs. Amateur photography in Europe practically ceased, see page 138.

Shortly after 1945 new designs began to appear again, despite a long shortage of raw materials. A precision rollfilm single-lens reflex first developed in Sweden for the Swedish Air Force began to rival the Rolleiflex. It was called the Hasselblad.

As a divided Germany struggled to re-establish itself after the war Japanese manufacturers such as Nikon were beginning to produce a range of original lens and camera designs of the highest quality. They were quick to foresee that the future lay with 35 mm film, now greatly improved in speed, fine grain and resolution. From the late 1950s onwards Japan and then Germany turned most of their attention to this size single-lens reflex. Fitting a pentaprism over the focusing screen allowed the camera to be used at eye instead of waist level, and made it easier to see and compose the image. Above all this type of camera allowed you to see *exactly* the image which would be recorded on

Fig. 5.18 By the 1970s compact cameras like these replaced old box and folding types for beginners.

film, whatever type of lens you choose to fit.

New ways of making glass and the 'coating' of glass surfaces to reduce reflections allowed designers to combine a dozen or more elements in one lens. In this way a whole range of new lenses – from 'fisheye' wide-angle types, to extreme telephotos – appeared during the 1960s for SLR cameras.

In the low price range box and folding cameras died out in favour of direct viewfinder 35 mm types (eg. Kodak Instamatic cameras, Agfa, Beirette). Later, in the mid 1970s, still smaller pocket cameras appeared too (Fig. 5.8) using film 16 mm wide. Thanks to new high resolution films created for this size they gave even sharper less grainy enlargements than 35 mm materials had given before World War II. The short focus lenses on these tiny cameras could be fixed to sharply image all subjects from about 1 m (3 ft) to the distant horizon, so focusing controls were not essential. Films were more tolerant of over- or underexposure, and the modern electronic equipment used by

Fig. 5.19 Modern professional cameras. Top: 5 × 4 in monorail sheet film camera. Bottom right: Motor driven rollfilm SLR. Bottom centre: Precision 35 mm SLR. These are all developments of types shown earlier.

Meanwhile professionals specializing in architecture, studio still-life, and any subjects requiring features such as single picture processing or special perspective controls, still found plate type cameras unbeatable. The modern form of view camera is constructed mostly in metal and supported on a rail (Fig. 5.19). They use sheets of film 4 × 5 in (10 × 13 cm) or larger and have lenses of the highest quality. But as comparing Fig. 5.19 with Fig. 5.10 will show, they clearly still resemble the wooden cameras of 1900, which are now bought and sold as collectors' antiques.

Exposure measurement

One of the main technical barriers to photography has always been deciding what exposure to give. Throughout the nineteenth century working out correct exposure settings had been mostly a matter of experiment and experience. Camera manufacturers gave instructions of course, mostly suggesting that users kept to a narrow range of subjects and lighting conditions. Hurter and Driffield's 1890 work in expressing the sensitivity of plates and film accurately by a speed number also helped. But as better lenses and shutters, and a wider choice of films appeared photographers wanted to attempt a much greater range of subjects and get the exposure correct, every time.

Anyone working during 1900–1920 would either guess, or try consulting elaborate tables detailing subjects, time of year and day, weather conditions, latitude, etc, etc. A

developing and printing laboratories now gave a much higher percentage of successful prints from dark or light negatives.

Miniature exposure meters small enough to fit within a camera body automatically gave correct exposure; interlocks prevented mistakes in winding and loading; automatic focusing and built-in flash all helped to make the cameras of the late 1960s and 1970s simple to use. They could be as straightforward as the old snapshot cameras, but now gave technically excellent results under a much wider range of conditions.

Professional photographers also gradually began to use smaller cameras. However, for a long time portraitists preferred large negatives because they were easy to 'retouch', and therefore to hide features such as the sitter's face wrinkles (page 138.) Shortly after World War II press photographers turned from plate cameras to rollfilm twin-lens reflexes, and then increasingly to handier top quality 35 mm cameras– either single-lens reflex or viewfinder (Leica) types. Fashion and advertising photographers changed to SLR rollfilm cameras in the trendy 1960s. A few years later they also had turned mostly to precision 35 mm systems.

third method was to measure the light with an 'actinometer' like Fig. 5.20. Actinometers were mostly designed to look like pocket watches of the period. They contained a disc of light-sensitive paper (the self-darkening type, like the paper used for contact printing). You moved the disc until a small area appeared behind a hole in the dial, then exposed this to the light reaching the subject, and timed how long it took to darken and match a standard grey tint. The time was converted into the correct shutter and *f* number settings needed for your particular film by moving a dial shown around the outer rim of the device.

By the 1920s and 1930s people also used visual extinction meters – tubes having glass tinted in a range of greys at one end. You looked at the subject through a tube and noted the darkest grey through which your eye could just make out detail. Aids of this kind were fairly cheap but not very accurate, particularly for artificial light.

Electric cells able to convert light intensity into electric current became available in the early 1930s. Early 'electric exposure meters' were the size of a transistor radio (Fig. 5.21). They also cost £20, which was nearly two months' average wage! However the accuracy of photo-electric cell measurement was vital for colour slides – a one-stage process which does not allow corrections by printing. Gradually meters of this kind became smaller and relatively cheaper. From 1938 onwards a few were made to fit on the front of cameras themselves. However, with these current generating meters

Fig. 5.20 A 1903 actinometer – forerunner of exposure meters. The time light sensitive paper P took to match grey tint T was converted into exposure data.

the smaller the cell the less sensitive and accurate it became.

It was not until the 1960s that new cadmium sulphide (CdS) miniature cells were devised, needing battery power but responding to much lower light

levels. Button-size batteries were now coming into use, so manufacturers were able to build complete meters inside camera bodies. Single-lens reflexes were ideal for this development as the cell could be small enough and sensitive enough to measure the actual image light entering the camera lens.

The next step was to devise a system of exposure 'automation' – levers linking a camera's shutter or aperture to a built-in meter, so that correct values were automatically set. By the 1970s these circuits used miniaturized electronics, with tiny light signals in the camera viewfinder showing when the exposure settings were correct. Some made settings entirely automatically. Measurement of exposure therefore progressed from complicated calculation to something handled within the camera itself. Like instant picture materials the technology was 'built-in'.

Fig. 5.21 The first popular photoelectric exposure meter (1932). A light-sensitive cell at the back of the unit converted light into electricity. The smaller meter is the same maker's 1965 model.

Lighting

A textbook written in 1900 suggested that 'artificial light is, as a rule, so poor in photographically active rays, that its use in photography is confined to copying and other purposes which admit of long exposures'. The advent of panchromatic film, with its sensitivity to all colours including the yellowish light of lamps, and improvements in lamps themselves eventually disproved this. But for a long time magnesium flashpowder was preferred for its brilliance.

The first commercial flashbulb contained magnesium foil, later wire, set off by electricity from a torch battery. This had the advantage that bulbs could be fired by contacts inside the shutter, and instantaneous shutter speeds coincided with the flash. Now professionals could carry a pocket full of lighting and take photographs anywhere with a hand-held camera (bulbs were still expensive for amateurs). At first photographers had to have electrical contacts added to their camera shutters—it was not until after World War II that these were built-in as standard.

Practical forms of *electronic* flash also date from the 1950s. It was not a new idea—Fox Talbot had taken a photograph by the flash of an electric spark 100 years earlier. Sparks however are much too weak for general use, and development of this type of lighting was held up until gas-filled flash tubes and high voltage power packs were developed in the late 1930s. Harold Edgerton, professor of electrical engineering at Massachusetts Institute of Technology was a leading figure in improving electronic flash before and during the years of World War II.

By 1947 crude, heavy, shoulder harness 'portable' flash units for general photography were used (Fig. 5.22). They gave even less light than a small flashbulb and were expensive to buy. On the other hand electronic flash did give you hundreds of flashes at almost no cost.

During the next 20 years improvements in electronic components were to dramatically reduce the size of this form of flash, and increase its light output. Bulbs too became smaller but by the 1970s had almost reached the limit of their development. A few years later complete electronic flash units were sufficiently miniaturized

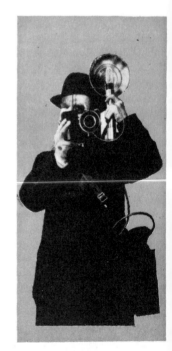

Fig. 5.22 (Left) A 1946 flashgun with plunger. (Right) 30lb portable electronic flash, 1947. It gave less light than a small flashbulb.

to be built into cameras. Some contained a light controlling cell which ensured correct exposure.

In professional studios of the 1960s new high powered electronic flash offered the most convenient form of lighting. Each unit housed modelling lamps to show exactly where light and shadow would form when the flash went off. Flash meters were made for measuring exposure. Although this form of lighting never completely replaced filament lamps in spotlights and floodlamps (now greatly improved) it gave out less heat, was cheaper to run, and allowed the subject to move freely and cameras to be used hand-held. This contributed greatly to the liveliness of 1960–70 fashion and advertising photography.

The effects of technical improvements

In the period 1900–1970 technology improved the tools and processes of photography enormously. Picture taking expanded and became freer – the modern camera is like a modern car which packs its technology under its bonnet and so allows you to concentrate on the road. Gradually most of the problems which so bedevilled earlier photographers were solved by the makers of equipment and materials. Knowing that results would probably "come out" gave people more confidence, and encouraged them to concentrate on the picture content of their photographs.

Colour photography was a late arrival on the scene – almost 100 years after photography's discovery. Perhaps this is a reason why photographers long regarded colour as a 'special' ingredient in picture making. Its reputation for being difficult, complicated, and expensive lingers on; older people still regard colour photography as an area you work up to from black and white, rather than the reverse.

The advent of colour materials meant that for the first time photographers had to consider colour composition . . The way one coloured object is emphasized when contrasted against another for example, and how colour schemes alter mood and atmosphere. These were new elements, so it was hardly surprising that many established workers preferred to keep to the black and white they already knew well.

Another factor important to professional colour photography was the expense and difficulty of reproducing colour well on the printed page. Clients preferred to keep to the more predictable black and white. Between 1935 and 1939 for example only about one in seven industrial or commercial photographs were taken in colour.

Weekly illustrated news magazines, such as *Life* in the US and *Picture Post* in Britain, had appeared in the late 1930s and grown enormously popular. They exploited the new candid type of photojournalism made possible by small cameras such as the Leica (see Chapter 6). But colour rarely appeared on their pages before World War II.

Colour reproduction calls for several separation printing plates inked in various colours, and all printed in exact register onto the page. At first it could only be occasionally afforded for showcards, expensive brochures, magazine advertisements etc. (In America, in 1939, only 9% of total expenditure on advertising photography was for colour; by 1945 this was 26%.) Slowly colour spread to fashion, feature and news in magazines. Newspaper 'colour supplements' which began to appear in the 1960s hastened the general trend towards colour in print; so did colour TV. By the 1970s colour photographs appeared in newspapers themselves from time to time – like the occasional half-tone photographs which had appeared 90 years earlier.

Right from the turn of the century new uses were being discovered for photography, in all directions. Aerial photography was used for military purposes during both World War I and II, and for civilian map-making, town planning, and surveys of archeological sites. Medical, dental and industrial photographic materials allowed shadow pictures to be made with X-rays and gamma rays showing hidden contents of the body, metal castings etc. Accurate record photographs of people, scenes of events and evidence of all kinds were taken for security and law court use by police photographic units. Many large industrial organizations – engineering, oil, construction, transport – set up photographic units to record new projects, illustrate reports, provide pictures for publicity. Documents of all kinds could be copied onto narrow gauge microfilm for compact storage and easy handling.

Specialists in natural history,

astronomy, underwater studies etc, realized the possibilities of new cameras, films and light sources and applied these to their needs. In fact by mid century more of the world's photographic materials were used for these applied purposes than all forms of amateur and professional photography.

In the space exploration programmes begun in the 1960s photographic cameras were vital for recording at every stage. At a more humble level photography was the direct means of selling millions of goods through mail order catalogues. Overall, this century firmly established the photographic image as the preferred form of printed illustration – unsurpassed for detail and apparent truth.

Photography became drawn into the trendy scene of the 1960s and early 1970s, rediscovered by another younger generation. Its influence was so strong pop artists of the period used photographs attached to canvasses and repeated in silk-screen prints as symbols of the period.

Gradually too modern photography was recognized as a creative discipline in its own right as well as a means of training the eye to respond to natural and manmade shapes, forms, colours etc. It had been included in a few art and design courses in Europe as from the 1920s (Chapter 9) and after World War II photography could be studied in American universities and at technical and art colleges in Europe. From the early 1970s it became an examinable subject in high schools, right through to postgraduate institutions.

Public recognition of photo-graphy as more than just a trade or casual hobby has grown enormously. One early achievement was the acceptance, in 1940, of an area devoted to photography at the Museum of Modern Art, New York. The idea that photographic images could receive public interest and respect in the same way as other art objects was hotly argued at first. It took almost 20 years for centres in other countries to treat photography on an equal footing. But by the mid-1960s photography exhibitions had begun to appear in galleries in Europe too. Museums and centres for contemporary photography appeared; award schemes and scholarships for photographers were set up.

Outstanding photographers were able to make a living selling original prints, on the same footing as other artists. More publications began to credit the photographer's name alongside the pictures they used. Collections of photographs were published in book form. Society in the 1960s and 1970s saw photography as a young, important and relevant means of expression.

Summary – Technical improvements 1900–1970

–Overall, this was a period of easier use and improved performance, from slow (blue sensitive only) plates to instant picture colour film; from wooden studio cameras to precision automated pocket cameras.

–The first precision 'miniature' (35 mm) camera was designed by Oscar Barnack. It was called the Leica and went on sale in 1924. The grainy quality of 35 mm movie filmstock showed up badly when pictures were enlarged. Film resolution was greatly improved in the 1950s and 1960s.

–By the 1920s candid photography in existing light, even indoors, was just possible using equipment like the Ermanox folding plate camera. Gradually, as precision equipment appeared, professionals followed the trend towards rollfilm and 35 mm camera types. Hand-held reflex plate cameras gave way to the smaller twin-lens reflex (1930s) and then miniature single-lens reflexes (late 1950s).

–Improvements in lenses (wider apertures, better resolution, greater choice of focal length) followed developments in new types of optical glass, the post World War II introduction of anti-reflective coating, and computer calculation of new lens designs.

–Soon after panchromatic emulsions appeared (1906) many efforts were made to devise a practical form of colour photography. Using a tri-colour system you could re-create subject colours by making separate negatives or using emulsion covered with a mosaic screen of filters. But the first really satisfactory system – 1936 Kodachrome – used three emulsions coated on a single base. Coloured dye images were formed chemically during processing.

–Other important developments in light-sensitive ma-

terials included colour negative films and printing paper (1940s), and instant picture materials in black and white (1947) and colour (1963). However, more people continued to photograph in black and white than colour until the early 1970s.

– Exposure calculation was first aided by paper-darkening actinometers, than visual meters and (1930s) photoelectric cell meters. Miniature battery-powered cells were built into cameras such as 35 mm single-lens reflexes, where they could link with shutter and lens aperture to give various degrees of automatic exposure control.

– Portable flashpowder lighting led to synchronized flashbulbs (1929) and electronic flash (late 1930s). Both gradually improved in light output, and were reduced in size. By 1960 powerful electronic flash units were used in most professional studios; they gave less heat and more light than regular lamps, and eliminated movement.

– Some of the main effects of all these technical changes: colour became an important visual element in photography; the range of conditions under which pictures could be taken were greatly extended; important medical, industrial and scientific applications developed. As technical problems were reduced by improved films and equipment visual aspects became more important; photography became drawn into the popular culture of the 1960s and 1970s, also attracting greater public interest and respect.

Projects

P5.1 Seek out early colour photographs from family and friends. Try to identify dates and processes – remember that most coloured professional portraits were tinted by hand until the 1960s. Old looking colour transparencies can be checked through a strong magnifying glass for signs of a filter mosaic pattern. Remember that clothing fashions often give clues to dates.

P5.2 Most large manufacturers of cameras publish information tracing the history of their camera systems. Pick a well-known brand – Leica, Rollei, Nikon, Minolta etc – and write to the importer or maker for this information. Use it to trace the various improvements made possible by developments in technology.

Questions

Q5.1 A number of advances in the evolution of photography have resulted in greatly reduced exposure times being required for a typical pictorial scene, from minutes or even hours to fractions of a second. Describe the most important factors which have contributed to this situation and outline briefly how the approach to picture making has changed over the years as a result.

Q5.2 Briefly discuss the contributions to modern photography of three of the following: Dr Edwin Land; Oscar Barnack; Professor Herman Vogel; Ducos du Hauron.

Q5.3 Why was the arrival of easy-to-use reliable colour film so long delayed? Outline some of the technical problems which had to be resolved.

Q5.4 Describe how a photographer, using the most advanced materials and equipment available at the time, might have taken a colour photograph in (*a*) 1930, and (*b*) 1950. Your answer should make comparisons under *each* of the following headings: Camera; Sensitive material; Exposure estimation; Lighting.

Q5.5 How have advances in electronics since World War II influenced the design and performance of cameras?

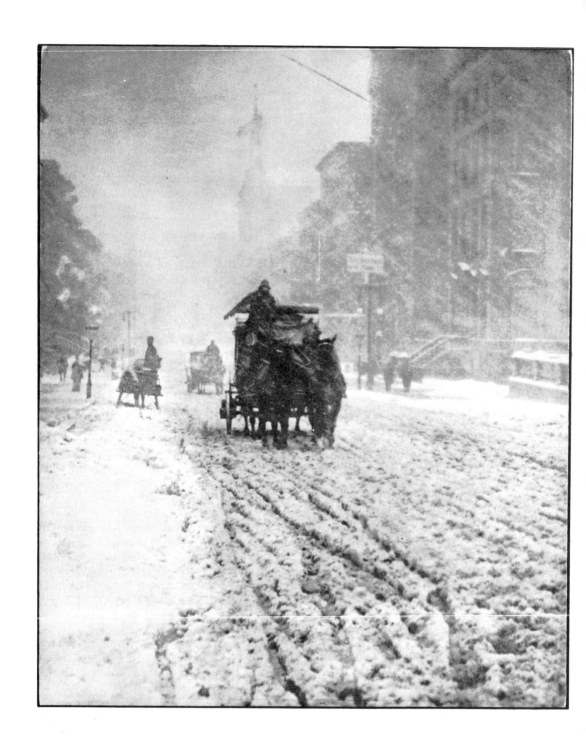

Winter on Fifth Avenue 1892, by Alfred Stieglitz. From 'Camera Work',
October 1905.

Part 2—Subjects, Styles and Approaches —

So far this book has been concerned with photography's technical history–its year by year progression of improved processes, better equipment, materials and methods. Where work by individual photographers was seen this was mostly to illustrate the sort of pictures one process or another made possible. But technique is only a means to an end. Once you can control your results the success of the final photograph depends far more on the way you select or organize your subject and the effect you want to achieve.

Gradually, as the technical limitations of photography became less, *choices* could be made between subjects and the various ways they might be interpreted in pictures. Of course, some subjects were considered more 'suitable' for pictures than others, according to people's taste at the time. But photographers (if they were perceptive enough) could now express a point of view. For some this meant romantic picturesque studies; for others photographs which documented and revealed situations like poverty, or were harnessed to some scientific and technical application. Still others were absorbed by shapes and forms, picture structure irrespective of the actual subject. A great range of different kinds of photographs therefore grew and developed, reflecting the varied interests of people using cameras–people whose attitude to photography was often so individual that only their use of the process itself linked them together at all.

Photographers have also been influenced by current ideas on 'good' art, and attitudes to life generally. Some of these seem quite odd today, for even photographers who were rebels were often rebelling against things which have now completely changed. This part of the book discusses 'movements' and 'groups'–words used to pigeon-hole various people working at one time and make them easier to recall. However, this catogorizing is only a learning aid, for photographers, like painters, seldom join movements *as a movement*. More often they are individuals concerned with expressing ideas (art thrives on conflict).

Mostly they grouped together to put on exhibitions, which were at first the only way serious photographers could publicize their efforts. Often these shows were like religious crusades. Catalogues poured scorn on rival groups while containing extravagant claims of their own importance. Some movements adopted strange fetishes too, like frowning on any manipulation of the image before processing (but approving it in printing.) Retouching was expected on negatives but

This second half of the story of photography looks at areas discouraged on prints, etc. which, for convenience, are labelled documentary, pictorial, abstraction and realism of various kinds. It explains the meaning of these terms, showing and comparing work and discussing the aims of a representative number of photographers. Space limits the number of photographs which can be shown, so it is especially important to back this up by looking at work by particular photographers. A further reading guide for each chapter is on page 151.

Part II concentrates on *what* and *why* photographs were taken rather than *how* they were produced. It will help if you try looking at the pictures as they might have been viewed at the time they were taken . . . not as they are seen today, influenced by millions of photographs which followed later. It is also useful and interesting to read generally about the period. Get acquainted with the pioneering spirit of nineteenth century America, the rules and conventions of 'genteel' living in victorian Britain, the restlessness of Europe between the two World Wars, and changes in attitude towards social inequality and human rights. The date table at the end of the book (pages 148–150) will help you relate each picture to the other events in history that were happening at the same time.

THE DOCUMENTARY APPROACH

Photography, even in its earliest form, has always been admired for its detail and 'truth'. After all, it needs light from an actual subject, whereas a drawing or painting–or a written description–can be conjured up purely from the imagination. Photography meant that accurate records of scenic views, portraits and events could be handed around, or printed as engravings, or used as lantern slides. Later the audience they reached vastly increased when it became possible to mass-reproduce photographs on the printed page. Choice and juxtaposition of pictures in the way they were presented also became important, although not fully appreciated at first. Look at the powerful way life styles can be compared simply by publishing two pictures together (Figs. 6.1 and 6.2).

Documentary photography means pictures of actual situations and events, although composition, choice of moment etc, may be used to help communicate the photographer's own point of view. Hopefully this means he has researched and understood his subject, and will recognize what is significant, what points need to be made . . .

This chapter traces the growth and achievements of documentary photography and

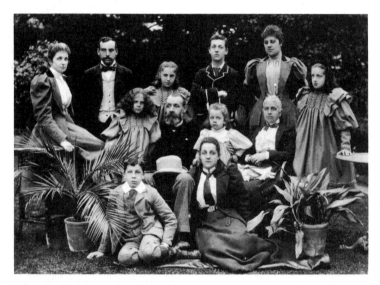

Figs 6.1–2 Even 100 years ago documentary photographs could make startling comparisons when presented together. (Top) Typical Victorian English family, 1890s. (Bottom) An Indian family photographed during the Madras famine 1878.

looks at the problems it raises. It shows why certain kinds of pictures were taken and where they were used. Work by a selection of important documentary photographers is discussed (suggested reading on others appears on page 151).

The beginnings

The simple beginnings of documentary work can be found in the record photography of Delmotte (page 30), also travel pictures by Frances Frith and photographers commissioned by firms such as the London Stereoscope and Photographic Co. People were extremely interested in pictures of far away places, famous people and important events. Roger Fenton's battlefield landscapes and groups in the Crimea were authentic documentation of war, although dull by today's standards. Sponsored by publisher Thomas Agnew, Fenton went with the blessing of the British Government. A great scandal had occurred – five soldiers died from disease for every one killed by the Russians. A new government needed to prove that they were now giving troops the right facilities. This is one reason why Fenton's 360 pictures often show orderly camp scenes, supplies (Fig. 3.8.), formal groups of officers, and battlefields long after the action. Dead bodies are rarely shown.

Mathew Brady Fenton was the first but not the most prolific documentary war photographer. The American Civil War (1861–1865) was covered far more extensively,

Fig. 6.3 Dead Confederate sharpshooter at the Gettysburg battlefield 1864, by Tim O'Sullivan. O'Sullivan headed one of the many photographic teams Mathew Brady sent out to cover the American Civil War. They used converted wagons as mobile collodion darkrooms.

Fig. 6.4 O'Sullivan later became official photographer to government geological expeditions exploring little-known US western territories. This 1873 view documents Canyon de Chelley, Arizona. The expedition's tents can just be seen near the bottom of the picture.

using photography which did not side-step the carnage (Fig. 6.3). The idea of covering this war was the brainchild – and obsession – of one Mathew Brady, well known as proprietor of fashionable portrait studios in New York and Washington. Brady had already published a portrait series of 'Illustrious Americans' and was convinced of the historic importance of documenting the war. He received reluctant official clearance to work in the battle zones, but no financial backing. However Brady spent thousands of dollars putting teams of collodion photographers into the field to cover most important aspects of the war. Some 7000 negatives were taken, mostly by employees, although all credited as 'Brady photographs'.

Of course, other photographers covered war scenes too, but none with Brady's thoroughness and organization. He saw himself as the pictorial historian of his times, and his obsession with the war photographs contributed to his financial downfall. After the war ended in 1865, people were too sickened by the conflict to want reminders. The government were not at first prepared to buy the collection and by the time Brady had been voted a realistic sum he was hopelessly in debt.

Today most of the Brady pictures are housed in the Library of Congress, Washington, increasing in their importance with the passing of years. Despite the limitations of the process the best ones offer more than just records – they communicate something of the bitter struggle of American against American.

Tim O'Sullivan A few years after the war an ex-Brady photographer, Tim O'Sullivan, was working at another new aspect of documentary photography. The now United States sent out expeditions to map and discover geological information about its lesser known territories – Nevada and the Rockies, Panama, New Mexico. Photography was the ideal way to document the mountains, passes and other scenic marvels to show in detail to officials back in Washington. Imagine how exciting it must have been to take pictures like Fig. 6.4, of a virtually unknown canyon. They must have been the equivalent of today's space survey photographs of other planets.

William Jackson Other photographers trekked West with those packhorses and tented expeditions of the late 1860s and early 1870s. The most famous was William Jackson, a professional photographer who freelanced scenic views along the newly complete Union Pacific Railroad,

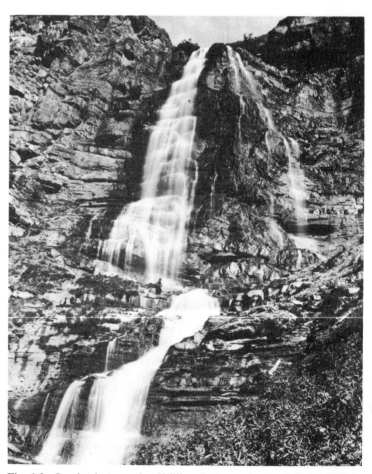

Fig. 6.5 Scenic photographer William Jackson pioneered thousands of pictures like this Provo Falls viewcard, about 1870. He used mostly 10 × 8 in and stereo collodion cameras. Note the man included for scale.

E. E. J. M.
Home for Working & Destitute Lads.

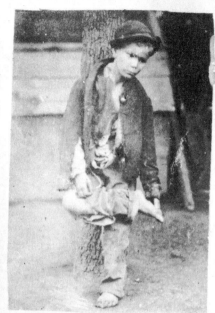

No. 27.—ONCE A LITTLE VAGRANT.
(The same lad as on card No. 28.)

E. E. J. M.
Home for Working & Destitute Lads.

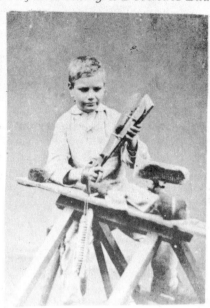

No. 28.—NOW A LITTLE WORKMAN.
(The same lad as on card No. 27.)

Fig. 6.6 During the 1870s small 'before' and 'after' photographic cards were sold to help Dr Barnardo's East End Juvenile Mission.

then joined surveys through Wyoming and the Yellowstone region. Like O'Sullivan he had a flair for landscape composition, using 11 × 14 in (28 × 36 cm) or 8 × 10 in (20 × 25 cm) wet plate view and stereo cameras. Jackson's photographs of the wonders of Yellowstone were exhibited in the halls of Congress as evidence of expedition discoveries. They strongly influenced votes in passing the 1872 bill creating Yellowstone as the first US National Park.

Several of the natural features these surveys discovered were named after members of the expeditions, including their photographers. Hence Jackson Canyon, Jackson's Lake, Mount Haynes, Mount Watkins and others are all reminders of pioneer documentary photographers.

Social Documentary

Dr Barnado Just as Brady pictures helped to show what war was really like, documentary photography was gradually put to use revealing the lives of the poor and under-underprivileged. Dr Barnardo, famous British founder of homes for destitute boys, started using photography as early as 1870. He was shrewd enough to have professional photographs taken of boys as they appeared on arrival (Fig. 6.6) and again when they left the Barnado homes. Each photograph was mounted on a card like a carte-de-visite, with text printed on the back explaining the work of the homes. Cards were sold and collected in sets. They created very effective publicity as well as raising funds to pay for food and clothing.

John Thomson A few years later, in 1877, a book called *Street Life in London* was published by social reformers John Thomson and Adolphe Smith. It described the lives of various specimens of the London poor and contained 36 Thomson photographs (reproduced by Woodburytype). The

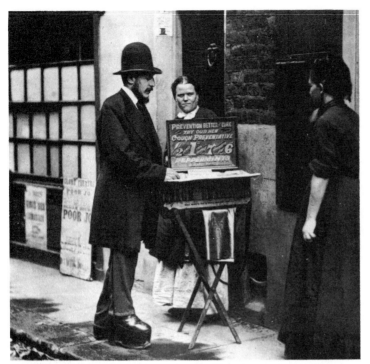

Fig. 6.7 One of a series of photographs of London street life, 1877, by John Thompson. It shows the way the poor relied on 'street doctors' (peddlers of patent medicines).

onwards made it easier to create photographic records of ordinary people's lives in a less formal way. Many such pictures have become lost with time, but a few collections remain and now give us valuable information. There exists for example much work by Paul Martin, a London wood engraver who foresaw that the half-tone block (page 57) would make him redundant and so turned photographer. Martin handled the normal run of professional work but also enjoyed recording people and things as seen by the man in the street in the 1890s.

Mostly he took photographs with an enormous disguised box camera, shown advertised on page 49. It looked like a parcel or case and was arranged to be operated when held under his arm. Martin could therefore photograph whatever he was

photographs were used as visual examples of the various trades and lifestyles described.

John Thomson's collodion pictures are 'set up' in the sense that most of his subjects were posed in their normal environment, like the street doctor in Fig. 6.7. He photographed them in an unsentimental but rather detached way – as carefully documented examples of an unusual tribe or species. (The painter Bruegel recorded medieval peasants' activities in a similar way.) Nevertheless it was quite a breakthrough to publish photographs of such 'unsuitable' subjects as the poor and neglected . . . some people thought it was mis-use of an artistic medium.

Paul Martin New snapshot cameras from the late 1880s

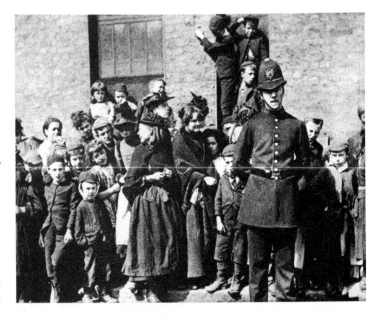

Fig. 6.8 Children in a tough area of London await a big procession, 1893. Paul Martin's plate camera was disguised as a parcel and used held under his arm.

looking at, without anyone noticing. Fig. 6.8 shows his marvellously candid record of each individual in a group of Victorian youngsters with a policeman. Pictures like this contrast sharply with stuffy posed studio portraits of the time.

None of Paul Martin's documentary photographs crusade for reforms or express a point of view other than his interest in fellow human beings. They simply record the authentic passing scene and as such were dismissed at the time as 'non-artistic'. (It is sad that amateur photographers who grew more advanced and competent turned *away* from contemporary life and the real world, leaving this to hit-or-miss beginners. Similarly professionals could find no market for everyday scenes photographed in the cheaper parts of town.)

Jacob Riis The injustices underprivileged people were forced to live with were much greater in the nineteenth century than today. It was a time of 'self-help'—the poor were accepted as having failed and held up as a warning to others. The public had a detached morbid interest. They went to lectures with titles like *The Heathen Abroad and The Unfortunate or Improvident At Home.*

Despite this, honest documentary photography could make people become more concerned. It could show convincingly and in great detail just what it was like to live walled up in the slums, or to work 10 hours a day in a cotton mill or coal mine at the age of eight or nine.

Conditions were particularly bad in parts of America, a country hurrying to catch up in industrial growth after the civil war. It seemed people did not matter as much as reducing production costs and increasing profits. A New York newspaper reporter called Jacob Riis cared passionately about the situation in his city, where children worked for 30 cents a day and whole families lived rough in damp cellars. During the 1890s he wrote bitterly about slums, campaigning for better living, learning and working conditions. He discovered for example that a third of a million people, mostly immigrants from Eastern and Southern Europe, were packed into one square mile of the Lower East Side.

People thought Riis was exaggerating, so he took up photography to prove his reports. Flashpowder allowed him to record pictures of destitute people at night and under other technically difficult conditions (Fig. 6.9). Riis was not interested in photography's artistic aspects. He turned his picture evidence into lantern slides and used them to give public lectures. They were also crudely reproduced as illustrations for nine books including his now famous 1890 title *How The Other Half Lives.*

Riis photographs revealed facts and situations most citizens hardly imagined existed. Eventually his efforts resulted in new child labour laws, schools became better equipped, some of the worst slums were pulled down and replaced by settlements and open spaces. In New York today Jacob Riis Park marks the site of one of the worst areas—a permanent reminder of this early documentary journalist/photographer.

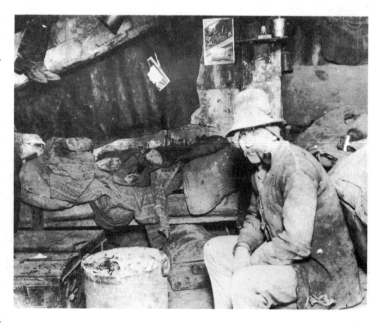

Fig. 6.9 Jacob Riis used photographs to campaign against New York's slum conditions. People were forced to live like this, 1891.

85

Lewis Hine Other reformers discovered the persuasive power of photography too. Lewis Hine, an ex-labourer who worked his way to university and a degree in sociology, was sickened by the way the US government put welfare of corporations before welfare of people. In 1908 he gave up his teaching job to become a full-time documentary photographer, having learnt how to use a view camera and a flash-powder device.

Hine began photographing some of the tens of thousands of people entering America at that time to find the promised land – immigrants who as often as not ended up working in

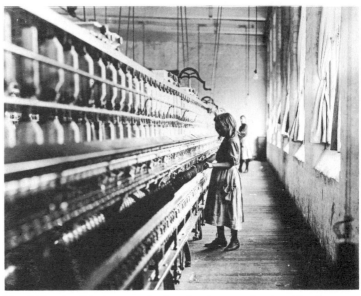

Fig. 6.10 Candid photograph of a school-age worker in a Carolina cotton mill, 1909, by Lewis Hine.

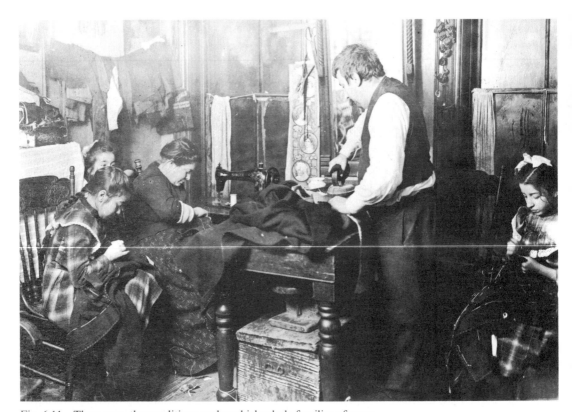

Fig. 6.11 These were the conditions under which whole families of poor immigrants worked, making garments in a New York tenement room. Hine documented the scene in 1910.

sweat shop factories, living in slums. Soon he was hired by the National Child Labor Committee and travelled the US as investigator/photographer showing the way industrialists were using youngsters for cheap hard labour. About 1.7 million children were then in industrial employment, but most citizens just accepted this–until Hine turned the statistics into detailed pictures of flesh-and-blood people. Often he 'infiltrated' a factory with a Graflex hand camera hidden in a lunch box, then interviewed and photographed child workers.

Hine discovered situations such as youngsters of six or seven in cotton mills working a 12 hour day (Fig. 6.10). He took statements, recorded their height (against his coat buttons) and general health, then photographed them unsentimentally in their cramped dangerous work conditions. All this sort of human information was paraded publicly through NCLC pamphlets which were now illustrated with halftone blocks.

Some people called Hine a muck-raking journalist; others called him a conscience with a camera. Either way his thousands of photographs and detailed case histories chipped away at the powerful opposition of employers against reforms. Hine carried on this work into the 1930s until a federal law was finally passed against child labour. In his own words 'I wanted to show the things that had to be corrected; I wanted to show the things that had to be appreciated'. In many ways Hine began a tradition of social documentary photography, which can be traced through to the recent work of Shelter, and

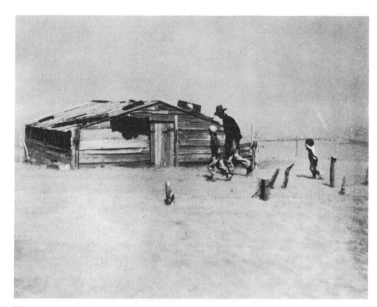

Fig. 6.12 Drought, dust storms, and shortage of money destroyed many small farmsteads in the US mid-west during the 1930s. Arthur Rothstein revealed the situation along with other FSA photographers.

United Nations' children's organizations.

Farm Security Administration
In 1929 the New York stockmarket crashed. It was the beginning of a depression which was to last throughout the 1930s. Soon millions were out of work, banks tightened up on credit, many businesses came to a stop. On top of all this a prolonged drought hit the farmland plains of central America during 1932–1936, creating a great dustbowl from Texas to the Dakotas.

Mechanization by tractor had already forced small farmers off the land and reduced the jobs available. Now this combination of disasters made people trek westwards into California. They included sharecroppers (migrant workers who normally followed the season's crop of peas, oranges, cotton etc), and failed or dispossessed farmers. Whole

families were piled into battered cars, or pushed their belongings in handcarts. People lived in tents or shanty towns at the side of the highway.

A Resettlement Administration was set up by the US government to help these unfortunate people. In 1935 it was named the Farm Security Administration, and a college economics graduate Roy Stryker was hired to run a historical section. His brief was simply to record the work of FSA, but in the spirit of Hine and others he decided to employ photographers who could show Americans directly what it was like to live in the stricken areas.

Photographers Dorothea Lange, Walker Evans, Arthur Rothstein and others (about 30 in all but no more than 6 at a time) were briefed to take persuasive pictures, get to know the refugees' experiences at first hand. Stryker chose intelligent committed documentary

87

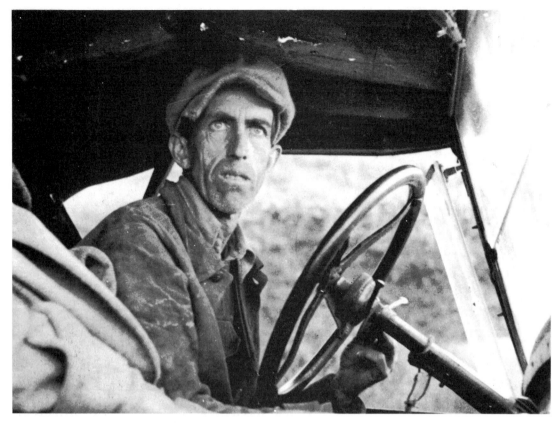

Fig. 6.13 Dorothea Lange captioned this photograph Ditched, Stalled and Stranded. The hollow face of a dispossessed farmer turned migrant farmhand sums up the desperate situation.

photographers. He gave everyone a thorough background briefing and insisted that it was important to understand the migrants' problems before they could recognize what was significant and important to photograph.

Stryker was not a photographer himself but a brilliant user of photographs. He had a sense of historical perspective like Brady – both saw the value of recording events of great social significance. But now, pictures could be fed directly to the nation's press. People throughout the country could see the scandal of these rural slums. Members of the FSA

unit photographed migrant camps (Fig. 6.14), denuded landscapes, abandoned homesteads, people on the highways (Fig. 6.13), families helpless, defeated, forgotten. Mostly they avoided pictures which were just picturesque, or smug or false. Stryker even had photographs taken of rich Americans down on holiday in Miami at the time, to strongly contrast the life-styles.

To begin with FSA pictures were used to illustrate written articles and features on what was happening, but the photographs were so persuasive they soon took over. Pictures and captions were distributed to

newspapers and magazines; exhibitions were sent to Washington DC, New York and other cities. John Steinbeck, inspired by Dorothea Lange's immigrant pictures researched and wrote *Grapes of Wrath*. Walker Evans' pictures were used by poet James Agee in his book *Now Let Us Praise Famous Men*. Documentary movies were now now being made too – they contrasted sharply with the glossy image of America given by Hollywood at that time.

Public support blossomed and soon Government aid for re-settlement schemes increased – transit camps were set up, work provided, help given

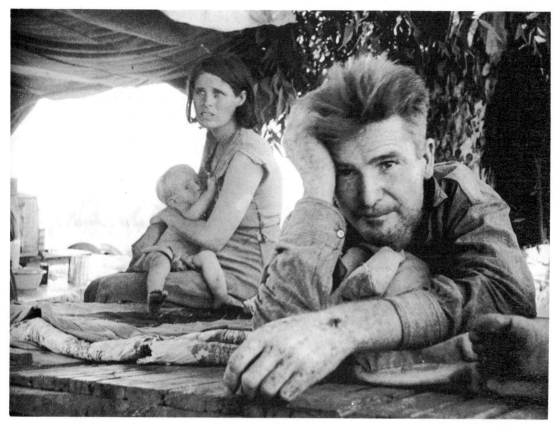

Fig. 6.14 Penniless migrant workers from Oklahoma ('Okies') camped beside the highway. A 1936 FSA picture by Dorothea Lange which shocked America when it appeared in newspapers and magazines.

for people to start again. It was a classic example of a small group of photographers succeeding in changing a situation. The FSA unit lasted from 1935 until it was absorbed into the US Office of War Information in 1941. By then photojournalism was well established in both America and Europe.

Newspaper photography, photojournalism

Chapter 3 showed how technical problems of reproducing photographs in ink on the printed page were solved in the 1880–1890s. Compulsory edu-

Fig. 6.15 Walker Evans documented these negroes waiting in the food line at an emergency refugee camp, Arkansas, 1937.

½d.

Daily Mirror

All the News by Telegraph, Photograph, and Paragraph.

An Illustrated Paper for Men and Women.

No. 154. Registered at the G. P. O. as a Newspaper. MONDAY, MAY 2, 1904. One Halfpenny.

THE LATEST PHOTOGRAPH OF THE KING AND QUEEN.

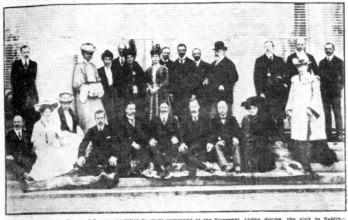

This photograph of the King and Queen was taken by royal command at the Viceregal Lodge during the visit to Dublin.— (Photograph by Lafayette, Dublin.)

SATURDAY'S CRICKET.

Sewell, who made 181 for London County against Surrey at the Crystal Palace on Saturday.

THE NAMELESS PICTURE.

Ask your friends who is the original of this charming picture. Send your solution to the "Picture Puzzle Department," "Daily Mirror" Office. A guinea will be paid for the first correct answer. For Saturday's winner, see page 3.

OPENING OF THE POLO SEASON AT HURLINGHAM ON SATURDAY.

Hurlingham began its season on Saturday with a match between A and B teams. The A team consisted of the Earl of Harrington, Captain Godfrey Heseltine, Mr. F. Jay Mackoy, and Captain W. G. Renton (back). B team: Mr. Bernard Wilson, Mr. R. Grenfell, Major F. Egerton Green, and Mr. T. B. Drybrough (back). The A team won easily by 8 goals to 3. At Ranelagh the season proper commenced with a polo match between the 60th Rifles (past and present) and a contingent representing the club. The military team had matters much their own way, and finished up winners by 5 to 1, the solitary goal for Ranelagh being secured towards the end of the fifth period.

WORLD'S FAIR AT ST. LOUIS OPENED ON SATURDAY

The great "Exposition" at St. Louis was opened on Saturday by the pressure of a gold electric button by President Roosevelt in Washington, a thousand miles away. All the "biggest things on earth" are gathered together in the 1,240 acres of the Exhibition grounds, and include everything, from the largest gas-engine ever built and the largest organ ever blown to a full size model of an American battleship.

SCILLY'S MAY QUEEN.

The ceremony of crowning the May Queen is being carried out with unusual display this year in the Scilly Isles.

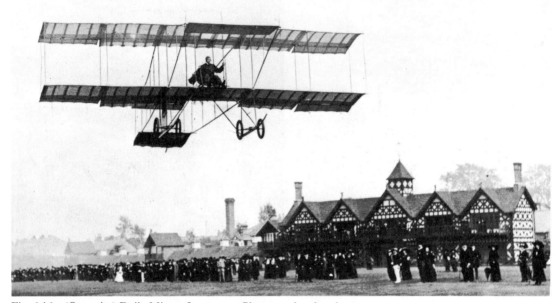

Fig. 6.16 (Opposite) Daily Mirror front page. Photographs plus short, easily digested stories attracted millions of new readers.

Fig. 6.17 (Above) A flying machine takes off. This action news picture really captures the achievement of getting airborne in 1910.

cation for children up to 10 years had started at about this time too. This meant that by the turn of the century far more adults were able to read (although not very well). Existing newspapers, with their solid columns of small type, were not very encouraging to this new readership. Newspaper owners realized that news expressed in *pictures*, with easy-to-read captions and short paragraphs would capture a vast new market. This led to papers like the *Daily Mirror*, launched in 1904 as the world's first newspaper illustrated exclusively with photographs and priced at a $\frac{1}{2}$d ($\frac{1}{5}$p). It was an instant success. Fig. 6.16 shows how simple words and sentences were used.

The newspapers employed their own photographers, and also bought photographs from press photo agencies which sent out cameramen covering most main news events. Their jobs were essentially to sum up a situation or a person in the news in one picture, then rush this through ready for the next edition. Speed was more important than technical quality (one reason why plates were preferred – they could be wiped off and enlarged when still wet from processing). Most of the first news pictures were portraits, or at least 'candid' scenes. But as lenses and photographic materials improved more action pictures became possible (Fig. 6.17) with flash-bulbs being used for subjects under difficult lighting conditions. By 1907 photographs

could even be transmitted by telegraph wire from one newspaper office to another – including country to country. 'Hot' news pictures could be distributed almost as fast as the written word.

The possibilities of using photographs in print became even greater when weekly picture magazines began to appear, in the 1920s. Here the photographer could be given more scope – allowed several pages to tell a story and develop a theme through a *series* of pictures. For example, instead of the single press photograph of a goalkeeper saving a goal the magazine could give in depth coverage of 'A day in the life of a goalkeeper'. A picture feature allowed much broader aspects than one news happening to

91

Fig. 6.18 Picture magazines in Germany and Russia made new and adventurous use of layout during the 1920–30s. This double-page 'spread', part of a story of Moscow's Metro, appeared in 'USSR Reconstructs' published in 1935.

be covered.

Photographers on picture magazines needed to work in ways similar to a journalist, aiming for picture sets with an interesting story line and a strong beginning and end. This sort of work soon became known as *photojournalism*. It differs from straight documentary photography in that events are often interpreted by the photographer or magazine. Like written journalism a picture essay can be a personal point of view. Nor does it end with the photography, for choice and cropping of prints, text writing, and the way the sequence is presented ('laid out') on the magazine pages can strengthen or weaken the final

picture story. The art editor, whose job it is to put the photographer's work together in a meaningful way (rather than just grouping them on the page) becomes an important member of the team. Look at Figs. 6.18 and 6.19.

Picture magazines really began in the mid-1920s in Germany, when that country was the printing centre of the world and was also the source of the world's most advanced cameras with wide aperture lenses (page 69). These were beginning to make possible photography in quite dim existing lighting, without needing the flash paraphernalia of the press photographer. Probably the earliest picture magazine was the *Ber-*

liner Illustrierte Zeitung (Berlin Illustrated Newspaper) in 1928.

During the 1930s the new style reporting spread throughout Europe and America. The publishers of *Time Magazine*, began *Life* in 1936; rivals launched *Look* the following year. In Britain *Picture Post*, and *Illustrated* appeared in in 1938 and 1939, *Paris Match* in 1949. 1935–1955 was the golden age for picture magazines.

Erich Salomon. Berliner Illustrierte's most talented photographer was a discreet self-effacing Jewish doctor, Erich Salomon. In the early 1930s Europe was a hive of international conferences. Poli-

ticians met in Berlin, Paris, Vienna and Rome, hoping to avoid impending conflict, trying to set up a League of Nations, forerunner of the United Nations. Conferences between diplomats and statesmen were held behind closed doors – the only photographs that people saw were occasional formal groups posed for the Press.

Salomon had a tiny plate camera called the Ermanox (see Chapter 5) with an enormously wide aperture $f1.8$ lens. Disguising himself in evening dress (Fig. 6.21) and exploiting his ability to speak seven languages, Salomon politely gatecrashed many conferences. He discreetly passed among famous politicians, taking photographs by available indoor lighting, the camera half hidden under his jacket. He brought back unique sets of pictures conveying the general atmosphere and showing the personalities of those taking part at unguarded moments, engrossed in after-dinner discussions. They contrasted sharply with the blinding flash and smoke which everyone associated with cameramen and made them an unwelcome nuisence.

For the magazine reader this new form of political reporting gave a real feeling of 'being there'. What were these people talking about – what were they plotting? Other photojournalists followed Salomon's lead, mostly with smaller cameras such as the Leica which allowed pictures to be taken in quick succession and gave greater depth of field. Tragically Salomon was to die in 1944 at the hands of the Nazis at Auschwitz extermination camp.

Henri Cartier-Bresson Probably the most famous and original of all 'candid' reportage photographers, Henri Cartier-Bresson originally aimed to become a painter. He started taking photographs in the early 1930s when he bought a Leica and found it a marvellous device

Fig. 6.19 A typical spread from the British picture magazine 'Illustrated' in 1940. It is part of a six-page story on the ways ordinary people sheltered from Nazi air raids. 'Illustrated' began in 1939 as a rival to 'Picture Post' (1938).

for capturing what he describes as 'the decisive moment' in everyday situations. In other words he finds there is a fleeting fraction of a second in which the significance of an event can be summed up and expressed in a strong visual composition.

Cartier-Bresson is mainly a photographer of people–but not as a social reformer or news event reporter, simply as observer of the passing scene. He documents ordinary people with warmth and humour, never influencing his subjects but showing them at moments of extraordinary intensity. Often he turns his back on a newsworthy event–procession, celebration etc–to concentrate

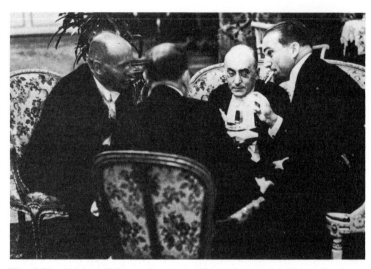

Fig. 6.20 (Above) Salomon's after-dinner candid of statesmen, Rome, 1931. Mussolini on left.

Fig. 6.22 (Right) Henri Cartier Bresson excels at documenting ordinary people.

Fig. 6.21 Dr Erich Salomon, equipped with dinner jacket and Ermanox f1.8 plate camera.

on the reactions of onlookers (Fig. 6.22).

At all times Cartier-Bresson never intrudes. He never uses flash or special lenses, and the whole of each negative is always printed without cropping. He has photographed the people of most countries, but excels at showing fellow Europeans. His pictures have been used in all the most important magazines, over a period of more than 40 years. They have been exhibited and purchased by many of the world's art galleries. Collections of his work published as books best show his very distinctive style and approach.

After World War II, in 1947, Cartier Bresson and photographers Robert Capa and David Seymour formed a picture agency called 'Magnum'. Run as a cooperative and owned by the photographers themselves, Magnum has about 25 full members in various countries. It sells pictures to publishers of all kinds and has become the most famous photo-

journalistic agency of its kind in the world.

Bill Brandt One of Britain's most distinguished photographers was also working as a photo-journalist during the late 1930's. Bill Brandt was born in London and in 1929 learnt photography in Paris as assistant to Man Ray (Chapter 8). Reportage work was the new most challenging area for young photographers, and Brandt was influenced by the work of Cartier-Bresson and others. He returned to Britain during the depression years, producing pictures of the industrial North (Fig. 6.23) which made pointed comparisons with other richer levels of British society.

Brandt's work was published as picture books such as *The English at Home* and *A Night in London*. He also undertook many *Picture Post* assignments where his pictures often appeared anonymously (until the 1950s the photographer, unlike the writer of the text, seldom

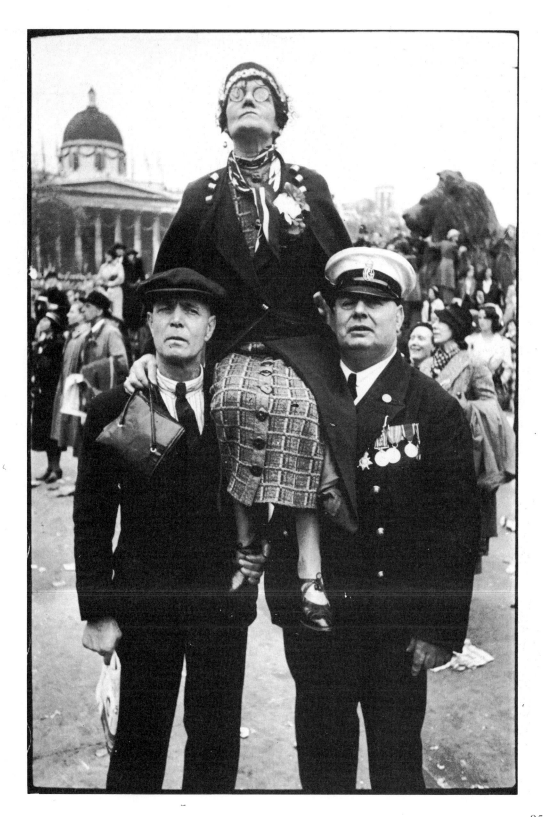

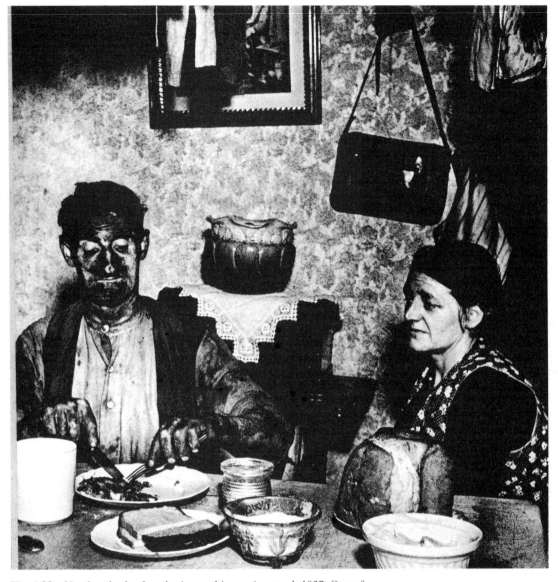

Fig. 6.23 Northumberland coal miner at his evening meal, 1937. One of
Bill Brandt's documentary pictures strong in compassion and respect.
It was taken for 'Picture Post'.

received a credit line). Later
Brandt was to specialize in
landscapes and original dis-
torted images of the human
form, see page 128.

During the war years (1939–
1945) most photojournalists
worked for organizations such
as the US Information Service,
or the British Ministry of
Information, or were drafted
into Air Force or Army photo-
graphic units. The British Army
Film and Photography Unit
produced over 137,000 docu-
mentary pictures of offensives;
there was an equivalent organi-
zation in Germany called the
PBK (German Propaganda
Corp).

Robert Capa, who hated war
and tried to show its futility,
became a renowned combat
photographer. Like many war
photographers, both Capa and
fellow Magnum founder David
Seymour were to die in action
a few years later – Capa cover-
ing conflicts in Indochina, and
Seymou in Egypt.

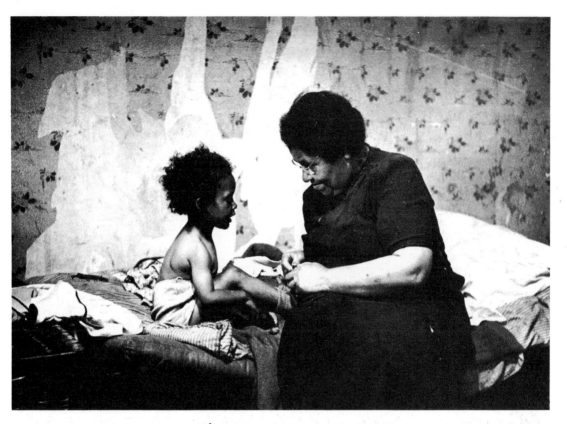

Fiġ. 6.24 A social documentary photograph from a series on the colour problem in Liverpool 1949, by Bert Hardy. The picture magazines often ran features exposing situations they thought wrong.

Rise and fall of picture magazines

In some ways picture magazines of the 1930s and 1940s were the modern equivalent of the stereoscope cards of the nineteenth century. At their best they offered the ordinary person a window on the world – coverage of great events, a peep behind the scenes, a day sharing the lives of famous people – in greater detail than newspaper press photographs could provide. They could also make readers more aware of the gap between what life is, and might be.

Of course, the magazines always contained a great deal of purely entertainment material such as cute pictures of animals, stills from new Hollywood movies, the latest fashion craze . . . But they could also be powerful moulders of public opinion on more vital issues. Unlike today's colour supplements most of them ran occasional 'crusades' on topics like bad housing, pollution, help for the handicapped etc. They took sides rather than going for bland neutral coverage. This made a lively and much more interesting magazine but put responsibility on the shoulders of photo-journalists, writers and editors.

The production team had to be well informed and able to present a reasoned argument rather than propaganda. They were operating possibly the most persuasive visual medium in the days before television, for cinema newsreels were mostly flippant and quickly forgotten. Of course, the photographer or art editor was always tempted to give a picture dramatic treatment so that it had visual impact on the page, but distorted its importance within the story as a whole.

Picture magazines influenced each other too. Stephen Lorant, a Hungarian Jew and editor of the Munich rival of *Berliner Illustrierte* left Germany under Nazi pressure. A few years later in 1938 he

Give me a hand–any hand will do! PHOTO NEWS

The man who needs friends hasn't time to look at faces

Sightseers line railings of a Brussels park as President Nixon signals; "Shake hands if you're quick." He was counting every second on his way to lunch with King Baudouin...

Stephen Harper

Fig. 6.25 Photographs are given new meanings by the words written around them. This picture of President Nixon would not normally have rated newspaper reproduction, but due to strong anti-Nixon feelings over the Watergate scandal it was presented this way.

became *Picture Post*'s first editor. Together with photographers Kurt Hutton, Felix Man and other European refugees, he brought the use of 35 mm cameras and the ideas and layout of German picture magazines to Britain. They filled *Picture Post* (and its rival, *Illustrated*) with action pictures and features which looked very different to traditional British weeklies like *Tatler* or *Illustrated London News*. In America other European immigrant photographers such as Alfred Eisenstaedt and Robert Capa made outstanding contribu-

tions to *Life*.

Picture magazines thrived during the conflict and excitement of World War II, despite shortage of paper. They seemed to sell everything they could print and had enormous status – *Life* photographers for example always happened to be given the best press vantage points at any public event. However, by the 1950s *Picture Post* had begun to lose its sense of purpose. Even the novel use of several regular pages of colour could not revive it. *Illustrated* closed in 1958, *Picture Post* in 1957, *Look* in 1971.

Life lingered on in more-or-less its original form until 1972.

Television had taken over as a faster, more universal method of visually communicating news and features; it was also stealing most of the advertisers. By the 1970s photojournalism had lost a lot of its influence. It was to be found still in newspaper colour supplements (mostly without 'teeth'), in a few remaining magazines such as *Stern* (Germany) and *Paris Match* (France), and in growing numbers of expensively produced company magazines for the oil industry etc.

Distortion and manipulation

The way the world is presented by documentary photography is often distorted in one form or another – it is almost impossible to be completely objective and truthful. At first it was thought that photography must, by its recording nature, be wholly accurate. But as equipment and materials improved greater technical choices were offered, greater freedom to decide what and when pictures were to be taken. Again, as soon as pictures could appear in print the photographer's choice of decisive moment was followed up by decisions on which picture(s) were to be reproduced, the ways captions were written, and how pictures were related one to another on the page.

Half-tone reproduction created a big market for documentary photography, gave it a huge audience and made it influential. People soon wanted to manipulate such a powerful medium. Photographers began doing this by posing their subjects, and choosing the viewpoint and moment in time; editors by selection and presentation of their results. Even the subjects of pictures can manipulate results by what they stage in front of the camera.

This manipulation need not always be bad. For Dr Barnardo's before-and-after pictures (page 83) boys were usually dressed up in rags to re-create the 'before' situation. One of the FSA photographers was severely criticized when it was discovered he had shifted a cow's skull several feet from a patch of scrub grass to sun-baked soil to make a stronger picture. However, neither really distorted the truth of the general situation they were trying to show – they simply communicated it in a visually stronger way.

On the other hand, from the early days of picture newspapers it has been normal practice to file photographs of prominent people looking confident, defeated, agressive, stupid etc. They may be taken at various times or even at different moments in the same speech. The pictures are pulled out and reproduced as press portraits to suit the mood of the moment, when that person is either favoured or disliked. Again, an editor can easily select from a photographer's picture series an image he would normally reject, like Fig. 6.25. By adding a headline and caption he gives it strong meaning.

People gradually realized the publicity they can gain through photography. A demonstration often becomes violent when professional photographers or TV crew are seen to be present. In one extreme instance in the late 1960s a public execution was held over for 12 hours, as the evening light was too poor for the press to take pictures. The concerned photographer therefore has to ask himself whether something he documents would have happened that way had he not been present? Should he use a wide-angle lens, which makes close-ups of people with their arms out look more violent? Would grainy film and dark printing make bad living conditions look worse?

As can be seen, the more strongly the photographer or editor feels about a particular situation the more tempting it becomes to present it in a powerful way. Strictly objective recording is almost impossible – it often gives cluttered pictures which confuse what is being shown. But then, too much concern for clear presentation can distort the real events. In practice documentary photography has to function somewhere between these extremes.

Summary – Documentary approach

—Photographs, as documents, have a reputation for truth and accuracy. They can convincingly reveal situations, describe events, help to explain things. The photographer still uses aesthetic qualities, technical detail etc, but as a means to an end – to strengthen what he considers needs to be shown.

—Roger Fenton's Crimean documentary photographs were intended to sell, and incidentally support Government actions. Mathew Brady foresaw the historical importance of documenting the American Civil War. Tim O'Sullivan and William Jackson showed the US government remote, unknown parts of America. Enormous technical difficulties limited these early photographers' style and approach.

—The fund raising 'before-and-after' photocards of Dr Barnardo, set piece book illustrations by John Thomson, and Paul Martin's hidden hand-camera shots of London street life are among the few remaining nineteenth century examples of social documentary pictures of the poor. Jacob Riis, and then Lewis Hine,

used photography in personal crusades to expose US social injustice in living and working conditions.

—Farm Security Administration photographers–Dorothea Lange, Walker Evans, Arthur Rothstein and others, coordinated by Roy Stryker–documented the terrible conditions of the mid-west US farming community during the 1930's depression. The understanding and involvement by FSA photographers resulted in pictures which raised public concern, increased government aid.

—Reproduction of photographs on the printed page extended the power and influence of documentary photography. Press photographs in new illustrated newspapers communicated information in an easily digested form. Picture magazines, beginning in Europe in the 1920s, brought extended picture essays and introduced photojournalism.

—Photographers such as Erich Salomon and Henri Cartier-Bresson, using new small format cameras and photographing by existing light, were able to take candid actuality pictures. Cartier-Bresson's work is renowned for his use of 'the decisive moment', summing up an event and giving well structured picture composition.

—The picture magazines of the 1930s and 1940s–*Berliner Illustrierte*, *Picture Post*, *Life* etc –employed some of the finest talent of their day. Robert Capa, David Seymour, Alfred Eisenstaedt, Bill Brandt, Kurt Hutton and many others covered topics ranging from local community issues to wars. Magazines ran crusades, adopted strong points of view.

—A good documentary photographer does much more than record. He can communicate what a situation felt like. However, the photographer decides where to point the camera, when to fire the shutter, and usually afterwards (with the editor) which results to use or discard. Each picture may tell a particular truth but a general lie. Even the event itself may be changed by his presence. Honest reporting is a compromise between recording a confused real world and simpler more powerful but manipulated images.

Projects

P6.1 Find examples of picture stories published in magazines before or during World War II. (Some public libraries hold these on microfilm, they are also reproduced in books.) Compare these with the way similar topics are covered by picture magazines/colour supplements today.

P6.2 Pick a day when a particular news event (preferably political) is reported by pictures in most daily papers. Obtain a copy of each paper and compare how the choice of photographs and use of captions slant the reports.

P6.3 In addition to the photographers named in this chapter look at books of the collected documentary photographs of Benjamin Stone, J. H. Lartigue, Brassai, Bert Hardy, W. Eugene Smith and Robert Frank. See page 151.

Questions

Q6.1 Comment on the significance of photographs as documents and show how photography was used for documentary purposes between *either* 1851–1900 *or* 1900–1950. Reference should be made to methods of publishing photographs during this period.

Q6.2 Discuss *two* of the following photographers in terms of the type of subject matter and approach by which they are best known: Dorothea Lange; Henri Cartier-Bresson; Lewis Hine; Erich Salomon.

Q6.3 During the nineteenth century photography was employed in the study of:
 movement
 social documentation, and
 geographical exploration.
Describe the contribution made by photography to one of the above areas.

Q6.4 How does the work of the press photographer differ from that of the photojournalist? Outline an event which might be covered by both types of photographer and explain how each result might appear on the final printed page.

PICTORIAL PHOTOGRAPHY

This chapter follows the work of photographers concerned with making pictures which are *aesthetically pleasing*, i.e. which appeal to people's sense of beauty. The terms 'pictorial photography' or 'pictorialism' are used to describe photographs of this kind in which artistic qualities of the picture are more important than the actual scene shown.

Pictorial photographs are complete in themselves – to be hung on the wall or shown in exhibitions as examples of the photographer's art, rather than documenting and communicating much about the subject itself. For example, people outside a house in a mean back street might be recorded by a documentary photographer to illustrate bad housing conditions. A pictorial photographer, by grouping the people in a compositionally pleasing shape, perhaps using a soft focus camera lens, and waiting until the street surface glistens

Fig. 7.1 'Rienzi' painted by Holman Hunt, 1849. This pre-Raphaelite style was the most important 1850s British art movement. Themes were sentimental, often poetic, and painted in detail.

Fig. 7.2 'Two Ways of Life' a composite photograph constructed with enormous effort by Oscar Rejlander. Exhibited in 1857, its moral storytelling was greatly admired. Copies were bought by royalty.

after rain, may create a moody atmospheric study. One photograph might be called *Victims of the housing problem, Glasgow*, the other *Dusk*. Clearly, documentary and pictorial photography can be poles apart.

Attitudes to pictorial photography have changed over the years too. Although difficult to believe today, pictorialism was considered modern and experimental in the late 1880s. This was because it was a break away from the earlier constructed 'high art' photography of the mid-19th century, towards art pictures direct from nature. Once again it is important to try to see these photographs from the standpoint of what good art was considered to be at the time. The first part of this chapter therefore looks back at the high art movement, to

appreciate what pictorial photographers were rebelling against.

Beginning in Britain, pictorial photography soon spread to Europe and America. It became very much the concern of photographic clubs and societies for the serious amateur. Like-minded pictorial photographers also formed break-away groups; exhibitions were battlegrounds over which reviewers argued and fought. Eventually a newer approach – 'straight photography' – was to take over, leaving pictorial work repetitive and diluted during the 1920s and 1930s.

Pictorialism had made Britain the centre of new ideas in the 1880s and 1890s but then seemed to hold back the progress of its serious amateur photography. It was left to American and European work-

ers to move on into newer and more experimental approaches described in Chapter 8.

The background to pictorialism

Like art groups, the photographic societies which had sprung up in many cities during the 1850s (Chapter 3) ran regular exhibitions of members' work. The camera was the new way of making pictures, but photographers were extremely conscious of its being only 'a mechanical recording medium'. Naturally they wanted to be considered as good as the accepted artists of their day.

Popular mid-nineteenth century painters used a romantic approach, strongly expressing the emotional and the dramatic, and often using subject themes

from history or literature. 'Pre-Raphaelite' style painting dominated British Royal Academy exhibitions during the 1850s. Lofty, poetic themes like Fig. 7.1 were chosen, treated sentimentally but painted in great detail and with careful regard for accuracy to nature. They worked in a manner similar to painters before the High Renaissance Art of Raphael.

Art critics sent to review exhibitions of photography naturally compared this new work with painting. They advised photographers to avoid ordinary everyday scenes, draw a veil over 'ugly truth' and beautify their subjects if they were ever going to elevate photography to a high art. This was none too easy to achieve when you consider the subject detail and accuracy the camera gives. To solve the problem (and help with technical difficulties like long exposures) subjects were specially staged. People dressed in costume and posed artistically in arranged settings (Fig. 7.2). Photographs had to be contrived to be beautiful, just as the professional studios stage-managed portraiture at this time (page 40).

Choice of theme for a would-be 'high art' photograph was also very restricted. It was safest to pick episodes from the bible, or a telling phrase from a then modern poet like Tennyson or Longfellow, or some dramatic scene from life like 'Home From the Sea'. The Victorians loved pictures which narrated stories and pointed morals, like novels of the time. They preferred scenes which unfolded before their eyes in clear precise detail, thoroughly worked and finished. In some ways therefore painting had a story-telling function like movies or TV today, particularly for the large number of people who could not read.

Imagine visiting the Manchester Art Treasures Exhibition in 1857. Full of Rembrandts and Van Dycks, there were also over 500 British and European photographs organized by Philip Delamotte. These included some of the Prince Consort's own collection of photographs such as studies by Lake Price (Fig. 7.3). But the photograph which created greatest stir was Oscar Gustav Rejlander's *Two Ways of Life*

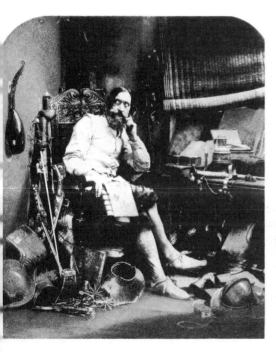

Fig. 7.3 'Don Quixote in His Study'. Artistic photographer William Lake Price used antique oddments to produce this studio composition in 1855.

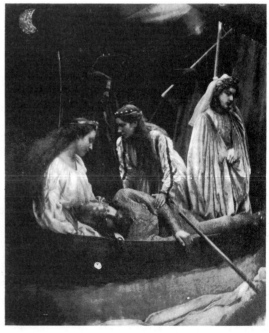

Fig. 7.4 J. M. Cameron's photograph 'The Passing of King Arthur', illustrating a Tennyson poem, 1874. Note the muslin waves and cardboard moon.

(Fig. 7.2). Queen Victoria, who had opened the exhibition, probably stood admiring this work while Prince Albert explained the allegory it showed. A father leads two sons into the wide world. One (looking rather self-satisfied) turns towards the 'worthy' things of life – knowledge, industry, married life, religion. The other turns away from father's guidance towards 'bad' influences, including idleness, drink, sex and gambling (this naughty half had to be curtained off when the photograph was exhibited in Scotland later).

Rejlander was an ex-painter who ran a studio at Wolverhampton, mostly producing reference photograph figure studies for artists. In a sense *Two Ways of Life* was a catalogue of his wares. He had used over 30 separate negatives to create his tableau – photographing the artistically posed figures singly or in groups. The background was photographed in a friend's garden; the draperies in Rejlander's own studio. He sold full 16 × 31 in (41 × 79 cm) prints for 10 guineas (£10.50) each, an enormous sum, about 3 month's average wage. Reduced size copies were twelve shillings and sixpence (62p).

Other high-art photographers such as the young Henry Peach Robinson (page 33) also used combination techniques, but mostly they stage-managed the complete picture in front of the camera. Settings were made up using whatever bits and pieces could be found around the house. Often results were ludicrous. Even Julia Margaret Cameron indulged in such flights of fancy (Fig. 7.4) and the results were much more

appreciated by fellow-photographers than her 'blurred' portraits (page 44).

The imaginary literary themes these photographers chose were extremely difficult to portray with something as realistic as photography. (Even today it is difficult to illustrate a magazine story or novel with photographs.) Bear in mind too that examples of high art work shown in this book were generally regarded as good. The bad ones were sickening.

Among artists, photographers began to be sniggered at as visual morons – upstarts who merely knew how to use a mechanical device. Among photographers, high art photography during the 1870s and 1880s was a cosy and enclosed world. Henry Peach Robinson wrote books laying down what was or was not permissible. Apart from better technical

skill it really all repeated photographic work done back in the late 1850s, which was itself a copy of academic painting 10 years earlier.

Emerson and 'naturalism'

As one writer described it, 'it was like a bombshell dropped at a tea-party'. The tea-party was the restricted world of Robinson and his followers. The bombshell was an 1889 book *Naturalistic Photography for Students of Art* by Dr Peter Henry Emerson, a physician turned photographer working in East Anglia. Emerson argued that photographers were foolish to imitate the themes and methods of academic painting. It was wrong to use the camera as a convenient machine to construct pictures. Photography was a much more

Fig. 7.5 'In the Haysel' by P. H. Emerson is an example of his naturalistic photography, unmanipulated pictures of real life subjects. The idea that this too could be art was revolutionary.

independent art form – fully the equal of other fine arts.

He urged photographers to study the appearance of nature rather than paintings. Look at the beauty of the image of natural scenes given by the lens on the camera's ground glass focusing screen – and the moods and emotions it arouses. Use essentially photographic effects such as focus and lighting rather than false techniques of combination printing to give pictorial qualities.

Photography should also be true to human vision. With his science background Emerson pointed out that the eye concentrates on one part of a scene at a time. Vision is indistinct towards the edges of the viewed scene and is most detailed near the centre. 'Overall' sharpness (considered important in high art) is therefore unnatural. By making some objects less sharp than others and having soft focus effects at the corners and edges of photographs the result was more natural, closer to truth.

Emerson added the advice that every photography student should 'try to produce one picture of his own ... which shall show the author has something to say and knows how to say it, as perhaps no other living person could say it; that is something to have accomplished'.

Emerson was not just a forceful writer and lecturer, he was a brilliant photographer of the natural landscape. Already, in 1886, he had published a picture album *Life and Landscapes on the Norfolk Broads* containing 40 actual prints (Emerson contact printed his large negatives on platinum paper which gave an extremely

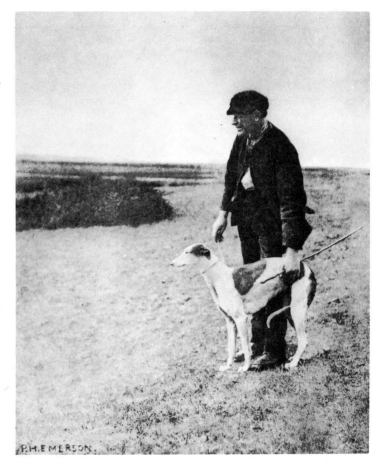

Fig. 7.6 Another Emerson photograph 'The Poacher – A Hare in View' uses a simple true-to-nature situation rather than the elaborate themes of academic painting.

permanent image in a soft silver grey colour). Altogether he published eight collections – either with pasted-in platinum prints or reproductions in ink from photogravure-etched metal plates. Just a few hundred copies were printed off each.

Emerson's unretouched interpretation of 'real' scenes – helped now by the faster and more convenient dry plates – had an immense influence on young photographers frustrated by 'accepted' photography. Comparing Figs. 7.6 and 7.4 shows how revolutionary his

ideas on pictorial photography were.

Robinson and his followers of course attacked the new trend. Emerson, they argued, has a total lack of imagination and 'healthy human eyes never saw any part of a scene out of focus'. Photography can never be truly naturalistic. After all a negative exposed for land detail gives an overexposed, featureless sky. But one negative exposed for sky and another for land detail which are then combination printed give results much truer to original

105

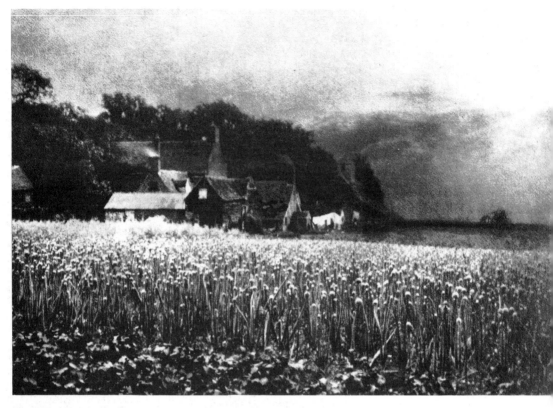

Fig. 7.7 'The Onion Field' by George Davison, 1890. A soft focus photograph influenced by impressionist painting. The Photographic Society's rejection of this and similar work helped create The Linked Ring.

appearance.

Strangely enough, at the height of his influence, Emerson renounced his naturalistic photography ideal. This was partly due to the newly published research of Hurter and Driffield (page 54) which Emerson saw as proving that photography gave a fixed range of tones over which the user had quite limited control. In 1891, in a dramatic pamphlet titled *Death of Naturalistic Photography* he took back all he had said about photography being an art form. But by then it was too late. The idea of a more direct form of aesthetic photography had broken in on the rules and pretensions of high art.

'The Linked Ring' and fellow travellers

Every pictorial photographer saw the hanging of his work in an exhibition as a great goal. Exhibiting was taken very seriously. Britain in the 1880s was the world centre for pictorial photography, based on the Photographic Society of London (soon to become the *Royal* Photographic Society). But in 1891 a serious debate arose between members, due largely to the society's hanging of scientific and 'trade' (professional) photography together with pictures of artistic intent. There was also disagreement over prints showing soft focus and diffusion to

which the older traditionalists objected.

Eventually in 1892, a group of younger pictorial photographers left to found their own breakaway movement. (This was a great time of upheaval in art, with small groups or 'brotherhoods' splitting from many establishments.) They called themselves *The Linked Ring*, a name which relates to the way they organized themselves, with membership by invitation only, and no President or exhibition hanging committee – the group being organized in turn by each 'link' for one month only. Early members included George Davison (Fig. 7.7), Frank Sutcliffe, editor of *Amateur Photo-*

grapher, A. Horsley-Hinton, Frederick Evans (page 108) and most followers of naturalistic photography except the self-renounced Emerson. The next year they ran their first annual pictorial exhibition, calling it The Photo Salon of The Linked Ring.

Much the same thing was happening in Europe. During the early 1890s exhibitions limited to pictorial photography were held with great success by the Vienna Camera Club, the Photo-club of Paris, and clubs in Hamburg and Turin. The sort of work you would find hung in these 'salons' did not differ greatly country to country. Many photographers had elaborated Emerson's theory of limited sharpness in vision into overall soft focus effects. Spreading the highlights of a picture by diffusion (Fig. 7.7) also gave it an effect resembling the style of a relatively new movement in art known as impressionism (page 113).

New variations of photographic printing processes were devised which gave an image in gum (gum bichromate). By daubing this with pigment you could build up a picture by hand with complete control over tone values – defying the grey tone relationships which Hurter and Driffield proved existed in ordinary papers. Various other techniques were used to make photographs take on the qualities of painting. People exposed their plates to close-ups of canvas textures before then exposing them to the subject; they printed on rough drawing paper coated with emulsion. Images were toned to resemble drawings in coloured chalk or crayon.

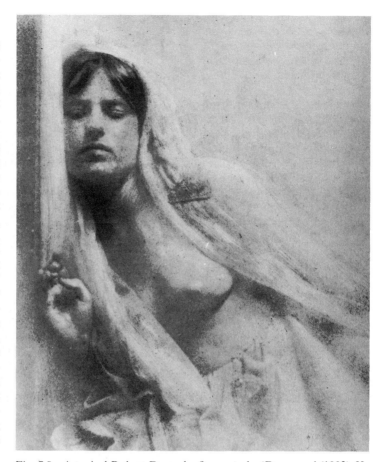

Fig. 7.8 A typical Robert Demachy figure study, 'Dormeuse' (1902). He printed negatives by gum-bichromate, which allowed great manipulation, disguising the normal photographic image and even adding brush marks.

This movement was not a return to high art – the subjects in front of the camera were now mostly genuine and natural. Contrivance was directed to making the *process* look as little like a photograph and as much like a painting as possible. Perhaps this was also reaction against the army of snap-shooters newly at work with their Kodak cameras. It became important to be something different, more serious, of more advanced status and conscious of painting aesthetics.

Not that all the new pictorial photographers worked in the same way. Some were noticeably 'straighter' in their methods. This is shown, for example, by the difference between the work of Robert Demachy and Frederick Evans (Figs. 7.8 and 7.9), two pictorialists at opposite extremes of manipulated and straight approaches.

Robert Demachy He was a banker, amateur painter and photographer, and was a leading member of the Photo-club de Paris. Almost all the pictures Demachy exhibited used some form of manipulated process to

eliminate the 'uninteresting and unnecessary'. Most were figure studies, printed by a gum or oil process (page 153) which largely destroyed their 'photographic' appearance.

Demachy wrote persuasively explaining why he worked this way. A work of art must be a transcript, not a copy of nature, he argued. The beauty of nature does not itself make a work of art – this is given only by the artist's way of expressing himself. Slavish copying of nature, whether by brush, pen, or camera, can never be called art.

Demachy's followers and some art critics of the time described his pictures as having poetic charms 'which are appreciated by the cultivated'. His portraits, they said, are artistic ideals of personages. His print brushwork fuses art and nature. Demachy had no time for fellow pictorial photographers who worked 'straight'. He pointed out that in all the best paintings you can see that the artist intervened between commonplace reality and the final work. Did Turner's sunsets exist just as he painted them? Were Rembrandt's scenes just as they would have appeared to the eye? A straight photograph cannot possibly be a work of art even when taken by an artist, for it may be repeated exactly by someone else who is no artist simply by setting up a camera immediately in the same spot. Straight prints may suit documentary photographers who have special factual interests in the subject, but the whole idea of the pictorial photography movement was surely to break away from *recording*?

Demachy was defensive about the new rollfilm camera

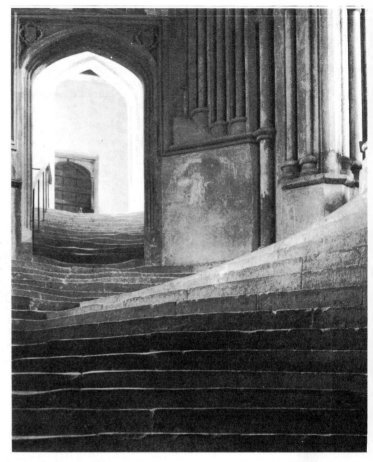

Fig. 7.9 Frederick Evans' photograph 'Sea of Steps', 1903. Evans took enormous care in choice of lighting and viewpoint, but unlike Demachy believed in 'straight' technique.

owners, commenting . . . 'The button pressers will continue to extol the purity of their intentions and make virtue of their incapacity to correct and modify their mechanical copies'. All this · may seem ridiculous today, but at the turn of the century it was terribly important to produce photographs which would publicly rate as works of art.

Frederick Evans Although he became a member of The Linked Ring a few years after it began, Frederick Evans believed in a 'straighter' approach to pictorial photography. Evans was a London bookseller and amateur photographer, turned professional. His subjects mostly ranged from portraits to architectural studies for *Country Life* magazine. Fig. 7.9 is typical of the type of photograph for which he was best known at salon exhibitions. It is called *Sea of Steps* and shows the Chapter House steps at Wells Cathedral. The fact that the subject is a particular thirteenth century staircase is less important than the way

Evans communicated his feeling for wave after wave of worn steps.

Evans believed that *seeing* was the most important single aspect in photography. Picture making was best carried out on the focusing screen or viewfinder of the camera, using factors such as choice of viewpoint and the direction of light at a particular time of day, or the softness or hardness of shadows given by different weather conditions. Having spent hours walking about a cathedral deciding the area he would portray, Evans would return at different times to see the changing effects of light and shade. All this was done before his large 8 × 10 in (20 × 25 cm) plate camera was even unpacked.

Frederick Evans believed in 'plain, simple, straightforward photography' although taking great care technically to ensure his negative reproduced all the delicate tone values he saw as important in the subject. Printing was equally straightforward – prints were made by contact onto platinum paper, using the whole picture area and with absolutely no handworking of the image.

Evans' idea of making the creative decisions behind the camera, instead of in the darkroom 'like the gummists' was directly opposed to Demachy. He argued that it would indeed be possible for two photographers to occupy in turn the same spot with the same size camera . . . but only one might produce a picture perfect in proportions, atmosphere and sense of space. The other would fail owing to wrong choice of lens, camera height, moment in time etc, but above all by not responding to the delicacies of what he saw. Too many photographers tried to fake this sort of result into a work of art by disguising its photographic qualities later . . .

Stieglitz and Photo-Secession

In 1887 Peter Henry Emerson was the judge for a competition run by *Amateur Photographer* magazine. He awarded first prize for a naturalistic study of street urchins sent in by Alfred Stieglitz, an American student at Berlin Polytechnic. Stieglitz was in Germany to study engineering but had become increasingly interested in photography. He attended classes in photochemistry by Dr Vogel (page 54) and made his own study of the work of artists. The photographs Stieglitz took were pictorial but straight and unmanipulated, although he

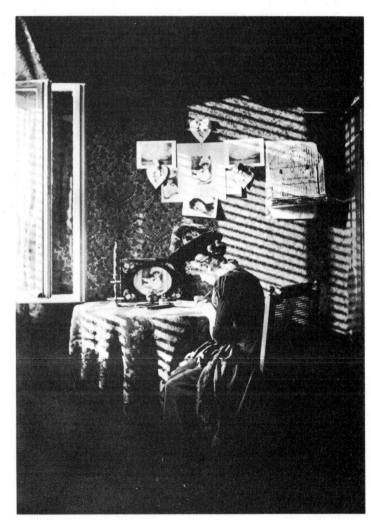

Fig. 7.10 Sunlight and Shadows, Paula, Berlin 1889. Alfred Stieglitz's photograph of a friend taken when he was a student. Other Stieglitz prints appear here on the wall.

109

was less obsessed by the importance of this than Emerson. Mostly they featured ordinary daily life (Fig. 7.10). Many were hung at the 1891 Vienna Salon and were greatly admired.

It was therefore a shock when Stieglitz returned home to New York to find that the American photographers there were still struggling with a high art approach – years behind Britain and the Continent. For a time he worked as a partner in the new business of photoengraving, making printing plates of photographs. He continued taking pictures mostly with a hand-held plate camera in and around the New York streets. But unlike Riis and Hine, Stieglitz saw the city as a source of beauty and form, even in the most commonplace daily scenes. He was particularly interested in the visual effects of weather conditions, sometimes waiting hours for the right juxtaposition of people and objects (page 78).

The idea of a pictorialist using a hand camera was unusual, but Stieglitz also dared to crop his images, often printing only the part of the negative which gave best composition. Some of his photographs at this time had the softness of detail and delicate use of tone similar to impressionist paintings he had admired in Europe.

By 1894 Stieglitz's work had won him election as one of the first American members of The Linked Ring.

The following year he retired from the engraving business on a small private income, determined to encourage creative photography in America. Appointed editor of *American Amateur Photography* Stieglitz wrote knowledgeably on both

creative and technical matters (thanks to his studies under Vogel) as well as setting high standards for the pictorial photography he chose to print. In fact this was his undoing, for he insulted readers in turning down their work and had to leave.

Soon he was editing a house magazine, *Camera Notes*, for The New York Camera Club, of which he was vice-president. They really needed a cosy journal announcing meetings and showing members' work, whereas Stieglitz was determined it should crusade for modern pictorialism. He discovered and reproduced work by unknown young American photographers such as Clarence White, Edward Steichen and Gertrude Käsebier. The magazine began to attract the notice of leading pictorialists in other countries, but club members complained he failed to devote enough space to their own photographs. Squeezed out for being too ambitious, in 1902 Stieglitz was offered the chance of exhibiting his own work and the work of his dis-

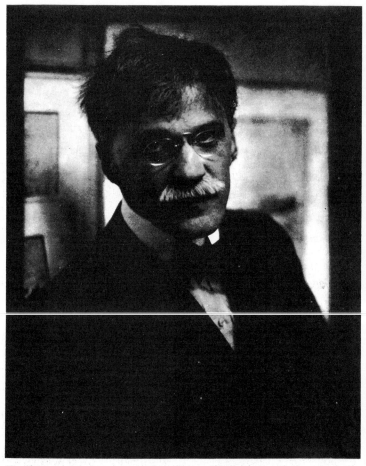

Fig. 7.11 A low key portrait from Edward Steichen's early, manipulative period when he used the gum print process, 1915. The subject is his friend and fellow photographer Alfred Stieglitz.

coveries at the prestigious National Arts Club. On the spur of the moment he called this show the work of the 'Photo-Secessionists' (secession in art means breaking away from accepted ideas).

At first Stieglitz was the only photosecessionist, but he quickly organized the other exhibitors as founder members. The group's aims were 'to hold together those Americans devoted to pictorial photography and exhibit the best that has been accomplished by its members'. Many of their ideas for advancing photography were similar to The Linked Ring—one closely knit group, membership by invitation only, and emphasis on exhibitions. However they had a much broader acceptance of style—from straight photography to the diffused manipulated gum print processes used at the time by Alvin Langdon Coburn (Fig. 7.12) and Edward Steichen.

In Stieglitz they also had a very dictatorial leader. He would only permit photo-secessionists to show their work as a group and then only on the understanding that all work (approved by him) was hung without submission to any exhibition selection committee. Despite this arrogant attitude, Stieglitz's brilliance in maintaining high standards across a wide range of pictorial styles paid off. Group work hung at most of the major European exhibitions proved what a distinctive medium of individual expression photography could be.

As from 1903 Stieglitz financed, published and edited the secessionist's own quarterly magazine called *Camera Work*, to show contemporary pictorial photography. It contained work from all over the world, written criticisms, exhibition reviews, and articles on trends in art and photography. The gravure printed illustrations, on the finest paper, were of outstanding quality (Stieglitz's photoengraving experience no doubt helped). By 1905 Stieglitz had also opened a small gallery at 291 Fifth Avenue to show and sell photographs, and later modern drawings and paintings.

Both gallery and magazine helped to introduce the work of British and European photographers to America. Within the first year this ranged from retrospective photographs by Hill and Adamson, to the current work of Frederick Evans. Once again Stieglitz insisted on selecting exactly which prints he would hang, however distinguished the photographer. He also showed his own work which included portraits of fellow artists and photographers as well as his city scenes—sombre, atmospheric, full of rich tone values. In many ways one man's efforts as

Fig. 7.12 'St Pauls from Ludgate Circus' 1908, an atmospheric gum print by A. L. Coburn, most versatile member of Photo-Secession.

critic, writer, art dealer and photographer had shifted the centre of new ideas in pictorial photography from Britain to America.

Edward Steichen Born in Europe but brought up in the USA, Edward Steichen was an apprentice lithographic artist and amateur photographer. Some work he submitted to an exhibition judged by Alfred Stieglitz led to photographs published in *Camera Notes*. After a period studying in Paris, mostly with the idea of becoming a painter, Steichen's soft-focus low-key portraits and landscapes were included in the first 1902 Photo-Secessionist show of which he was a founder member.

Having designed and helped set up the 291 gallery for Stieglitz, he returned to live in Europe. Here he both painted and photographed, including portraits in colour using Lumière's new Autochrome plates. From Paris he arranged for drawings and paintings by then unknown artists like Rodin, Matisse, Cézanne and Picasso to be sent for hanging at 291.

Later, after 1914–18 war experience as a US photo-reconnaissance officer, Steichen gave up painting and totally changed his earlier manipulated style of photography. He taught himself to use images with crisp hard edge detail and full tone range. By the 1920s he had become chief fashion and portrait photographer for *Vogue* and *Vanity Fair* magazines. Steichen was to end his career as curator of photography at The Museum of Modern Art, New York during the late 1940s and 1950s (page 140).

Winds of change

Meanwhile, in the period just before World War I time was running out for what had been the new movements in pictorial photography. By 1909 The Linked Ring had become 'the establishment' stifling rather than encouraging new ideas; lack of leadership now produced argument and in-fighting between the 'links'. Within the Photo-Secession many members had turned professional and drifted away by about 1911–1912. The group's sense of purpose seemed to be lost.

The '291' Gallery and *Camera Work* now featured modern drawing and painting more often than photographs. Stieglitz was running short of money. The last two issues were devoted to the strikingly direct straight approach of a young American photographer Paul Strand, but already subscribers had dropped to less than 40. Both the publication and gallery closed in 1917.

In the general state of change which followed World War I Stieglitz rather dropped out of sight. His own photography was changing and he was exploring a more personal form of image, expressing feelings about life through symbolic pictures of trees, clouds etc. which he called 'equivalents'. By 1921 this and other new work – showing beauty of form in commonplace objects by straight photography – filled a highly successful one-man show.

Stieglitz went on to open the 'Intimate Gallery' in 1925 and its successor, 'An American Place,' which he ran until he died in 1946. Always these were meeting places for creative people working in photography or paint. He remained dedicated to the new and the emerging, always opposed to institutions which had a repetitive deadening influence. Thanks to pioneers like Stieglitz, public recognition of photography as an aesthetic medium separate and different from painting began to develop. In fact, American art galleries began buying photographs on the same basis as other forms of art as early as 1910. It took about 40 years for British galleries to follow suit.

Long after the 1910s the forms of pictorialism promoted by The Linked Ring and by the Photo-Secessionists lived on in hundreds of amateur photographic societies. Even today it can be seen in work by traditionalists hung at exhibitions such as the Royal Photographic Society annual show. Meanwhile young imaginative photographers of the 1920s and 1930s had moved on to a more modern realistic approach, described in Chapter 8.

Influences of painting on photography

It is difficult to prove the two-way influences between painting and photography. However, the period of the formation of The Linked Ring and Photo-Secession also related to revolutions in other areas of the art world. In France back in 1874 painters Monet, Renoir, Pissaro, Cézanne, Degas and others formed themselves into a secessionist group. They exhibited their work in Nadar's recently vacated Paris studio. (Like Stieglitz, Nadar believed in encouraging young artists.

He doubtless helped in the enterprise.) One work shown, *Impression: Sunrise* provided a name for the new group, who were thereafter known as the *Impressionists*.

The movement was against established painting of the time and aimed to achieve greatest possible naturalism by trying to render the play of light on object surfaces, and exact control of tone and colour. Most impressionist paintings have an atmosphere of light, and objects lack a firm outline. Many were painted out of doors where fleeting changes in natural conditions could be observed. All the impressionist exhibitions held in France between 1876 and 1886 (when the group disbanded to work separately) were received with hostility. The first exhibition of impressionistic work to appear in London did not take place until 1889, three years before the formation of The Linked Ring. At the same time Photo-Secessionists admitted that they were influenced by the styles of painters of their day like Corot or Whistler.

Most painters preferred not to admit to the use of photographs, although they often took or commissioned them for reference. Nor could they afford not to notice the new kinds of images adventurous photographers were producing. Look at the way Monet painted moving figures in city streets, or the shimmering leaves of trees, as discussed on page 59. Equally the slight spread of light or 'halation' around bright highlights given by unbacked photographic plates was as interesting to painters as it was annoying to photographers.

The general growth of black and white photography as an art form must have encouraged impressionist painters to emphasize use of colour. In fact the general movement among painters towards more personal expression and less realism was probably influenced by the need to distance themselves from photography.

The insular British One odd feature of the pictorial movement is that, whereas Britain in the 1890s provided probably the most important breakaway photographic movement of its day (The Linked Ring), twenty years later there was little further development – in fact British photography had lost the initiative to America (and later Europe, Chapter 8).

Much of this was due to the importance in Britain of tradition, of avoiding novelty. New ideas were considered threats. One upper-crust Edwardian critic (with an eye on the American scene) called this 'the artistic restraint of the older races'. Typical members of British photographic clubs or societies were conservative and middle class. Some felt it was a virtue to be unfamiliar with new art movements in other countries, insisting that beauty should be sought by the pictorialist using the principles of composition set down long ago by traditional painting.

Developments which included breaking the *rules* of composition were judged 'disturbing'. Some photographers working in Britain just before World War II, such as A. L. Coburn (Chapter 8), still managed to be adventurous – but in general the pressures were strongly against individuals stepping out of line.

Summary – Pictorial photography

– Pictorial photography, a wide-ranging term, generally means photographs in which picture qualities are considered of greater importance than subject information and significance.

– At first pictorial photography was a breakaway from the limitations of 'high art' (self-conscious artistic studies), like the work of Lake Price, Rejlander, Robinson, and even Cameron.

– Dr Emerson's photography and 1889 book on 'naturalism' urged photographers to observe the lens image of actual scenes, not to construct photographs which ape painting. He stated that the photographer should be true to human vision and use photography to express his own impressions of natural subjects. Although Emerson later renounced his ideas on photography as an art form, he greatly encouraged the growth of pictorialism.

– New naturalistic photography began to appear in European exhibitions during the 1890s. In London The Linked Ring formed a breakaway movement (1892) from the Royal Photographic Society and founded an annual Photographic Salon exhibition.

– Often gum or oil processes of photographic printing were used to help make results look like painted or crayonned art. Demachy was expert in this area; other pictorialists such as Frederick Evans believed in 'straight' technique with the accent on *seeing* in the first place.

– In New York Alfred Stieglitz, an outstanding straight pictorialist in his own right, wrote about, judged, published and generally encouraged American pictorial photography. Forming a group of Photo-Secessionists (Steichen, White, Kasebier and others) in 1902, he also published a magazine *Camera Work* 1903–1917 and opened a secessionist gallery ('291') for selected work by photographers and painters.

– Stieglitz showed a wide range of photographers' styles – from 'straight' work by Frederick Evans to Coburn's gum prints. He is also important for the way he introduced modern art painting into the US, long before it was considered respectable.

– Edward Steichen, a young Stieglitz discovery and gum print pictorialist, helped to set up the 291 gallery. From Paris – then world centre of modern art – he sent back work by impressionists and young, unknown European painters for Stieglitz to exhibit and publish. Later Steichen gave up manipulated pictorial photography to become famous as a professional portrait and fashion photographer.

– World War I brought to an end most of the breakaway movements begun 20 years before. Stieglitz continued developing his own unmanipulated work and ran other galleries promoting pictorial photography, remaining always anti-institutional. Pictorial photography lingered on in amateur clubs and societies.

– Pictorialists were influenced by nineteenth century breakaway movements in painting such as Impressionism, as well as individual artists (Whistler for example) who considered aesthetic approach more important than subject. Equally painters borrowed from and reacted against the new images photographers were now producing.

– British pictorial photography was least influenced by changes during 1900–1914, probably due to the value placed on tradition, and general distrust of novelty in art.

Projects

P7.1 Working from books find examples of straight (or 'pure') pictorial photography by Frederick Evans, Frank Sutcliffe, James Craig Annan, or Alfred Stieglitz. Compare these with pictorialists of the same period who favoured a manipulated approach e.g. Alexandre Keighley, Alvin Langdon Coburn, Frank Eugene, Robert Demachy, and (pre-1918) Edward Steichen.

P7.2 Most pictorialists at the turn of the century strove to distance themselves from snapshooters. Some were influenced by the ideas of the Impressionists and chose a similar style (as far as this was possible in black-and-white). Find examples of paintings of ballet dancers during the 1870s by Edgar Degas (who admitted the influence of amateur snapshots on his compositions) and compare these with the same subject photographed by Robert Demachy 20–30 years later.

Questions

Q7.1 What were the aims and ideals of naturalistic photography and why were these considered so revolutionary in 1889?

Q7.2 *The Linked Ring* and *Photo-Secession* were both groups of practising photographers. What else did they have in common and how did they differ? Name and describe the work of *two* members from each group.

Q7.3 Discuss the differences between documentary and pictorial photography. Compare the approaches of the two groups when confronted by the same type of subject.

Q7.4 Alfred Stieglitz has been described as 'An American Legend' in the development of photography. Describe his contribution and influence between 1900 and 1914.

ANTI-PICTORIALISM MOVEMENTS

This chapter is mostly concerned with the growth of abstraction and realism in photography. In other words photographs carrying abstract shapes and patterns, and others which show a subject with great realism. Both these opposite trends were developing at the same time in an intensive period after World War I (1914–18).

Europe in particular was then in a state of economic and political upheaval. People who survived the war no longer accepted all the old conventional patterns of life – it was a time to look for new values and new ways of expression in art, literature and music. In painting the idea that art meant pictures in gold frames was

mostly finished. Revolutionary movements like Dadaism followed Cubism and led on to Surrealism (all these terms are explained shortly). There was an urge to experiment using modern materials and approaches. In photography pictorialism generally had lost its momentum, and had changed from something once new and

Figs. 8.1–2 (Above) 'The House of a Thousand Windows' 1912, from A. L. Coburn's series 'New York from its Pinnacles'. (Right) Frederick Etchell's vorticist painting 'Stilts' 1915. A cubist approach to architectural forms.

Fig. 8.3 One of A. L. Coburn's many 'Vortographs', 1917. He directed the camera to look down angled mirrors to create these cubist-style abstract photographs.

adventurous into a convention which young photographers wanted to overturn. There was a general feeling that photography back in the nineteenth century had taken some serious wrong turnings. The time had come to rediscover photography as a modern creative medium, used honestly for what it could do best and not in any way trying to masquerade as something else.

Germany in the early 1920s was the centre of most of these changes. Here the boundaries of photography were mostly being extended towards semi-abstract or abstract images, using the process to give graphic shapes and patterns for their own sake. Developments in another direction – extending straight photography – were happening mostly in America but also independently in Germany. Here great use was made of photography's qualities – superb detail and sharpness,

full range of tones, etc – in pictures which were realistic and straight.

When you look at these varied visual ideas of the 1920s and 1930s try to see them in context, and understand what the photographers were trying to do. They were to strongly influence photographic trends for the following 25 years.

Experiments in abstraction

On the face of it, you would not think that photography and newly emerging forms of modern art would have much in common. If photography is seen mostly as a documentary or even a pictorial medium, then during the first 20 years of this century abstract painting and photography appeared to be moving away from each other.

However, most of these trends were revolutionary and

intended to overthrow the treatments, materials, and subject matter of earlier painterly images. Young modern artists thrived on controversy and took a special interest in using new processes, particularly if they could be 'bent' to give unconventional results.

Modern art movements
Abstract art began well before the war. The parent movement (1906–1914) started in Paris and was labelled *cubism*, which most people remember through work by Picasso and Braque. Briefly, cubists represented things not as they appear, but as chunky geometric forms increasingly broken down and 'analysed'. Often several aspects of an object were accented at once. Side views, front views etc were grafted onto one another to convey an idea instead of any single viewpoint. Whereas impressionists

Fig. 8.4 Marcel Duchamp's 1912 futurist painting 'Nude Descending a Staircase' inspired by photography.

(page 113) had been concerned with light and surface, cubists concentrated on forms.

Cubist work was of course greeted with great hostility but became enormously influential. Soon offshoots appeared as modern art movements in other countries – they differed mostly in what was considered suitable twentieth century subject matter and the way paintings were organized.

In Britain a small group of painters led by Wyndham Lewis called themselves *vorticists*. For a short while (1912–1915) they produced entirely abstract compositions or based their works on forms like the stark modern architecture which, they felt, expressed the vitality and energy of the new century. A series of photographs from the tops of tall buildings in New York in an exhibition by Alvin Langdon Coburn greatly interested Lewis and his friends (compare Fig. 8.1 with 8.2). For a while Coburn became one of the vorticist's group. In fact he made an experimental series of 'vortographs' – probably the first abstract photographs – using three mirrors clamped together like a kaleidoscope. The camera looked through this arrangement into an area where pieces of glass, wood etc were placed (Fig. 8.3).

In Italy a group calling themselves *futurists* were particularly concerned with painting moving figures and machines as a way of expressing dynamic modern times. Subjects were broken up and reassembled as flow lines or 'lines of force'. Naturally futurists were interested in movement analysis photography by Muybridge and Marey (page 53); similarly the sort of photographs pro-duced with stroboscopic lamps and flash. Marcel Duchamp, who painted *Nude Descending a Staircase* (Fig. 8.4) explained that it was based on Marey's photographs and others of that kind.

Duchamp was later a leading member of the *Dadaist* movement, formed in Switzerland during World War I by artists bitterly rejecting the society and traditions which had brought about such senseless waste. (Even the name Dada was picked at random from a dictionary – it means rocking horse.) Dadaist works were anti-Art, anti-logic, and intended to outrage – the absolute rejection of previous values and so perhaps cleansing the past.

They believed that in a creative work both the subject and the medium must be transformed. Ordinary ready-made objects, random cut-out pieces of paper etc, were exhibited as works of art, and it was thought an advantage to add all sorts of

Fig. 8.5 Photogram by dadaist Man Ray, 1921, using a gyroscope, string and a length of movie film.

oddments to pictures. For example, tickets, newspapers, sandpapers, photographs and bits of photographs were glued onto canvas, often as new ways to represent textures, forms etc. In other experiments objects were placed in random positions on photographic paper, which was then exposed to light to produce abstract shadow pictures.

This fitted in with their ideas utterly rejecting traditional art composition, materials and techniques. The extremes of Dadaism therefore helped to break down previous notions of any fixed relationship between photography and art.

Man Ray As one of the first American abstract painters, Man Ray was co-founder (with Marcel Duchamp) of the New York group of Dadaists in 1917. Naturally he came into contact with Stieglitz and the 291 gallery, although when he first took up photography this was purely to record his own paintings. Ray began experimenting seriously with the process soon after moving to Paris in 1921. He tried placing objects directly on to photographic paper and exposing it to a distant light bulb. The processed paper carried a strange shadow image like Fig. 8.5 with darks and lights reversed, and parts of objects not in exact contact giving a softer edge. The effect was like having used a spray of black paint from the same position as the lamp. (Man Ray often made paintings with an airbrush.)

Photograms—or as he preferred to call them, 'rayographs' —well suited the Dada approach to picture making. After all, they were unfamiliar abstract images produced almost at random by direct chemical means, free of all the irksome traditions of art. Dadaists must have been delighted to abuse the conventions of both photography and art. At the same time this was a return to the very early experiments of Wedgwood and Talbot, Chapter 1.

Man Ray pioneered other forms of experimental photography such as solarization— a part positive, part negative image given by fogging photographic materials to light during development. From the mid 1920s onwards he made a living mostly from creative portrait and advertising photography, while continuing his main interest, painting.

Fig. 8.6 A snow scene photographed from Berlin Radio Tower by Moholy Nagy, 1928. Pattern and viewpoint were explored as new sources of design.

Fig. 8.7 'Jealousy', 1930. Moholy Nagy montaged photographic and drawn elements, combining real and unreal to express space and create new images.

Fig. 8.8 An x-ray photograph of a sea shell reveals the pattern of its hidden internal structure.

Fig. 8.9 An object dropped into milk. Lit by electronic flash 1/100,000 sec, 1936.

Laszlo Moholy-Nagy While Ray worked on photographs in Paris, a Hungarian abstract painter Moholy-Nagy (pronounced 'Mo-holy Narge') was making similar experiments in Berlin. Moholy-Nagy was already well-known as a writer and experimenter in new art forms, and was associated with Dada artists. But his most important contribution was as a teacher at the Bauhaus ('Bowerhouse'), Germany's famous school of architecture and design.

The Bauhaus was the most adventurous and influential art school of this century. In the mid-1920s when other schools were still sketching classical plaster figures or studying William Morris designs for handmade products, the Bauhaus staff and students attempted to face the problems of machine production. They explored the visual possibilities of modern materials like plastics, chromed

steel and sheet glass, using modern industrial machinery for new forms of art and design.

Modern design was to be based on the function of products, buildings etc, plus the special qualities of the new materials. It was an attitude which is accepted today but was revolutionary at the time, and helped to put German and Italian products well ahead in appearance and functional design. In fact Germany, with its enthusiasm for industrial production, geometric forms and undecorated surfaces, really started modern industrial design. Through the work of the Bauhaus ex-students had worldwide influence, giving a functional streamlined appearance to objects from chairs and teapots to screwdrivers and electric kettles, from poster or textile design to complete metal and glass buildings.

Abstract painters such as Klee, Feininger, and Kandinsky

taught at the Bauhaus; Moholy-Nagy ran the first-year course which was concerned with exploring the widest range of materials. Their methods of teaching encouraged students to look at ordinary things around them afresh, to make their own discoveries of form and design in things often taken for granted. The effects of light on an object's shape, the effects of unusual viewpoints (Fig. 8.6) or reversal of tones, could all be explored by use of photography, photograms and movies. Photography helped to intensify seeing. Equally photomontage was a wideranging method of combining reality and fantasy, discovering ways space and scale can be deceptively presented (Fig. 8.7), and creating strange juxtapositions.

Moholy-Nagy also taught the importance of looking for sources of design in new forms of image which modern photo-

Fig. 8.10 A shadow pattern by Paul Strand, 1915. Part of an ordinary sunlit veranda, imaginatively seen and composed. Strand's image uses photography's own rich qualities 'straight'.

graphy in the 1920s now made possible. For example, photographs from aircraft, or through microscopes or telescopes, X-ray images (Fig. 8.8), pictures taken by high-speed flash or stroboscopic lamps all revealed natural structures which had not previously been visible to the eye. Moholy-Nagy preferred to ignore the exact scientific purpose of such photographs. *The New Vision* as he called it was an aesthetic of its own, leading to greater awareness of form and design.

Bauhaus ideas and examples, including Moholy-Nagy's fascination for creating effects by direct use of light (including photograms), are still interesting and relevant today. Multi-screen slide-tape shows, pop record sleeves, abstract movies, even the design of items around some homes still show some of this late 1920 influence. (At about this time too Germany was the centre of growth for photojournalism and picture magazines, Chapter 6.)

This exciting period came to a sudden end however. In 1933 the Bauhaus was closed by the Nazis, who actively discouraged artistic experiment and free expression. Paintings were confiscated and the teaching staff, like many leading magazine editors and photographers, dispersed to other countries. Their ideas and influence therefore quickly spread beyond Germany. After a short stay in Britain, Moholy-Nagy emigrated to America in 1937 to direct the New Bauhaus in Chicago, which later became Chicago Institute of Design.

Realism in America

In 1929 an important international exhibition called 'Film and Foto' opened in Stuttgart. It was a revelation. Over 1000 exhibits showed the various ways in which new kinds of photography were developing. On the one hand there were abstract photograms by Man Ray and Bauhaus photography, plus the scientific and technical photographs of 'New Vision'. On the other hand there was a

120

new 'straight' photography—intensified realism—seen in the work of a group of young American photographers. This new realism began developing in 1917 with the last issue of *Camera Work*, which featured the work of Paul Strand.

Paul Strand was the first important twentieth century photographer to turn his back on pictorial photography and to create aesthetically pleasing pictures which were 'straight', ie. showing the subject realistically and not by manipulating the photographic process. About 1907 he learnt photography at his New York high school from his biology teacher, Lewis Hine (page 86). Strand flirted with the usual soft-focus scenes of pictorialism, then became interested in what was being shown and discussed at Stieglitz's 291 gallery. Here he was also introduced to the work of modern European cubist painters.

Paul Strand increasingly turned towards a direct form of photography. He concentrated on seeing and recognizing natural patterns (Fig. 8.10) and forms in everyday subjects. These however were never totally abstracted. Maximum use was always made of photography's own special qualities of detail, strong tone values, etc.

Strand's pictures therefore contain a combination of the documentary (Hine) and the aesthetic (Stieglitz). Other influences seem to include Emerson's original ideas on naturalism, some of the geometry of cubist painting, even Frederick Evans' careful use of qualities of light on form. Strand was encouraged by Stieglitz who recognized the importance and originality of this new realism

Fig. 8.11 'The White Fence', 1916. Strand's choice of viewpoint and lighting gives a strange perspectiveless effect, and strong design. Older pictorialists called his new realism 'brutal'.

approach (although it was considered too 'brutal' by many older pictorialists).

In 1916 when Strand was in his mid-twenties, his work was shown at the 291 gallery and published. Pictures like 'The White Fence' (Fig. 8.11), created special interest because of its stark tones, simple shapes and semi-abstract flattened forms. This was not someone slavishly following the 'isms' of art, but a photographer of everyday objects who had a fresh original approach.

Strand's later work became less abstract and graphic, but more documentary. This included modern portraits, particularly photographs showing the role of the working man. For twenty years he made his living as a news and documentary cinematographer, returning to still photography again after World War II.

During the period around 1920 Paul Strand often wrote

about his ideas on what photography should be. They express well the views of straight photography enthusiasts. Gum prints and diffused images may once have been valid as experiments, wrote Strand, but they destroy the qualities of the subject. Mostly this approach seemed to be used by people with a frustrated desire to paint. Photography is not a short cut either to painting, or being an artist, or anything else, for Strand maintained it is just another set of equipment and materials with their own strengths and limitations. He stressed that talent or lack of talent stemmed from *the photographer*, not from photography itself—and because many workers failed to really understand their medium the public did not take it or them seriously.

To use photography honestly two things were essential in Strand's view: firstly, respect and understanding for the ma-

terials; and secondly, feelings for and recognition of the subject qualities in front of the photographer. The visual forms of objects, their textures, relevant colour values, relationships of lines etc are like instruments of the orchestra. The photographer must learn to control and harmonize these elements, then by mastery of technique express them strongly, making fullest use of photography's qualities.

Strand stated that beginners should discover just what the machinery and materials of photography can do first. Having checked out what they will record, he should then find out how this affects what can be expressed through his prints. Even more importantly he should learn to observe the world immediately around him with a kind of extra sensitive vision. If the photographer is alive it will mean something to him . . . and he will want to photograph and intensify that meaning. 'If the photographer lets other people's vision get between the world and his own, he will achieve that extremely common and worthless thing, a pictorial photograph'.

This new American movement towards realism or 'new objectivity' had begun on the East coast of the United States. But 2500 miles to the West, in California, it was to influence a whole group of talented photographers, beginning with the work of one man.

Edward Weston In 1915 Edward Weston was running his own commercial portrait studio in California. He also contributed soft-focus type pictorial work to photographic exhibitions and salons, and was even an overseas member of The Linked Ring. But this was the year of the San Fransisco Fair which brought modern art, music, and literature to the people of the area. Weston was stimulated by the new

Fig. 8.12 Edward Weston could photograph an ordinary cabbage leaf and without manipulation, make a dramatic image of its flowing lines, 1931.

Fig. 8.13 'Nude, 1934'. Weston's nude is de-personalized. In the photograph, the human body is seen and lit as a still-life arrangement of forms.

abstract forms of art, and for this and other reasons decided to break with his former life style and concentrate on his own experimental photography. He continued earning money from various short-run portrait studios but lived a Bohemian life, devoting most time to making and exhibiting photographs to satisfy himself.

In the early 1920s he met Stieglitz and Paul Strand in New York. Like Strand, Weston's approach was developing towards straight photography of natural and man-made forms. At first this work included both realism and abstraction. However, during a period in New Mexico (1923–1926) where he was influenced by artist friends, Weston decided to concentrate on realism.

Subjects which he found interesting ranged from the rolling sand-dunes of desert landscapes to nudes, close-ups of vegetables, weathered materials, and industrial objects. In all these the rhythms and forms are expressed with a superb technique which helps the illusion of subject texture and substance. Weston could do so much with so little–for example, the play of light on a simple cabbage leaf (Fig. 8.12).

Technical quality was always of great importance to Weston. Like Strand he used an 8 × 10 in (20 × 25 cm) plate camera, contact printing the whole of each negative. He used the smallest possible lens aperture to render all parts of the subject, near and far, with sharpest possible detail.

Weston argued that every method of making images has its own characteristics. He felt that the three most important features of photography are its ability to record even more detail than the eye can take in; its ability to record quickly and so capture the scene when lighting conditions etc showed the subject to best advantage; and the way subject surfaces can be rendered via superb gradation of tones between black and white, given a good negative skilfully printed. For all this, the photographer's *seeing* creates his picture, while exposure records it, and developing and printing execute the final result.

Weston's reputation became international at the 1929 Stuttgart Exhibition. You can imagine the American's 'intensified realism' alongside the abstract design studies of Man Ray and Moholy-Nagy–and the way both new approaches must have surprised other photographers.

Three years later, in 1932, a group of like-minded young photographers (including Imogen Cunningham, Willard Van Dyke and Ansel Adams), together with Edward Weston, formed *Group f64*. The name was taken from the smallest aperture setting given by most lenses and giving greatest depth of field. This loosely formed group consisted mostly of professionals; it was dedicated to 'straight photographic thought and production'. To help publicize this attitude the group ran a combined exhibition in San Fransisco in 1932. Group *f64* soon disbanded (Weston withdrew within a year, preferring to work alone) but its name became a symbol which captured the imagination of anti-pictorial photographers.

In 1937 Edward Weston was the first photographer to receive a Guggenheim Fellowship Award. This he used to spend a year travelling 35,000 miles throughout the western United States, producing a vast

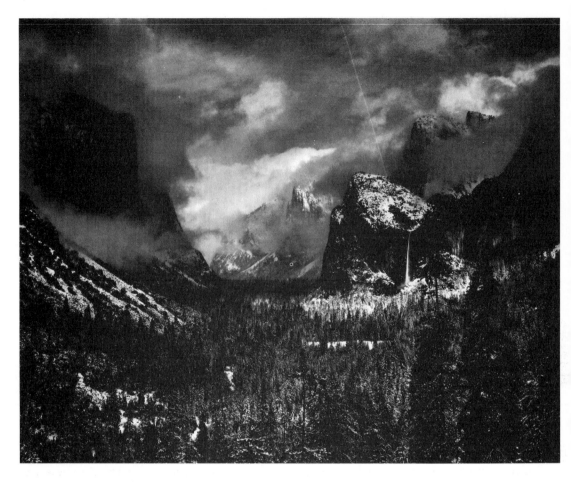

Fig. 8.14 'Clearing Winter Storm, Yosemite' by Ansel Adams, 1944.
Dramatic US landscape photography – strong in natural beauty.

range of photographs of natural forms.

Ansel Adams He was one of the original members of Group *f*64, the only photographer to continue their concern for straight, objective images into modern times. Back in the 1920s he was a young concert pianist who enjoyed taking pictorial landscape photographs of the nearby Yosemite valley (between San Fransisco and Los Angeles). Then in 1930 Adams discovered Paul Strand's fresh approach and technical quality. He de-

cided to devote all his time to photography, concentrating on the natural beauty and grandeur of American landscape.

Fortunately Ansel Adams possessed the unusual combination of a poetic eye for a picture, and the skill and interest in technique to really control his materials. Conservationist, mountaineer, writer and teacher, most of his photographs seem to express the mysterious living forces in nature. They have also been likened to musical compositions, Fig. 8.14 for example to a

dramatic Beethoven symphony, other gentler pictures of ferns and trees as sonatas or fugues.

Adams used the scientific researches of Hurter and Driffield in a positive way rather than seeing them as restrictions like Emerson (page 106). He devised a system – 'the Zone System' – whereby the use of an exposure meter and precise control over film development and enlarging allows the photographer to predict and control the tone values on his final print. With experience the photographer can pre-visualize the eventual black and white

Fig. 8.15 Albert Renger-Patzsch's 'new objectivity' approach was concerned with highly detailed, realistic images. Pictures were to be found in close observation of nature, everyday objects, machinery etc, 1923.

print at the time of shooting.

Taking this one stage further, Adams followed Stieglitz in closely concerning himself with the way his pictures were reproduced on the printed page. Photographers take great care in making exhibition prints which properly present their visual ideas, but work reproduced in ink is at the mercy of platemaker and printer. (Compare the same photograph reproduced in two different books to see how this varies.) Knowing that most people only see his work on the printed page, Adams carefully modifies the quality of his bromide prints and checks out various stages of reproduction right through to the final book, to maintain the technical excellence so important to his pictures.

Adams had already brought out his first technical book on photography when he was given a one man show by Stieglitz at 'An American Place' (1936).

More publications were to follow—some of these portfolios on landscapes such as the National Parks, others on how-to-do-it photography. He helped to create the first department of photography at the California School of Fine Art and ran annual photographic workshops in Yosemite valley. Through all these activities—photographing, writing, teaching—Ansel Adams has had a worldwide influence promoting the objective approach to photography.

Realism in Europe

Although most people think of the development of straight photography as an American trend, there was also an independent movement towards objectivity by a few German photographers. The 1929 Stuttgart show included work by Albert Renger-Patzsch and Karl Blossfeldt, both photographers who could be said to be part of the New Objectivity (*Neue Sachlichkeit*) movement.

New Objectivity was a phrase first used in 1924 to describe the interest of contemporary painters in realism—mostly a reaction against the 'muzziness' of impressionism. To such people the actual subject was

Fig. 8.16 One of the Renger-Patzsch photographs from 'The World is Beautiful', 1928. His subject is simply German suburban housing.

125

Fig. 8.17 Plant forms, looking like man-made cast iron decoration. From Blossfeldt's famous book 'Art Forms in Nature'.

them for its sensitivity. (During the 1920s comparisons between man-made and natural forms was a great discussion topic. People were fascinated by new streamlined functional designs, which were a reaction from the ornament and decoration of the late nineteenth century.)

Pictorial photographers were hostile. In Britain the Royal Photographic Society called the Renger-Patzsch pictures 'stunts' and soulless record work. However, he maintained his photography was not copying things, but exploring and displaying them – capturing our modern surroundings in pictures which should endure, *and* without any borrowing from art.

Renger-Patzsch created several other picture books, on portraits, flower studies, and on German landscapes and towns. Unlike the Bauhaus photographers he saw no need to extend the boundaries of photography. Abstract designs for their own sake belonged to graphic art. Self-conscious manipulation was for the pictorialists. He found ample scope working within photography's limitations and using its powerful quality of realism.

A year later, in 1929, Professor Karl Blossfeldt published a book called *Art Forms in Nature* consisting of 120 big close-ups of plant forms, each photographed in diffused light against plain backgrounds (Fig. 8.17). Their likeness to works of art produced by human hands was fascinating, and added further strength to New Objectivity. Clearly there were links here with New Vision (Moholy-Nagy and his colleagues' use of photographs through microscopes, tele-

all-important and should be represented in an accurate detailed way. (Eventually this was to develop into Surrealism, page 130.) New Objectivity began with painting but soon spread to photography and movies, for the camera seemed to allow the greatest realism of all.

Albert Renger-Patzsch In 1922 Renger-Patzsch, a young photographer at an art publishing house in Hagen, Germany, began a series of photographs

of what he preferred to call 'things'. These were everyday objects – basic materials, plants, buildings, people, industrial machines. He often photographed these 'things' close-up and he chose viewpoint and lighting to intensify their appearance. (Figs. 8.15 and 8.16.) One hundred of these uncontrived objective photographs were published as a picture book *The World is Beautiful* in 1928. The book was influential amongst painters and writers and praised by

scopes etc). Equally most of the opinions Renger-Patzsch held about photography matched those of the American, Paul Strand, who he never met.

Although the New Objectivity movement in Europe always remained on a much smaller scale than the American version, it had a strong influence on German and French professional photography in the 1930s, as will be discussed shortly. It also had its critics – not only die-hard pictorialists, but fellow Germans working in the equally new area of journalistic and documentary photography. They accused Renger-Patsch and his followers of having a superficial approach, of encouraging 'seeing for the sake of seeing'. Subjects shown with such photographic clarity often had other, deeper meanings, such as the housing problem, unemployment, dehumanizing effects of industry etc, which were totally ignored. Eventually *everything* is seen as worthy, stated his critics – a beautiful mindless picture can be made from the pattern of advancing stormtroopers' boots . . .

Some influences of the new movements

Most of the trends which began in the 1920s were influential on approaches to photography and its uses in society. Germany's New Objectivity changed and broadened photography – particularly professional photography – in Britain from the mid-thirties onwards. The Americans were to have a slower but eventually stronger influence which reached other

countries mostly fifteen to twenty years later.

The best way to discuss these influences is to look at each of four main trends:

1 The objective or straight approach – affecting both advertising photography and photographs which are ends in themselves.

2 Photography as a source of design – affecting art college teaching of visual perception.

3 Documentary photography – mostly affecting the reporting

of events and situations (Chapter 6). This, as will be shown, also supplied raw material for photomontage constructions.

4 Photography as metaphor – affecting personal expression.

1 Objectivity Work by Group *f*64 and similar photographers – rich in detail, very considered and pre-visualized, and calling for large format cameras – was greatly admired and followed by photographers concerned with the richness

Fig. 8.18 Advertisements in the 1930s began using new objectivity style photography to show products in a much more direct way. This approach is still used today.

Fig. 8.19 Like a Henry Moore sculpture, this distorted nude form relates to the sea-shore, cliffs and pebbles. The photograph was taken by Bill Brandt in 1953.

reproduced photographs. Berlin at this time was an enormous attraction to creative writers, poets and painters. To these people the new realism of photography and movies in the late 1920s and early 1930s became almost an obsession. Later, as the Nazi policies encouraged immigration of talent, these influences dispersed abroad. The Riemann School of Photography moved from Berlin to London. Publishers of photography books relocated themselves in Britain or America, Andor Kraszna Krausz for example set up Focal Press in London in 1938.

2 Design The experimental approach to photography initiated by the Bauhaus had its greatest influence on art school courses (page 119). Ideas such as exploring photographic materials along with more traditional methods of making images (painting etc), the investigation of accidental effects, and design irrespective of subject – plus the New Vision of scientific and technical photographs – gradually became a

of the photographic image. The result was and still is an end in itself, a 'fine print', a kind of communion with nature for the photographer. This realism approach gained ground mostly through books by Ansel Adams and others. The quarterly US magazine *Aperture* (from 1952), published and edited by Minor White (page 131), has also been very influential.

The New Objectivity of Renger-Patzsch's photography and the visual impact it gave to unfamiliar aspects of familiar objects was an approach closely related to 'clean-cut' superior craftsmanship. The most direct application for this objective style was publicity and advertising photography – of products, tools, machinery etc. Throughout the 1930s 'German photography' became sought after by advertising agencies in Britain and most other continental countries, and helped to expand professional photography in directions other than portraits and photojournalism. See Chapter 9.

This New Objectivity style also provided material for the then (Germany, 1920) novel idea of photo-books which consisted of collections of well

Fig. 8.20 'A Weed', 1951. Harry Callahan's photograph has such extreme simplicity it looks drawn.

basic part of first-year courses. Photography as a means of developing a designer's or artist's sense of 'seeing' spread throughout Europe and Britain. From the late 1930s, when the Bauhaus was re-established in America, it was to affect the US scene too, although never with the same influence as in Europe.

The general atmosphere of experiment influenced all sorts of photographers. For a time during the 1950s for example *Bill Brandt* (page 94) produced a highly original series of photographs of the nude form in which close viewpoint and use of a wide angle lens gave extraordinary de-personalized shapes (Fig. 8.19). They were published as a photo-book *Perspectives of Nudes* 1961. You can also find distorted images in pre-war photography by Andre Kertesz.

The Bauhaus spirit can be traced most directly into recent times through the work of individuals like *Harry Callahan* (Fig. 8.20). Callahan began teaching at the Chicago Institute of Design the year Moholy-Nagy died there (1946) and three years later became Head of the Department of Photography. His work includes simple linear designs based on plants, the facades of buildings, figure studies etc – often presented as semi-abstract graphic shapes. Although Harry Callahan explores accidents too, his approach is cool, personal and like most Bauhaus photography somehow detached from the subject.

3 Documentary and montage

Germany's invention of illustrated magazines and photo-

DEUTSCHE NATURGESCHICHTE

DEUTSCHER TOTENKOPF-FALTER
(Acherontia atropos germanica) in seinen drei Entwicklungsstufen: Raupe, Puppe, Falter

METAMORPHOSE

«Metamorphose», (griechisch μορφή - Gestalt) bedeutet: 1. In der Mythologie: die Verwandlung von Menschen in Bäume, Tiere, Steine u. s. w. 2. In der Zoologie: die Entwicklung mancher Tiere über Larvenformen und Puppen, beispielsweise Raupe, Puppe, Schmetterling. 3. In der Geschichte der weimarer Republik: die geradlinige Folge EBERT — HINDENBURG — HITLER.

Fig. 8.21 Heartfield photomontage 'German Natural History' shows politicians Ebert (caterpillar) . . Hindenburg (chrysalis) . . resulting in Deathshead moth Hitler, 1934.

books spread new ways of communicating information and ideas visually. (Also at this time 35 mm precision-made German cameras and lenses were coming into use, see Chapter 5). The very existence of so many photographs in print encouraged new techniques of creative art. For example, some Berlin Dadaists had discovered the possibilities of photomontage–pictures constructed from photographs cut out of newspapers and magazines. The technique fitted in well with their obsession for machine-made art. Not only were the pictures made with a camera, but they had also been photomechanically reproduced in the press.

Moholy-Nagy used photomontage combined with drawn graphics to explore visual problems such as the suggesting of

Fig. 8.22 The actress Gladys Cooper, photographed and turned into a fantasy cut-and-paste montage by Angus McBean for popular magazine 'The Sketch', 1938.

space through changes of scale (Fig. 8.7). This was an instance of combining the visual and technical experiment of the Bauhaus with the reality of documentary photography. Max Ernst in Cologne was more concerned with the disorientating power of detailed factual photographs when combined in odd ways. Known realistic objects were brought together to create strange poetic situations outside normal experience. John Heartfield, a communist who specialized in the use of photomontage for book covers etc, was probably the first Dada artist to realize how effective this technique might

be for political attack. By cutting out documentary pictures of politicians and combining them with pictures from other newspapers, magazines, books or even specially taken photographs, he created brilliant posters and magazine covers against the Nazis. The people looked real, yet now they were shown in ridiculous poses which related to the current political situation (Fig. 8.21).

Heartfield's photomontages published in AIZ (*Arbeiter-Illustrierten Zeitung*) became increasingly vicious as the Nazi party took over the government of Germany. By 1933 he was hounded out and had to

work from Prague; in 1938, like many others, he took refuge in London. The use of montaged and retouched photographs to ridicule people continues today in magazines such as the British *Private Eye*.

Theatrical photographer Angus McBean was one of few British photographers to respond to the continental spirit of experiment during the 1930s (Cecil Beaton was another, see page 137). McBean's professional work was mostly publicity pictures documenting new London productions, but during 1938–1939 he made a brilliant series of montaged or otherwise faked portraits of show business personalities for *The Sketch* magazine (Fig. 8.22). They were all based on the new art movement developing from Dada montage and known as Surrealism.

Surreal pictures are based on thought – on subconscious mind and vision rather than reason–like a detailed dream in which familiar things are mixed up in strange ways. Look at the paintings of Salvador Dali or Rene Magritte (Fig. 8.23). Since surreal pictures usually feature highly detailed likeness of objects (straight or distorted) in unexpected relationships, it is effective to use the same approach with specially planned studio photographs. Angus McBean's technique mixed theatrical scenery, double exposures and photomontage to create light-hearted fantasies based on a performer's role in some current play.

All categories of photography sooner or later overlap and merge. The influences now being discussed are a long way from what is normally thought of as documentary photography

–in fact almost full circle back to those old constructed images of Rejlander and Robinson (see pages 102 and 103). The difference is that here photographic realism is openly used to deceive. Much of the picture's effect depends on knowing it is a photograph and therefore 'truthful', yet realizing the situation it shows is impossible. The viewer is no longer expected to regard the result as a work of art, but the expression of a point of view, dream-like fantasy or a piece of visual humour.

4 Metaphor This category of influence is again mostly American inspired and can be traced from the 1920's work by Stieglitz and by Weston. Here the subject is recognizable for what it is, but contains a kind of inner meaning and can be related to something else. For example, a fine close-up photograph of a rock formation can also be seen as signifying ageing and death. The photographer's feelings about his or her relationship with someone might be summed up in a photograph of clouds, and so on.

These 'equivalents' therefore attempt to express a special meaning or metaphor. It means that the *viewer* is expected to work at interpreting the equivalent in his own way – which may or may not be that of the photographer. Equivalents are like visual poems, and in fact may be presented in sequences with or without words.

Of course, photographs as personal as these may only be intended to signify something to the photographer alone, not communicate to other people. They can be self-indulgent and

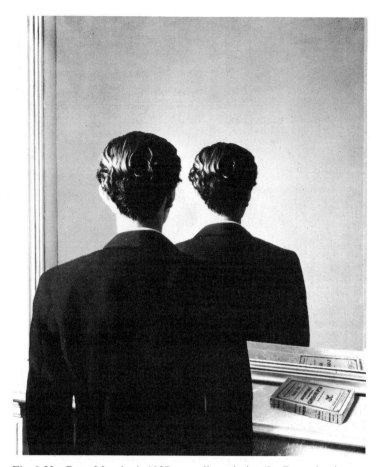

Fig. 8.23 Rene Magritte's 1937 surrealist painting 'La Reproduction Interdite'. It contains a cunning mixture of truth and fantasy, drawn with photographic detail.

inward looking. On the other hand, the photographer may be able to convey and evoke feelings about situations which cannot themselves be photographed easily – emotions such as anger, love, joy, despair, or various qualities of character. The viewer needs to be sufficiently experienced and sensitive to respond to this approach. Minor White has been described as the high priest of photographic metaphor. A teacher of photography at various American colleges, he at one time worked at the Museum of Modern Art where he met

Stieglitz, Weston, Strand and others. Like Ansel Adams he regarded mastery of technique as vital, in order to previsualize the final print when photographing. However his main interest was in the inner significance of pictures and the way the viewer responds to the photographic result. Equivalent photographs are steps in a process towards self-discovery of feelings, not end products,

Minor White produced several books of photographs – one titled *Mirrors, Messages, Manifestations* covered mostly nature and natural forms (Fig.

131

Fig. 8.24 Photography as a metaphor – images with inner meanings to the photographer, beyond the actual subject shown. A Minor White study from his book 'Mirrors, Messages, Manifestations' 1970.

8.24). He was also editor of *Aperture* publications (page 151) from 1952 until his death in 1976. As teacher, publisher and mystic, White influenced many thinking American photographers and also created numbers of followers in Europe.

You should remember that although trends discussed in this chapter were basically all movements away from the old ideas of pictorialism, the divisions made between each are not clear-cut. Bauhaus ideas on new sources of images relate through photomontage to documentary photography, and again the scientific, aerial, technical images of 'New Vision' overlap work by Albert Renger-Patzsch and other 'New Objectivity' enthusiasts. In America there are clearly similarities between the attitudes of Paul Strand and Albert Renger-Patzsch; also links between documentary work and 'straight' photography by

Weston and his followers. Farm Securities Administration photographer Dorothea Lange was for some time a member of Group *f* 64.

Divisions occurred more between countries, because exhibitions, magazines and books, and travel generally was not as international as it is today. Individual photographers too tended to be forceful characters, hell-bent on getting over a new approach. They sometimes created new categories and movements which were not quite so unique and independent as they made them out to be.

Summary – Anti-pictorialism movements

– The years before and after World War I were a period of intensive experiment and rediscovery in photography. This centred on Germany and America, it covered various

forms of 'straight' photography and photographs as a new source of design.

– In art the form-conscious cubism had replaced impressionism. The British vorticist group (including photographer Alvin Langdon Coburn) produced abstract images based on modern architectural forms. Italian futurists were concerned with dynamic movement, including use of multi-image photographs. Dadaists, the most revolutionary group, were out to reject all previous 'painterly' values. Their techniques included random photograms, prints attached to canvas, and works montaged from cut-up bits of photographs.

– Man Ray (France), painter and photographer, was a leading influence in the making of photograms, solarized prints and other experimental photographic images. All these were put to original creative use, mostly during the 1920s–30s.

– Moholy-Nagy (Germany), a multi-media artist, was influential as a teacher at the famous Bauhaus school. Students were encouraged to experiment with photography as a design tool, helping to intensify their 'seeing'. Similarly technical photographs of all kinds – The New Vision – offered new sources of design. Bauhaus principles, widely followed in other colleges, were brought to America by Moholy-Nagy in 1937.

– In contrast, Paul Strand (America) developed his own less abstract 'straight' approach. Observation and feeling for the qualities of the subject, respect and understanding for photographic ma-

terials were essential. Strand's work and writings on photographic realism during the 1920s influenced other workers.

– US west coast professional photographer Edward Weston also produced outstanding studies of natural and man-made forms. Subject qualities were revealed perceptively, and expressed with extreme realism and detail. Group $f64$ formed in 1932.

– Ansel Adams, a younger $f64$ member, continued Weston's straight approach, concentrating mostly on landscape. He devised an exposure technqiue (Zone system) to help in pre-visualizing the final black and white result at the time of photographing. Adams is a master of print quality, and has taught, written and shown his pictures since the 1930s, converting others to the possibilities of realism.

– Meanwhile Europe's equivalent to American straight photography was the New Objectivity movement (mid-1920s). Pioneered by Albert Renger-Patzsch, emphasis was on showing form and structure of everyday things – including landscape but also man-made objects ranging from buildings to machinery (reflecting Germany's industrial growth). Karl Blossfeldt's close-ups of plant forms also showed the power of objective photography.

– Four main trends in approach developing from the 1930s are (1) Objectivity – 'considered' images rich in photographic quality and visual impact which still show the subject in a realistic way. Important in commercial advertising photography. (2) Design – photography used for visual experiment and discovery, to develop an aware 'eye'. Important in art training. (3) Documentary – recording and commenting on life via press and photo-journalist work, but also used in an openly abused form to construct photomontages (Heartfield's anti-Nazi propaganda; McBean's surreal theatrical portraits). (4) Metaphor – photographs which evoke an inner meaning to the photographer. e.g. Stieglitz and Minor White's 'equivalents'. For some people this is an important means of self-expression – a new fine art.

– Broadly Germany's contribution during the 1920–1930s was to explore and widely *extend* the role of photography; in America it was developed more narrowly but in greater *depth*.

Projects

P8.1 Try making photograms. Stand flat and three-dimensional objects on bromide paper in the darkroom, then expose your arrangement to light from a hand torch i.e. a small torch dimmed down with tracing paper and fitted with a cone of black card to narrow its light beam. Hold this light at different angles, still or moving, for each photogram – imagine you are using a black paint spray. Process the paper as normal.

P8.2 Find examples of paintings which (a) use the futurist multi-image technique to suggest dynamism eg. works by Giacomo Balla, Marcel Duchamp; and (b) use actual photographs attached to or printed on canvas eg. Kurt Schwitters, Max Ernst, Robert Rauschenberg.

P8.3 Using photographs clipped from magazines, mail-order cataglogues, newspapers etc, try constructing a photomontage. Suggested themes – *The Consumer Society, Reversed Scale, Multiplication.*

P8.4 Find examples of a landscape photograph by a pictorial photographer, eg. one of The Linked Ring (Chapter 7), and another by a photographer dedicated to a 'straight' approach typified by Group $f64$. The subject itself should be as similar as possible. Now make similar comparisons with other subject choices – portraits, still lifes.

Questions

Q8.1 A fresh style of photographic image emerged shortly after the 1914–1918 War.
(a) Identify the innovators and significant features of this new imagery.
(b) Compare and contrast this later approach with the work of earlier photographers.

Q8.2 What qualities distinguish 'straight photography' from any other approach to photography? Discuss in relation to the work of two 'straight photographers'.

Q8.3 In what ways was photography used in Dadaist and immediately following movements in painting? Why did these artists embrace photography so readily?

Q8.4 Compare the aims and describe the work of the Bauhaus, and the New Objectivity movements. Which of the two has had the greater influence on current trends in photography, and for what reasons?

PHOTOGRAPHY COMES OF AGE

This chapter takes a broad look at changes in styles and approaches from the 1930s through to the early 1970s. At the beginning of this book the growth of photography was compared to that of a tree. Its roots are in science and art. Talbot's work forms the main trunk; Scott Archer and later Eastman form main technical branches. Pictorialists, realists, professionals, snapshooters, all evolve as different parts of the tree's structure. Now, more recent growth is symbolized by the many twigs and branches fanning out in the greatest number of directions.

The realism movements and the experiments in formal design which had been pioneered in the 1920s and early 1930s soon began to influence the style of photographs seen in exhibitions and published in photographic magazines. Professional photographers exploited the new realism. Better materials and equipment meant that 'action photos' became highly popular. Documentary photography revealed the hardships of worldwide depression, then followed this through into even more important and varied uses during World War II (1939–1945).

The end of the war brought great growth in professional photography. People and organizations began to realize just how powerfully photography, coupled with modern reproduction in print, could sell, publicize, educate, and entertain. Photography had now overtaken the drawn image as the most used form of visual illustration. Its influence was everywhere–from birthday

Fig. 9.1 Russian magazine photographers used the heroic realism approach of other official Soviet artists, 1935.

cards to company reports, billboard posters to wrapping paper.

During this post-war period too the public image of photography underwent a complete change, from something old-fashioned and scientific to a trendy, visually exciting occupation or hobby. It was helped by enormous improvements in the technical qualities of small format cameras and their films. New single lens reflex camera designs (Chapter 5) gave accuracy in focusing and viewfinding; new electronic circuits measured exposure inside the camera. All this gave a much higher percentage of technically accurate results. Also, Poloroid cameras gave final results on the spot – 'instant previsualization'.

The amateur in particular could concentrate more freely on the picture content of his or her photographs. Standards rose. Television's arrival helped to make everyone more experienced in reading photographic pictures. People talked of *visual literacy* and *visual communication*.

This chapter also looks at some portrait, industrial, fashion and documentary photography of the period, linking the 1920s work with the photographs which wallpaper our lives today. It should be possible also to see how the freer climate of the 1960s encouraged highly individual work by photographers – able now to sell prints direct through galleries, or published in ever-increasing numbers of photobooks.

Professional photography – 1930s and 1940s

Emigration was probably the most important single influence

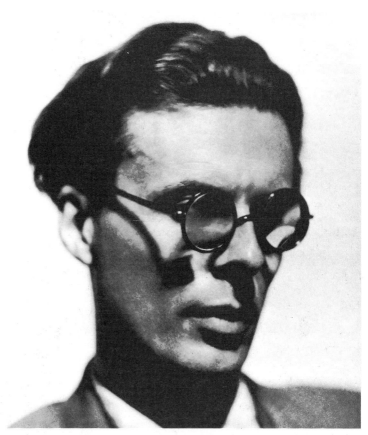

Fig. 9.2 Aldous Huxley by Howard Coster, 1934. A new severe style of realism in portraiture.

on photography during the years leading up to World War II. Thousands of intelligent creative individuals decided the best way to avoid

political regimes they disagreed with was to leave continental Europe for America or Britain. Photographers and designers such as Andre Kertesz, Robert

Fig. 9.3 Tyne Bridge by Humphrey Spender, 1937. Dramatic viewpoint and lighting.

CUIR de RUSSIE

All the spicy freshness of woods newly green . . . fragrant . . . last-

Fig. 9.4 This fashion magazine advertisement of 1932 has an 'open air' look, despite being a studio set-up.

Capa, Alexy Brodovitch reached America; Kurt Hutton, Felix Man, Walter Nurnberg and many others came to London. They brought with them new ideas and a refreshingly different culture. The most talented soon became influential editors, art directors and photographers in various fields. These people were professionals – and it was now professional photography which was to develop and use some of the new ideas pioneered in Europe.

Advertising, portraiture, fashion, photojournalism, commercial and industrial photography are all aspects of professional photography in which images have to do particular jobs. Beyond this the photographs need to look as equally up to date in style and approach as other images considered 'modern' at the time. In the late thirties straight photography of the New Objectivity movement and US west coast photographers (Weston, Adams etc) were the most modern modes. Another important public influence was cinema, then at its peak before TV arrived on the scene. The visual style of the Hollywood glamour movie therefore had to be respected too, particularly in portraiture and fashion.

Other work admired by leading professionals included documentary films, Russian movies and Russian still photographs with their strong use of close-up and 'heroic realism' approach (Fig. 9.1). The result of all this was that advertising photographs of commercial products, industrial processes and constructions often combine German-style realism (Fig 8.15) with some Hollywood style gloss. It gave a new kind of dramatized image of which Fig. 9.3 is a good example. Results were monumental powerful, and strong, but the photography nevertheless straight and much in the style of documentary films of the late 1930s.

In professional portraiture and fashion photography styles were mainly developing in two different directions.

1 Realism, in the form of simple severe portraits like Fig 9.2. They have a feeling of open air situations and natural lighting, even though usually taken in the studio. Pompous, 'artistic' style was totally rejected. Writers and artists were often shown as if at work – against a plain background or in their actual working environment. Fashion photographs began to be taken in genuine settings too (famous buildings, real motor cars, etc) or in made-up sets designed to look as outdoor as possible (Fig. 9.4).

2 Elegance and romance through use of clearly artificial 'out of this world' settings, as created for society and theatrical portraits and many magazine fashion photographs. Here glamorous 'top lighting' was frequently used to give halo effects to the hair and rimlight the shoulders (Fig. 9.5), while a diffuser over the camera lens softened fine detail, in the style of Hollywood movies. This style of work was adopted, for example, by Baron Gayne de Meyer, a fashion photographer to *Vogue* magazine in America during the 1920–30s.

Fig. 9.5 The romantic approach—back lighting and elegant setting for a wedding dress fashion illustration. By Baron de Mayer, 1920s.

Fig. 9.6 The flamboyant studio style of Cecil Beaton. This is a portrait of the writer Nancy Mitford, taken about 1932.

In Britain during the 1930s Cecil Beaton rose to fame as an outstanding and original fashion and portrait photographer, specializing in elaborate settings. Being a painter, stage and fashion designer in his own right, he was able to devise specially built studio sets for his striking portrait illustrations (Fig. 9.6). Beaton was always a great lover of the elaborate and some of his more bizarre pictures have a touch of surrealism (page 130). But like most fashion photographers of this period he comes over clearly as a 'gentleman of taste'. From 1928 until the mid 1950s he remained under contract to *Vogue* magazine working in London, New York and Paris. His work—best seen in his book *The Best of Beaton*—therefore traces great changes in fashion design as well as his own development.

Of course, there were enormous differences between the work of leading professionals working for advertising agencies and magazines, and the ordinary high street portrait photographer. The magazines were receptive to new styles (and also more demanding). When the actual sitter was paying for the photograph a much safer, more traditional approach was needed. People expected flattery and wanted their portraits retouched, so it was still routine at this time for large negatives to be taken, then worked over by hand, pencilling out all traces of creases and blemishes of the skin. The slight stippled surface appearance that this gave to the face of every sitter (Fig. 9.7) was accepted as all part of professional portraiture. Look at photographs of your own great grandparents.

Photojournalism in the years leading up to the war was discussed in Chapter 6. It was a time of lively expansion when the editors of magazines and picture weeklies welcomed and encouraged new talent. Action pictures of all kinds were now possible, thanks to faster films and new miniature camera equipment. Typical features dealt with the lives of film stars, animal stories, crafts and industries; also some social documentaries on housing and work situations etc in these years of the depression.

Sequences instead of single

Fig. 9.7 Prints from the same negative before and after retouching. Portrait studios have always preferred large negatives, as these can be handworked with pencil or dye to flatter the sitter.

illustrations helped to steer photographs away from being considered 'art objects'. As the political situation in Europe worsened photojournalistic stories had an increasingly national bias – themes such as armies in training, and the unreasonableness of other countries' politicians became common in British and German picture magazines.

Wartime role

World War II had a greater effect on the lives of ordinary civilians than any previous conflict. In Britain travel was restricted and newsprint, like petrol and food, was severely rationed. Also, cameras and photographic materials disappeared from the shops. Photography in many areas was forbidden – just carrying a camera often meant you were stopped and questioned by police. In the US there were fewer limitations, but lack of equipment from Europe and diversion of materials and manpower to war needs also slowed up the visual development of photography.

Instead photography became strictly functional. On both sides it played an important role in photoreconnaissance, giving armed forces up to date maps and military intelligence. Better lenses and films were developed for this work; experts trained in the new science of photo-interpretation – picking out what was significant from the mass of detail recorded from aircraft in this way. At government research centres special photographic equipment was hurriedly developed to assess the performance of new weapons, improve the accuracy of shellfire etc.

The Farm Security Administration (page 87) turned over to the Office of War Information. *Life* magazine ran a school of photography for army and air force personnel. Edward Steichen became commander of the US Naval Aviation photography unit, while in Britain fashion photographer Cecil Beaton and other distinguished professionals worked as documentary photographers for the Ministry of Information.

Pictures showing British civilians enduring the blitz were widely distributed to then uncommitted nations. Out near the front lines – in North Africa, Europe, the Far East – Army film/photographic unit teams covered all the important cam-

paigns. Their pictures were centrally processed, cleared for security, captioned, then distributed to news agencies for use in papers and magazines at home, and for propaganda abroad. Travelling photographic exhibitions were also made up which toured war factories and cities suffering bombing. Pictures released this way were designed to boost morale, show positive progress and success (Fig. 9.8). Horror pictures of the fallen were not acceptable; defeats and withdrawals were documented through 'we shall overcome' expressions of determination to make good. Germany produced pictures in a similar way, publishing them in the Nazi multilingual magazine *Signal* (Fig. 9.9). (The Nazis,

unlike the Allies, always printed credits naming individual cameramen for pictures.)

Seen from today's standpoint, one of photography's most important documentary functions came at the end of the war, revealing the concentration camps like Belsen and Buchenwald, and the results of atomic bombs on Hiroshima and Nagasaki . . .

Professional photography – post-war

Very gradually, after the war ended in 1945, shortages of materials, equipment and markets for photography gave way to a more normal consumer society. In America Moholy-Nagy's successors such as Harry

Callahan helped combine Bauhaus type elements of design with west coast 'straight' photography. (Looking over books of Callahan's photographs from 1945–1970 is a good way to follow this influence and the way it feeds into modern US work.) Other teachers such as Ansel Adams, Aaron Suskind and Minor White encouraged experiment in pushing outwards the boundaries of photography – expanding what it could do and what it should be.

Magazine fashion and portraiture Another teacher who had great influence on American professional photography directly after the war was Alexey Brodovitch. Alexey had been a successful stage and graphic designer in Paris before

Fig. 9.8 Allied soldiers with cheerful, determined expressions appeared frequently on British picture magazine covers during World War 2.

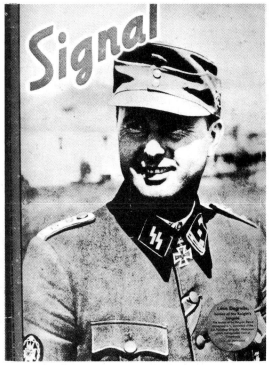

Fig. 9.9 At the same time Germany produced Signal magazine, distributed in several languages. It was full of morale-boosting pictures of their troops.

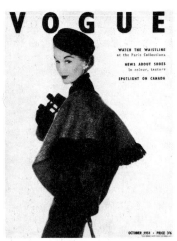

Fig. 9.10 The graphic approach of a 1951 Vogue cover by Irving Penn. Lighting and setting are simple and austere.

emigrating. In America he taught at Art School and his own New York 'design laboratory', as well as becoming an art director of *Harper's Bazaar*.

Brodovitch encouraged a new generation of fashion, portrait and advertising photographers such as Irving Penn, Richard Avedon and Arnold Newman. These people helped change the style of photography in the quality magazines from the fussy complicated work of photographers such as Baron Gayne de Meyer to something simple and austere.

Instead of elegant rooms, backgrounds were plain – often white paper. Back-lighting and harsh stagey spotlights were out. Lighting was diffused (often electronic flash reflected off white walls) to give an 'overcast daylight' effect. The approach was straight and retouching avoided. Results had immense directness. Notice (Figs. 9.10 and 9.11) how line and tone contrast is used to give strong graphic shapes.

John French, an ex-block-maker who like thousands of ex-servicemen after the war set up in photography, became the most influential British fashion photographer of the 1950s. His pictures – delicate, often high key and shadowless – were planned to reproduce well on the fashion pages of newspapers (which had previously used mostly line drawings). French therefore opened up a new market for fashion photography outside the expensive magazines, and also helped the fashion industry grow. One of the many assistants he trained was to become the famous photographer of the 1960s and 1970s, David Bailey.

As shown in Chapter 5, there was a period in the 1960s when Britain led the world in pop music, fashion design, pop and op art, and magazine layout. Photography became

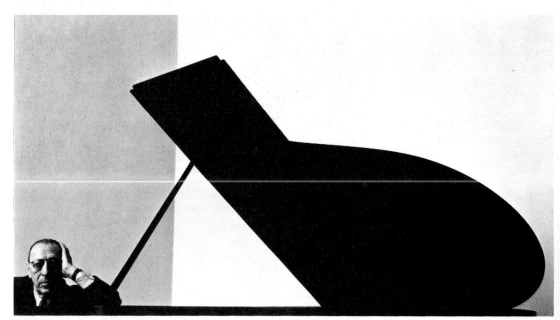

Fig. 9.11 Composer Igor Stravinsky by Arnold Newman, for Harper's Bazaar 1946. Brilliant use of the open top piano suggests a musical setting and creates a shape balancing and directing the viewer's attention to the man.

part of all these scenes. Young professional photographers were in great demand and earned incredibly high fees. The idea that fashion photography was a tasteful gentlemanly pursuit was overturned. Sexiness took over from elegance and every possible gimmick–from fisheye lenses, zooming and fogging, to solarization and colour toning–was used for effect.

Industrial and commercial photography

To return to the 1950s, industry was changing to a peacetime footing and competing again for international markets. 'Prestige' pictures of engineering projects, facilities and processes were needed. Industrialists preferred a dramatic approach rather than complete reality (after all, factories are frequently ugly and cluttered places), and British freelance photographers such as Walter Nurnberg and Maurice Broomfield became famous for this style of picture (Fig. 9.12). It combines Hollywood-style lighting with a Renger-Patzsch 'New Objectivity' feeling for the basic visual qualities of man-made objects. (Compare with Figs 9.1 and 9.3.) Nurnberg who was an advertising photographer before the war, made industrial workers look like filmstars. His pictures sold the idea of quality and care. Factories were specially lit with photographic spotlights placed to merge unwanted background detail into blackness, and the pictures were taken with a small (Rolleiflex) camera.

Large industrial firms were setting up their own photo-

Fig. 9.12 The dramatic approach to industrial photography–a 1956 cover by Walter Nurnberg.

graphic units too. Some of these achieved enormous prestige, such as the London-based Shell Photographic Unit, which sent its photographers all over the world to take record and documentary pictures for company publications.

Colour As already stated, colour films and colour reproduction in print grew more practical during the late 1940s and 1950s. Advertising shots of subjects such as clothing and food (which relies a great deal on colour) were the first to justify its high cost. But for years technical restrictions, such as avoiding strong contrasts of light and shade made it difficult for photographers to feel free enough to evolve their own approach.

141

Colour photographers also became obsessed with colour accuracy. Of course, accurate colour is vital in recording work – the colour reproduction of works of art for example revolutionized art history teaching. But in expressive photography the added element of colour just seemed to make images too realistic and difficult to handle visually. It lacked all the subtle local controls open to the painter. Perhaps this is why few photographers before the 1970s built up a strong reputation for colour work. Ernst Haas is an exception who often works by abstracting coloured reality – for example using long exposures to blur moving detail, or double images given by reflections. Haas is a member of Magnum who has worked frequently for *Life* and similar international magazines. He is best known for his use of colour in landscapes, close-ups of plants etc, like those in his picture books *The Creation*, and *In America*, see page 152. *Photojournalism* TV was a growing threat to the picture magazine, first in America then Europe. Several magazines folded in the years following the war (Chapter 6). The newspaper picture supplements which followed them concentrated on editorial colour, to compete with colour TV and to please the advertisers. From the mid-sixties onwards more picture stories were covered in colour than in black-and-white.

Of course, the loss of several magazines and newspapers gave fewer outlets for picture agencies. During the sixties some switched their activities away from news photography towards travel, personality portraits, sport and similar specialist subject pictures. These could be sold over and over again for publications such as company magazines or books which now used more illustrations than ever before.

Social influences

Over the years ordinary people have become better educated and better informed. They have a clearer grasp of social problems and greater concern for social injustices of all kinds. The uses of photography to reveal and help cure these issues can be traced through Jacob Riis, Lewis Hine, FSA photographers and many others, but has never developed more strongly than before and after World War II.

In New York in the thirties the growth of social awareness appeared in painting (realist scenes of everyday life, generally from a politically left viewpoint) and gave rise to The Photo League. The League was a society of photographers which from 1936 onwards gave photographic instruction to ordinary people and encouraged them to document the life of the city. Distrusting biased press reporting they aimed to 'put cameras into the hands of honest people'. Photojournalists such as Dorothea Lange, Robert Capa and an elderly Lewis Hine were behind the scheme. The community darkroom was directed by Sid Grossman. By the end of the war (1945) over 1500 photographers had trained through The Photo League. It filled a need at a time when schools of photography hardly existed, but had faded away by 1950.

The 1954 Museum of Modern Art exhibition *The Family of Man* created a much wider influence. It was chosen by Edward Steichen, and presented

Fig. 9.13 Vietnam police chief executes Viet Cong prisoner in the street, February 1968. When this press picture was published around the world it shocked the nations backing the Vietnamese in their war.

the peoples of the world to the people of the world, showing humanity's often common problems and aspirations. The Family of Man became the world's most attended exhibition and for the next decade travelled from country to country.

All the social protest movements of the period–ban-the-bomb, colour prejudice, anti-vietnam, women's rights–learnt to select and use effective photography for political ends. visual communication can be as influential as the written or spoken word, and avoids its language barriers. Fig. 9.13 is just one example of a press photograph which caused millions of people to question events in Vietnam in 1968.

The 1960s was the time of space exploration, with photography bringing back hitherto unimagined close views of the moon, including the first pictures of man on the surface (Fig. 9.14). These and photographs from satellites showing Earth as a 'global village' helped to give a new perspective to tribal disputes. (Ironically similar highly sophisticated equipment is used for military surveillance of one country by another.)

People began to show a renewed interest in all aspects of photography during the 1960s and 1970s, and this had some far-reaching effects. Work by important but practically unknown earlier photographers was discovered and published. Existing collections of photographs were catalogued, expanded, more carefully preserved.

Official backing for photography on a similar basis to other arts allowed far more

Fig. 9.14 First men on the Moon, July 1969. Like early Victorian travel views, photography revealed a strange new world.

exhibitions. It also meant money for grants and scholarships or for the museum purchase of work. During 1970 Britain had ten times as many public exhibitions of photography as in 1950. Photographers had become important and contemporary–they were regularly 'written' into novels, TV plays and movies. It was a far cry from the despised 'would-be artist' 100 years earlier.

Interface with art

At the war's end in the mid 1940s most artists, educationalists, and the general public still saw photography as more science than art. In the photographic clubs members were defensive and protective. Their exhibitions, divided up into subjects such as landscapes, portraits, still-lifes, spelt out what was acceptable. Prize-winners mostly worked to an accepted formula–it was a cosy enclosed world, but practically the only one which would publicly exhibit an amateur's work.

By the 1960s open exhibitions were run by groups not only interested in photography but other media too–video, drawing, print-making. Portfolios in photographic magazines and annuals broadened in scope. One man shows or work by small related groups appeared in dozens of art centres and galleries. Similarly publishers (led by Aperture in the US) brought out well reproduced portfolios of work in book form. Photographers were now given credit lines whenever

Fig. 9.15 'Jackie 1964'. This is a silkscreen print composition by Andy Warhol. It is based on stark, repetitive press photographs of Jacqueline Kennedy.

their work was reproduced in print and it was possible to build up a reputation outside the hot-house world of the clubs. As a final seal of approval people began to buy 'fine prints' just as they would 'fine art', and nineteenth century photographs began to fetch high prices at auction.

Photography had been accepted as a subject to be taught in colleges during the 1950s, but to begin with this took place mostly in *technical* colleges – better funded than art colleges and more able to afford equipment and staff. In Britain and most European countries this meant that meaningful art education was usually missing from photography programmes. The subject was at first taught by commercial photographers and students were sent out with mostly technical skills. In America photography formed a part of university courses in broad aspects of communications.

However, from the mid-1960s the science-versus-art nature of photography was better understood, and when art education schemes were updated, photographic courses

expanded into art colleges instead. Here practical photography could freely inter-relate with other visual media such as graphic design, painting and video. Photography came to be used by a much wider range of creative people.

All these changes added up. The art world was redirecting its energies from purely abstract images to expressionalism (work containing fairly recognizable forms but anti-naturalism and expressed in exaggerated style, with simple outlines and strong colours). This relates to the trendy professional magazine photography of the 1960s. Equally in Britain and America something called pop art was being exhibited – products of contemporary life used as art forms, often altered to increase their impact but still instantly recognizable. Photography played a double role here: (1) as a creative tool for image making, along with air brushing, silk-screen printing, plastic paints and so on. Also (2) as the actual subject of a drawing or painting (Fig. 9.15) photographs being the most used images in modern life, more real than reality. (After all, people now experienced more of the world secondhand through photographs than they ever managed to see directly.)

During the late 1960s most traditional guidelines of art seemed to have melted away. Academic ideas and art institutions were now less important than the individual. Gradually it was accepted that the term 'photographer' might cover any artist using light-sensitive materials – including people who cheerfully combined photographs with assemblages of actual objects, advertisements,

xerox prints, copies from TV screens, lettering and painted images on canvas. It was all a long way from the great traditions of American photojournalism – or British pictorialism.

The freedom of this period encouraged an enormous exaggerated range of approaches. Photographers concerned with individual expression ranged from the producers of art-objects to the disciples of 'Equivalents', deeply concerned with the creative process of taking the picture as much as the final result. Others, more into visual communications, saw every photograph as a social statement – to be used for purposes ranging from political agitation to the selling of products.

The number of users of photography expands well beyond the space available in a book of this size. In fact the story of photography leads into the study of the ways photographic images act as language. How are meanings placed in and read from images? Are photographic and (increasingly) TV images substitutes for first-hand experience – so that perhaps the actual subjects when seen face-to-face seem disappointing? And how does this affect our conception of what is real and unreal . . . art and non-art.

Summary – Photography comes of age

– The emigration of talent from Europe during the 1930s had a prolonged effect on professional photography in Britain and America. Another influence was movies – serious documentary and Hollywood-style entertainment films.

– In advertising, commercial and industrial photography the general pre-war trend was towards realism and drama. In portraiture and fashion for magazines, developments went in two directions – towards a natural 'actuality' straight approach, and the glamorous highly artificial settings produced by Baron Gayne de Meyer, Cecil Beaton and others.

– Most of the new style work appeared on the editorial pages of quality magazines such as *Vogue* and *Harper's Bazaar*; and in photojournalism published in picture weeklies such as *Life* and *Picture Post*.

– World War II (1939–1945) restricted amateur photography, diverted professionals of all kinds into documentary work. Photography's wartime role ranged from aerial reconnaissance and scientific and technical applications, to carefully censored press propaganda pictures produced by both sides.

– Post-war the west coast style of 'straight' photography flourished in America. It was influenced by Bauhaus ideas now based in Chicago. Teachers such as Ansel Adams, Harry Callahan and Minor White helped expand photography in directions other than photojournalism; Alexy Brodovitch encouraged a fresh generation of magazine fashion and portrait photographers. The new 'overcast daylight' look was graphic, uncomplicated, even austere. Leading names included Irving Penn, Richard Avedon and Arnold

Newman in America, John French in Britain.

– French and several of his one-time assistants, such as David Bailey, led into the exciting pop fashion/music/art 1960s, centred for a time on London. Photography and photographers became a trendy part of this scene. Expressionism was 'in', with every conceivable visual gimmick.

– Industrial photography also expanded after the war, using a dramatic approach (eg. Nurnberg) for prestige/public relations pictures. Large organizations set up their own photographic units.

– By the late 1950s colour had become general for advertising work and was increasingly used in magazine illustration. Many photographers found colour visually too 'real' – easier to use for recording than expressing ideas. Ernst Haas is one of few creative photographers to earn a reputation for use of colour.

– Whereas trendy magazines and colour supplements flourished in the 1960s, older picture magazines and newspapers suffered badly from the competition of TV. Photographers and agencies switched to the supply of book illustrations etc, from their picture libraries.

– Photography has also grown as a means of communicating social awareness, through exhibitions such as Steichen's Family of Man and the publications of various protest movements.

– Public interest in photography meant that more books were published featuring work of individuals. Well presented exciting exhibitions of photography (one-man shows and themes) began to appear in art centres and museums. Photography became important in art education; scholarships and awards were provided. The photographic clubs with their subject categories and judges were no longer the main way to get your work shown.

– Most younger artists by now saw photography as a creative tool, its images typical of contemporary life. Photographs were freely integrated with painting, silkscreen printing, assemblages of all kinds.

– Social statement, seeing aid, means of self-expression . . . photography had become a kind of language, limited only by the imagination and energy of the user. The ways photography and video images work as part of daily language was becoming an in-depth study of its own.

Projects

P9.1 Research and find modern examples of photographs used in each of the following ways: (1) To publicize industry in a dramatic way. (2) To make some form of social protest. (3) To advertise a product, showing it directly. (4) To advertise something without actually showing the product. (5) To record information difficult to obtain any other way. (6) To form all or part of a work of fine art.

P9.2 Compare styles in portraiture, 1930s–1960s. Find portraits by as many of the following photographers as possible, comparing them in terms of approach (candid or formal), use of setting, lighting, etc:- Yousuf Karsh, Brassai, Irving Penn, Henri Cartier-Bresson, Angus McBean, Cecil Beaton, Diane Arbus, Robert Capa, Walter Bird.

Questions

Q9.1 In what ways did the developments in new photographic equipment and techniques following World War II affect the style and approach of photography in the 1960s?

Q9.2 Discuss the influence on post-1945 photography of two of the following: Hollywood movies, Russian documentary photography, The New Objectivity and US west coast movements, Bauhaus teaching.

Q9.3 Contrast the public image of the photographer in society (a) in 1900 and (b) in 1965. Discuss some of the reasons for these changes.

Q9.4 Write about the use made of photography for propaganda purposes and for social protest, make particular reference to the work of two individuals.

Q9.5 Describe the portrait styles of either Cecil Beaton or Baron Gayne de Meyer with those of either Irving Penn or Arnold Newman. What changes and influences do you think have affected them in their approaches?

Q9.6 What were the factors which restricted amateur and professional colour photography before 1945? If you consider that black-and-white materials still have an important role in photography give your reasons; alternatively suggest why you believe they will be replaced by colour.

FINAL WORD

Looking back over the history of photography, with its odd mixture of skills in handling machinery and expressing visual ideas, what are your strongest impressions? It is surely sad that for so long hangups over whether photography is *technical* or *artistic* confused and held back its role in society. But then for years the process itself was very complicated to use. It is sad too that for so long photographers felt it necessary to copy superficial aspects of painting rather than freely exploring ideas of their own. The critics among their own ranks seem to have been limited to technical aspects of photography, whereas art critics harped on its relationship to popular painting. Today a broader view is taken because far more photographs of every kind are seen, and they cover a much wider range of visual approaches.

Clearly too, photography means different things at different times to different people. Even the 'isms' which have been discussed vary according to the individual's interpretations (eg. Emerson's 'naturalism' was not quite the same as other people's idea of the word). And every new movement seen as adventurous and modern in its day becomes tomorrow's crusty 'establishment', needing to be overthrown.

Apply your own practical experience of photography to the work of other people who have been discussed. Who was right and who was misguided? Tastes and fashions are gradually changing all the time – for example people have grown enthusiastic for romantic, then impressionistic, then abstract, then realistic painting. All were influential in their day. Equally pictorial photography (much despised since about 1918 but still practised) may be due for a comeback.

Try to assess what kinds of photographs you currently find pleasing or good. Select from books, say, twenty photographs which you feel are interesting. Work out, or ask someone to check out for you features these chosen pictures have in common. Perhaps you prefer something obscure and challenging, or a clear full statement. Is the actual subject of greatest importance, or is it more the picture's design? Technical qualities like detail and excellence of tone values, the freezing of fast action etc may stand out. Possibly the pictures are disquieting in some ways... or attractive and pretty. Look too at photographs you liked or disliked when you first started studying photography, and decide whether these views still hold good. The way a photograph is read is affected

by events in the rest of the world and changes in yourself.

Back in the 1840s the camera seemed a magical device which would allow everyone to make accurate excellent pictures. But it is really no more nor less of a machine than, say, a typewriter, which cannot itself produce good writing. Anyone can insert paper and press the keys, as anyone can load film and press the shutter. Whether your language is written or photographic, the challenge is to produce at least some work meaningful to other people.

On the next few pages a List of Events recaps aspects of the history of photography. It relates what was happening at any one time, and shows various time-scale relationships. Notice how often art movements influence the style of photography practised about ten years later, and how new processes or equipment (eg. in 1851, and 1876) widened the range of subjects which could then be tackled.

Finally, the history of photography is a continuing story. The photographs you see around you today, including the ones you take and preserve yourself, are also storing up information. They will reflect the ways of life, interests and attitudes of people in the 1980s to others in the twenty-first century.

EVENTS BY DATE

Date	Processes, Equipment	Photographers and Movements	Current Affairs, Art Movements
1727	Schulze describes light sensitivity of silver salts		
1800	Wedgwood: shadow shapes on sensitized leather (Britain)		Height of the romantic movement in Europe
1826	Niépce first photograph from nature (France)		
1839	Daguerre's process publicly announced (France)		
1840	Petzval portrait lens manuf. (Germany) Wolcott patents mirror port. camera (US)		Decline in painted miniatures
1841	Talbot patents Calotype process (Britain)	Beard opens first European port. studio (Britain)	
1843		Hill/Adamson collaboration using Calotype	
1844		Talbot publishes 'Pencil of Nature' (Britain)	
1847	Albumen on glass negatives introduced (France)		Railway bonanza. 5,000 miles completed since 1830 (Britain)
1850	Albumen on paper for prints introduced (France)	First albumen photo-print factory (France)	Pre-Raphaelite Brotherhood (Britain)
1851	Archer suggests collodion process (Britain)	Disderi introduces carte-de-visites (France)	Great Exhibition of '51 (Britain)
1854	Ambrotype version of collodion process (Britain)		Crimean War (1854–56)
1853		Photographic Society founded; RPS from 1894 (Britain)	
1855		Fenton documents Crimean War	First exhibition of realist movement (France)
1856	Smith patents tintypes (US)		
1857		Rejlander's 'Two Ways of Life' exhibited (Britain)	
1860	Maxwell demonstrates 3-colour theory (Britain)	Boom in stereo-photographs, sold in most stores	
1861		Brady photographers begin documenting Civil War	American Civil War (1860–65)
1864		Cameron begins portraits of famous men (Britain)	
1866	Woodburytype reproduction process invented	Carte-de-visite craze comes to an end	
1868	du Hauron publishes book on col. theory (France)	H. P. Robinson's book 'Pictorial Effects in Photography' pub.	
1871	Maddox suggests gelatin emulsion (Britain)		
1873	Gelatin bromide paper Vogel discovers orth sensitization (Germany)	Jackson photographs western territories (US)	
1874			First impressionist exhib. (France)

Date	Processes, Equipment	Photographers and Movements	Current Affairs, Art Movements
1876	First manufactured dry plates (Britain)		
1877	First electric light studio (Britain)		
1878	Platinum printing paper introduced	Thompson's pictures of London street life pub. Muybridge's experiments, photographing galloping horses (US)	
1882	First ortho sens. dry plates manufactured (Britain)	Marey locomotion photo-experiments 1882–96 (France)	
1883	First commercially produced halftone blocks	Photo-club founded, Paris	
1886	'Detective cameras' extremely popular		Eighth and final impressionist exhib. (France)
1887		Muybridge locomotion pics (11 vols) published (US)	
1888	First Kodak camera, processing service (US)	Riis photos of NY slums published (US)	
1889		Emerson's 'Naturalistic Photography' pub. (Britain)	First impressionist exhib. London
1890	Hurter and Driffield set down H & D emulsion speeds (Britain)	Steiglitz returns from Germany, to live in US	
1891		Vienna camera club founded	
1892	Edison perfecting movie equipment (US)	The Linked Ring formed (Britain)	Growth of 'Art Nouveau' (W. Morris, Britain)
1894	Gum bichromate process developed for pictorial use		
1895	Lumiere movie equipment demonstrated (France) Roentgen discovers X-rays, radiography (Germany)		
1897		Steiglitz edits 'Camera Notes' (US)	
1902	Zeiss Tessar f/3.5 lens designed (Germany)	Photo Secession founded, first issue 'Camera Work' (US)	
1904			'Daily Mirror', using all half tones pub. (Britain)
1905		291 Gallery opens. New York	
1906	First panchromatic plates introduced (Britain)		
1907	Autochrome colour plates introduced (France)		Futurist movement (1907–about 1914)
1908		Hine begins child labour doc. photography (US)	
1909		Final exhibition, dissolution, the Linked Ring	
1912	Compur bladed shutter invented (Germany)		Duchamp's 'Nude Descending a Staircase' (Germany)
1914			World War I (1914–18)
1915	Aerial plate cameras developed		Dada movement began (Zurich) until about 1922
1916		Strand's photography pub. in 'Camera Work' Coburn 'Vortographs' (Britain)	
1917	Platinum paper discontinued	Final issue Camera Work. 291 Gallery closes	
1919			Bauhaus design school founded (Germany)

Date	Processes, Equipment	Photographers and Movements	Current Affairs, Art Movements
1921		Man Ray, Moholy Nagy, photogram experiments	Regular 'wireless' programs broadcast (US)
1922		Renger-Patzsch begins realism photography of everyday objects	Surrealist paintings from about this date
1924	Leitz manuf. first Leica camera (Germany)	Weston, in N. Mexico, begins 'straight' approach	
1925	Ermanox camera, f1.8 lens, manuf. (Germany)		
1927	Sound movies now universal		'Picture palaces' built everywhere to show movies
1928	First Rolleiflex TLR rollfilm camera (Germany)	Salomon begins political candids (Germany) Renger-Patzsch 'World is Beautiful' pub (Germany)	Picture magazine Berliner Illustrierte Zeitung pub.
1929	Flashbulbs introduced (Germany)	Film und Foto exhibition (Germany)	Stock-market crash – start of world-wide depression
1931	First photo-electric meter (US)		
1932	8mm amateur movie film and equipment (US)	Group of f64 formed	
1933	First panchromatic roll films (US)	Heartfield, photomontagist, flees Germany	Bauhaus closed. Nazis come to power (Germany)
1935	Dufaycolor rollfilm introduced (France)	FSA photo project launched (US)	
1936	Kodachrome 35mm films introduced (US)	Photo League of NY still photographers formed	First issue 'Life' magazine (US)
1937	First 35mm SLR camera – Exacta (Germany)	Weston receives first Guggenheim Award to a photographer	New Bauhaus opens, Chicago
1938	First camera with built-in meter, for rollfilm (US)		First issue 'Picture Post' (Britain)
1939	Edgerton evolves first electronic flash (US)	McBean surrealist theatre portraits (Britain)	Second World War (1939–45)
1940			Photo sect. of Museum of Modern Art opens (US)
1942	Agfa neg/pos colour film & paper (Germany) Kodacolor film & paper (US)		
1947	Instant pic (B & W) film & cameras. Polaroid (US)	Magnum photo-cooperative formed by Cartier Bresson, etc	Cinema-going reaches its peak, soon rapidly declines
1949			George Eastman's House opens as museum (US)
1951		Photo League ceases (US)	Popular growth of TV (B & W) begins
1955			'Pop Art' first coined
1957	First Japanese 35mm SLR (Nikon) generally available		Last issue 'Picture Post'
1962			'Sunday Times' pub. first Brit. newspaper col. supp.
1963	Instant pictures in colour. Polaroid (US)		Colour TV becomes general
1969	Offset litho gives improved printed page repro. of colour		First photographs taken on moon

RELATED READING

General reference These books are wide-ranging, mostly covering photography from its discovery up to the present day. Most are available in paperback.

BEATON, C. & BUCKLAND, G.	*The Magic Image*	Little Brown
BRAIVE, M.	*The Photograph – A Social History*	McGraw-Hill
GERNSHEIM, H.	*Concise History of Photography*	Thames & Hudson/McGraw-Hill
NEWHALL, B.	*History of Photography*	Secker & Warburg/MOMA
POLLACK, P.	*Picture of History of Photography*	Abrams/Thames & Hudson
SCHARF, A.	*Art and Photography*	Penguin
SZARKOWSKI, J.	*Looking at Photographs*	Idea Books
MACDONALD, G.	*Camera – Victorian Eyewitness*	Batsford

Chapter by chapter The books below concentrate on the work of particular photographers, or cover more limited periods in time. Use them from the library to expand the topics of each chapter in this book – particularly to see quantities of pictures by various individual workers, or to fill in background information on society and events of the day.

Chapter 1

COE, B.	*Birth of Photography*	Ash and Grant
	The First Negatives	HMSO (Science Museum London)

Chapter 2

SCHARE, A.	*Pioneers of Photography*	BBC
TAFT, R.	*Photography and the American Scene*	Dover
	The First Negatives	HMSO

Chapter 3

	Victorian Life in Photographs	Thames & Hudson
SCHARF, A.	*Pioneers of Photography*	BBC
TAFT, R.	*Photography and the American Scene*	Dover

Chapter 4

	The Camera	Time-Life
BAYNES, K.	*Scoop, Scandal and Strife*	Lund Humphries
COE, B.	*The Snapshot Photograph*	Ash and Grant
SCHARF, A.	*Cameras – from Daguerrotypes to Instant Pictures*	Marshall Cavendish
	Pioneers of Photography	BBC

Chapter 5

	Color	Time-Life
COE, B.	*Colour Photography*	Ash & Grant
COE, B.	*The Snapshot Photograph*	Ash & Grant
LANGFORD, M.	*Professional Photography*	Focal Press
MEES,	*From Dry Plates to Ektachrome Film*	Ziff-Davis
HERCOCK & JONES	*Silver By The Ton*	McGraw Hill

Chapter 6

	Documentary Photography	Time-Life
	Henri Cartier-Bresson	Aperture/Gordon Fraser
ANDREWS, R.	*Picture Gallery Pioneers*	Superior
BAINES, K.	*Scoop, Scandal and Strife*	Lund Humphries
EVANS, H.	*Pictures on a Page*	Heineman
HURLEY, F.	*Portrait of a Decade*	Da Capo Press
MELTZER & COLE	*The Eye of Conscience*	Follett

Chapter 7

	The Great Photographers	Time-Life
	Pictorial Photography in Britain 1900–26	Arts Council
	Edward Steichen	Aperture/Gordon Fraser
	Alfred Stieglitz	Aperture/Gordon Fraser
	The Print	Time-Life
COKE, V. D.	*The Painter and The Photograph*	University of New Mexico Press
GAUNT, W.	*The Restless Century*	Phaidon Press
NEWHALL, B.	*Frederick Evans*	Aperture/Gordon Fraser
SCHARF, A.	*Creative Photography*	Studio Vista/Reinhold
TURNER, P.	*P. H. Emerson*	Aperture/Gordon Fraser

Chapter 8

ADAMS, A.	*This is The American Earth*	Sierra Club
ADES, D.	*Photomontage*	Thames and Hudson
BRANDT, B.	*Shadow of Light*	Gordon Fraser/Viking
LYONS, N.	*Photographers on Photography*	Prentice Hall
LYONS, N.	*Photography in the 20th Century*	Horizon Press
MELLOR, D.	*Germany – The New Photography*	Arts Council of Great Britain
MOHOLY-NAGY, L.	*Painting, Photography, Film*	Lund Humphries/MIT Press
NEWHALL, N.	*Edward Weston*	Aperture/Grodon Fraser
SCHARF, A.	*Creative Photography*	Studio Vista/Reinhold
TAUSK, P.	*Photography in the Twentieth Century*	Focal Press

Chapter 9

	Harry Callahan	MOMA/Gordon Fraser
BERGER, J.	*Ways of Seeing*	Penguin
HAAS, E.	*The Creation*	Viking
HAAS, E.	*In America*	Thames & Hudson
HOPKINSON	*Bert Hardy*	Gordon Fraser
HOPKINSON	*Picture Post 1938–50*	Penguin
JANIS & McNEIL	*Photography within the Humanities*	Addison House
LYONS, N.	*Photography in the 20th Century*	Horizon
LYONS, N.	*Photographers on Photography*	Prentice Hall
SONTAG, S.	*On Photography*	Penguin
STEICHEN, E.	*Family of Man*	MOMA
STROEBEL, ZAKIA & TODD	*Visual Concepts*	Focal Press
WHITE, M.	*Mirrors, Messages, Manifestations*	Aperture

GLOSSARY

Abstract image In painting and photography an image in which the depiction of real objects in nature has been discarded for a pattern or structure of lines, shapes, colours etc. The subject may be real but so stylized, blurred or broken down into basic forms that it appears unrecognizable.

Air-brushing Painting or colouring by hand using a paint-spray.

Albumen A clear faintly-yellow organic material found in plants and animals. White of egg is albumen in its purest form.

Albumen prints Prints made on thin paper coated with albumen containing silver halides. Recognizable from their glossy surface and yellowish whites. In general use in 1850–1890s.

Ambrotype An (underexposed) whitened wet-collodion glass negative presented against a black background, which gave it a positive appearance. Very popular for modest cost portraiture in the 1850s and 1860s.

Aperture The circular hole controlling the amount of light which passes through a photographic lens, therefore affecting image brightness. Aperture sizes are calibrated in f numbers.

Autochrome process Early colour transparency process using mixtures of red, blue and green dyed starch grains and a layer of panchromatic emulsion. The grains acted as a mosaic of tiny filters. In use 1907–1930s.

Avante-garde Art which differs from what is considered normal at the time in an original experimental (even outlandish) way. The term is french for vanguard.

Bitumen of Judea A type of asphalt found in Syria, Trinidad etc. Can be dissolved to form a varnish which gradually hardens when exposed to light.

Bromide prints Photographic paper coated with silver bromide in gelatin. Introduced in 1873 and still in use for black-and-white prints and enlargements.

Bromoil Printing process by which suitable bromide paper is exposed to a negative (by contact or enlargement), processed, then bleached to remove the black silver image. Oil pigment is then applied with a brush and 'takes up' in image areas only. The use of different brushes, pigments and brush strokes allows the result to be given a hand-finished appearance. Invented 1907.

Calotype From the Greek for 'beautiful picture'. Talbot's paper negative process, patented in 1841.

Cinematography See **Movies**.

Collodion Guncotton (cottonwool dissolved in nitric acids) in a solution of ether and alcohol. A clear sticky solution discovered in 1847 and used for dressing wounds eg. in Crimean war. Later (1851) formed the basis of the wet-collodion photographic process.

Collodion positive See **Ambrotype**.

Contact prints Prints made by direct contact with the negative. To produce large prints you need an equally large negative.

D & P Developing and printing service, for customer's films.

Daguerrotype Process invented by Louis Daguerre and introduced in 1839. The positive image was produced on a small silvered plate.

Depth of field Distance between nearest and furthest parts of a scene which appear on the photograph in sharp focus. Greatest when using short focal-length lenses and small aperture settings.

Development Chemical treatment by which an exposed but invisible (latent) photographic image is made visible, either as black silver or coloured dyes.

Diffusion Scattering of light. Image diffusion by means of a lens attachment gives photographs with spread or 'smudged' highlights. Light diffusion (eg. light through cloud, tracing paper in front of lamps) gives soft shadowless subject illumination.

Diorama Theatrical entertainment using large translucent paintings lit from the front and/or behind, moved and changed to give realistic and dramatic scenic effects. Very popular in the 18th and 19th centuries.

Dye transfer process Slow expensive method of making excellent colour prints from separation negatives. Three enlarged prints are made on special matrix film, dyed yellow, cyan and magenta, and pressed in sequence onto paper. Introduced in 1946.

Emulsion (photographic) Light-sensitive salts in gelatin, as coated on photographic plates, film or paper.

Exposure Allowing the light-sensitive material to receive a light image, either in the camera or enlarger or by direct contact with a negative, actual objects etc.

f-number Effectively the diameter of the lens aperture divided into the lens focal length. The *higher* the f-number the *smaller* the aperture.

Ferrotype Another name for **Tintype**.

Filter (light) Transparent glass, acetate or gelatin sheet, usually coloured. Mostly used over lens (or lights) to alter the way coloured objects are rendered in a photograph.

Fisheye lens Extreme wide-angle lens, often able to include over 100° viewing angle of a scene. However, gives a bowed appearance to most straight lines, plus distorted perspective.

Fixing In processing, the chemical stage after development, to make remaining (undeveloped) silver halides insensitive to light, allowing the processed image to be examined in normal illumination without spoiling.

Flashbulb Glass bulb containing metal wire or foil which is ignited by an electrical or mechanical fuse. Burns out in a brilliant light flash, without smoke. Unaffected by damp. Introduced 1929, mainly for press photography.

Flashpowder Consisted mainly of finely ground magnesium powder which was ignited by a taper or spark. Could give an extremely bright flash, but also smell, ash and smoke. Unreliable in damp conditions.

Focal length In simple terms, the distance between lens and image when focused for a distant subject. Normally a camera has a lens with focal length about equal to the diagonal of the picture size it gives.

Focal plane shutter Blinds just in front of the film surface, which open briefly to make the exposure. Being part of the camera body this shutter can be used with any lens.

Focusing Altering the lens-to-film distance (or lens-to-subject distance) until a clearly focused image is formed on the focusing screen or film.

Gelatin prints See **Bromide prints**.

Gum bichromate process Paper coated with gum arabic, potassium bichromate and watercolour pigment is (contact) printed from a negative. The exposed print is treated in warm water which washes out pigment in unhardened highlight areas only. Considerable control is possible at the coating and washing stages. Introduced 1894 but eventually replaced by bromoil which could be used for enlargements too.

Gum process Shortened name for **Gum bichromate** process.

Hand camera Camera designed to be used held in the hand.

Heliography Means 'sun drawing', the name of the 1820's light-sensitive process devised by Nicéphore Niépce, using bitumen coated polished pewter.

High key A picture made up of predominantly light tones or colours.

Highlights The lightest parts of the final (positive) photographic image.

Hypo Chemical known in the 19th century as hyposulphite of soda (now named sodium thiosulphate). Used for photographic fixing, as first suggested by Sir John Herschel in 1839.

Instant pictures General term for camera materials, by Polaroid and Kodak, giving finished prints a minute or so after making the exposure.

Laterally reversed Reversed left-to-right, as when you see yourself reflected in a mirror.
Low key A picture mostly consisting of heavy dark tones or sombre colours.

Miniature A very small painted portrait, generally oval in shape and produced on ivory or card, using transparent water colours. Most popular in the 18th century until the invention of photography.
Miniature cameras Term used mostly in the 1920–1960s to describe all cameras designed for small rollfilm and (particularly) 35 mm film. The advent of still smaller pocket cameras has outdated this description.
Montage A picture made up from several separate images, arranged so that they join, overlap or blend with one another.
Movies Moving pictures, created by presenting the eye with a rapid sequence of still images.

Negative An image in which subject highlights appear dark and dark shadows appear light. In a colour negative subject colours are reproduced in complementary hues.

Oil process See **Bromoil**.
One-shot colour camera Camera containing semi-reflective mirrors, which gave three separate images, identical in size and viewpoint, from a single exposure. Used during the 1930s and 1940s to give separation negatives (through red, green and blue filters) for making early colour prints.
Orthochromatic Photographic material sensitive to blue and green light but not red. (ie. Red subjects are reproduced as a very dark tone on the final print).

Panchromatic Black-and-white emulsion sensitive to all colours of the visual spectrum – red as well as green and blue – therefore reproducing them in correct tones of light and dark.
Photography 'Drawing' or 'writing' by means of light. (From the Greek *photos* meaning light, and *graphos* meaning writing.) Term suggested by Sir John Herschel to William Fox Talbot in 1839.
Photogravure A process for printing mechanically in ink. A final size negative image is formed on special tissue, then transferred to a copper plate or cylinder. After etching and inking this plate is printed on a press. Gives rich half-tones without an apparent screen pattern.
Photomechanical printing General term covering those processes which result in a hard-wearing surface able to be repeatedly inked and brought into contact with paper to give large quantity reproductions of photographs, paintings etc.
Pinchbeck A metal alloy used to imitate gold. Often used for the decorated mounts and frames of 19th century photographs.
Plate camera Camera designed to use light-sensitive materials in the form of glass plates. From the late 1930s onwards such cameras were usually adapted to accept sheet film instead.
Platinum paper Ready-manufactured material for contact printing which, after development, clearing in hydrochloric acid and washing, gave an image of platinum fused into the fibres of the paper. Prints had extremely rich blacks unobtainable by other processes, and the image was very permanent. Invented in 1873, but went out of production about 1917 owing to its high cost.
Plates Originally this term referred to the light-sensitized, silvered copper plates used for the Daguerreotype camera. From the 1850s however, when collodion allowed the use of glass, it continued to be used for sensitized glass sheets of various set sizes.
Platinotype print A print made on platinum paper.
Positive An image in which subject highlights appear light and shadows appear dark.

Realism General term for pictures which depict things as they appear naturally, without much apparent distortion or stylization.
Reflex camera Any camera using a mirror between the lens and a (horizontal) focusing screen. Allows the image to be seen and composed right way up.
Repeating back A mechanical device holding a row of three plates at the back of an ordinary stand camera. By sliding the back sideways three separation negatives could be exposed in quick succession. Gave results similar to the more expensive one-shot colour camera, but limited to still-life subjects.
Resolution (of films) The ability of an emulsion to record fine detail – particularly important when negatives are greatly enlarged in printing. Resolution depends upon the use of small silver halide grains coated in a thin layer, plus the giving of correct exposure and development.
Resolution (of lenses) The ability of a lens to form an image containing fine detail. Depends upon correction of lens faults (aberrations), gloss surface coating to reduce flare, accurate focusing, lens condition, etc.
Retouching Handwork on a negative or print, generally with brush or pencil to disguise unwanted marks, wrinkles in faces etc.
Reversal process Processing sequence by which the film exposed in the camera is made to form a positive (instead of negative) image. Usually consists of about 6 to 8 stages.

SLR Single-lens reflex camera. Designed with a hinged mirror which reflects the image to a focusing screen for viewfinding. When the shutter release is pressed the mirror moves to allow the lens to project the image through a blind shutter directly onto the film.
Sensitometry The scientific study of the light sensitivity of photographic materials.
Separation negatives Normally three black-and-white negatives taken identically in all respects except that each is exposed through a strong filter of a different colour – either red, green or blue. The set of negatives can be used to make colour prints or photomechanical reproduction in colour.
Sheet-film Single sheets of film (replacing earlier glass plates) loaded into filmholders in the darkroom and used in large format cameras.
Shutter Device to control the time the image is allowed to act on the film.
Silver halides Silver chloride, silver bromide and silver iodide are silver halides – compounds of silver used for most photographic materials. First used by Daguerre, and Talbot, they are still unrivalled for light sensitivity and image resolution.
Snapshots A term originally used in rifle shooting, but from about 1890 coined for photographs taken with a hand camera involving little or no delay in aiming. Generally describes results given by simple cameras used by beginners.
Soft-focus image An image in which sharp sharp detail is overlaid with a slightly diffuse image, 'spreading' light parts of the picture. Produced by a special soft-focus lens or attachment.
Solarization (Strictly called pseudo-solarization or Sabattier effect) Image manipulation by exposing photographic film or paper to light part-way through development. Gives a part positive, part negative result.
Speed (of films) Numbers denoting the relative sensitivity of films. Various speed ratings systems have been used, the first being H & D. Today's most popular system uses ASA or ISO speed numbers.
Speed (of shutter) Timing of the shutter open period eg. 1/125 sec, 1/250 sec etc.
Stand camera A camera designed for use on a tripod or stand only.
Stereoscopic photographs Three-dimensional pictures produced by taking two photographs from viewpoints about 65 mm ($2\frac{1}{2}$ in) apart, then viewing these in a device which allows each eye to see one picture only. Most popular in the 1860s.
Stops Aperture settings, see **f-numbers**.
Straight photography An approach to photography in which the process itself is used in a direct way. Most creative decisions are taken in the choice of subject, lighting, viewpoint etc. After making the exposure the image is manipulated as little as possible.

TLR Twin-lens reflex camera. Designed with two lenses of identical focal length. One lens, fitted with a shutter, forms an image direct onto film; the other gives an image via a reflex system on a focusing screen at the top of the camera. Both focus together.
Talbotype Alternative name for calotype. Talbot's friends preferred to use the word talbotype in view of the way Daguerre's name featured in daguerreotype.
Telephoto lens A compact long-focus lens, able to give a large image of a distant subject – as when looking through a telescope.
Time exposure General term referring to exposures longer than about one second. Since this is beyond the speed scale of most shutters, the lens must be held open while the photographer times his exposure.
Tintype A low-cost reversal process very similar to the ambrotype but produced on collodion-coated black or brown enamelled tinplate sheets. Particularly popular in America as from about 1860. Used until recent times by 'while-you-wait' street photographers.
Toning Changing the image of a black-and-white photograph from the normal black silver to a chemical of a different colour.
Tripod Three-legged folding and adjustable height camera support.

Unbacked plates Early dry plates without a dark dye coating on their rear surface to prevent image light reflection from 'flaring' bright highlights.

Viewfinder Sighting device to ensure that the camera is aimed in the right direction and includes only the wanted parts of the scene.
Viewpoint The position of the camera relative to the subject.

Washing The stage of processing which removes unwanted chemicals and byproducts from the negative or print.
Wash-off relief Early form of dye transfer process, used for making colour prints from separation negatives. Invented 1926.
Waxed paper process Variation of the calotype process using waxed paper to give more transparent negatives.

BRIEF BIBLIOGRAPHY

Ansel Adams (1902–) American. Professional concert pianist turned professional photographer 1930. In 1932 a founder member of Group f64. From 1941 photographed characteristic landscapes of various US regions as photomuralist for the Department of Interior. 1950s and 60s taught and published books on visual and technical aspects of photography. Page 124.

Robert Adamson (1821–1848) Scottish. Learned the calotype process and in 1843 opened a professional portrait studio in Edinburgh. Approached by painter D. O. Hill for reference portraits for a major painting commission, the two went into partnership. They produced over 1500 calotypes of portraits, architecture, and Newhaven fishing scenes, until Adamson's death. Page 21.

Frederick Scott-Archer (1813–1857) English. Sculptor and professional photographer. Inventor of the revolutionary collodion wet-plate process 1851, which he did not patent. Author of a manual of collodion photography. Died in extreme poverty. Page 27.

Eugene Atget (1856–1927) French. Ex-actor who turned to photography in 1898, documenting the people and architecture of Paris–mostly in areas soon due for demolition and redevelopment. Produced straight reference photographs for authors and painters such as Utrillo, Braque, Picasso and Marcel Duchamp. Recognized after his death as a 'straight' photographer of great sensitivity. Left about 10,000 photographs, the best of which have now been extensively published.

Richard Beard (1802–1885) English. Ex-coal merchant and business opportunist who bought the British rights to the daguerreotype process and Wolcott mirror camera. Set up first photographic portrait studio in Britain (1841) and later several others in London and the provinces. Made his fortune from studio profits and sub-licence fees. Eventually became bankrupt through continually suing other British photographers infringing the patents. Page 16.

Cecil Beaton (1904–1980) English. Amateur photographer turned professional portrait and fashion photographer for *Vogue* 1928. Until 1953 worked as a top photographer for this magazine in London, Paris and New York, specializing in flamboyant settings. During World War II became a documentary photographer in Britain and the Middle East. Important stage and costume designer. Author of many picture books on ballet, travel, portraits. Page 137.

Mathew Brady (1823–1896) American. Owner of several East Coast daguerreotype portrait studios in the late 1840s, and a photographer of important contemporary personalities. Strong believer in the importance of historical records. At outbreak of US Civil War (1861) sent out teams of photographers to cover most important actions. Produced well over 6000 collodion negatives of the war, which were eventually bought by the US government. Page 81.

Bill Brandt (1905–) English. Learnt photography in Paris from Man Ray, 1929. In 1931 settled in London as a freelance reportage photographer. Worked for British and American magazines (mostly *Picture Post*) covering Northern towns during the depression, the British way of life, portraits, landscapes. Published six books of photographs including *Perspectives of Nudes* (1961). Page 94.

Henry Callahan (1912–) American. Student of Ansell Adams 1941, then industrial photography technician until he met Moholy-Nagy and began teaching at Illinois Institute of Technology, 1946. Associate, then professor, Rhode Island School of Design 1964. Frequent international exhibitor–his subjects mostly semi-abstract nudes, austere natural forms, and multiple image experimental photography. Page 129.

Julia Margaret Cameron (1815–1879) English (born Calcutta). Began amateur collodion photography after her husband retired in 1863. Self-taught. Photographed many distinguished Victorian friends, and intellectuals visiting her neighbour the poet Tennyson. Published pre-Raphaelite style illustrations to Tennyson's works, but today most famous for her original and striking male portraits 1864–1875. Frequent exhibitor in London shows. Ceased serious photography when the family moved to Ceylon. Page 41.

Robert Capa (1914–1954) Hungarian, naturalized American. Born Andre Friedman. Photojournalist who became the best known combat war photographer during the late 1930s and 1940s. Made his reputation covering the Spanish Civil War (1936), World War II, Israel, and Indochina–where he was killed. His work was published mostly in *Life* magazine, also several books of war photographs. Co-founder of Magnum agency in 1947.

Lewis Carroll (1832–1897) English. The Reverend Charles Dodgson, Oxford don and author of *Alice in Wonderland*. Enthusiastic amateur photographer 1856–1880, mostly child portraits of pretty girls; also Victorian celebrities. He had a naturalistic approach to portraiture well ahead of his time. Page 41.

Henri Cartier-Bresson (1908–) French. Painting student turned reportage photographer. Travelled extensively recording various countries in the 1930s using the new 35 mm Leica camera. For three years worked as assistant to film director Jean Renoir. After World War II (1945) returned to the still photography of actuality human interest subjects–using his gift for exploiting the decisive moment. Exhibited and published extensively in picture magazines throughout the world. Produced eight books of photographs. Founder member of Magnum agency 1947. Page 93.

Antoine Claudet (1797–1867) French. London-based sheet glass importer who learned the daguerreotype process and purchased (for £200) a personal licence from Daguerre to practice in England. Set up a rival studio to Beard in London, 1841, and also became sole agent for Daguerre's cameras. He had considerable skill as a photographic scientist and was an enthusiast for stereoscopic photography. Claudet's professional photography was widely shown and he often acted as an exhibition judge during the 1850s. Page 16.

Alvin Langdon Coburn (1882–1966) American. Founder member of Photo-Secession, but worked mostly from London where he was elected a member of the Linked Ring. Believed in liberating photography from 'having to express reality'. Many one-man shows 1906–1913, mostly portraits of celebrities and city landscapes. Extremely versatile and experimental in his styles and techniques; links with abstract, cubist painting. Very influential exhibitor, particularly during 1920s and 1930s. Became a British subject 1932. Pages 111 and 117.

Jean Corot (1796–1875) French. Painter and etcher. Founder of Barbizon School of Intimate Mood Landscape Painting. Interested in photography and for a time drew directly on collodion-coated glass instead of metal to produce reproductions by photographic printing. Famous for his paintings of landscapes having diffused detail and muted grey-green colours and tones.

Louis Daguerre (1787–1851) French. Realist painter, stage designer, showman. Manager and joint inventor of elaborate Parisian diorama show (destroyed by fire 1839). After unfruitful 1829 partnership with Niépce he worked out his own, *daguerreotype*, process–the world's first practical method of photography, announced 1839. Awarded special pension in return for making his invention freely available (but already patented in England). Greatly honoured in France. Wrote a manual of the daguerreotype process. Page 10.

George Davison (1856–1930) English. Amateur photographer and an early secretary (1886) of the London Camera Club. Considered a pioneer of modern pictorial photography at this time. Leading figure in the secession of RPS members who left in 1892 to form the Linked Ring. In 1900 appointed managing director of Kodak Limited (England), but asked to resign eight

155

years later owing to his anarchist political activities. Page 106.

Edgar Degas (1834–1917) French. Painter and sculptor known in the 1870s for his deceptively informal compositions and unusual viewpoints, openly influenced by hand camera photography. Concentrated on contemporary subject matter–often dancers and ballet trainees. Organized and exhibited in most of the Impressionist exhibitions, 1874–1886. Page 58.

Philip Delamotte (1820–1889) English. London artists and designer who began calotype photography in the late 1840s. Using the collodion process he documented the re-erection of the Crystal Palace in 160 photographs, 1854. Became professor of drawing at King's College 1856. Organized the Manchester Art Treasures Exhibition 1857, and illustrated many books with photographs or drawings. Page 29.

Robert Demachy (1859–1937) French. Banker, amateur painter and photographer. Leading member of French Photographic Society and Photo-Club of Paris, late 1880s. Produced impressionist style romantic portraits and landscapes with figures from 1907. A believer in the manipulated pictorial print. Regularly exhibited and honoured by Royal Photographic Society, London. 1905 Member of the Linked Ring. Ceased photography in 1914. Page 107.

Andre Disderi (1819–1890) French. Of humble origin, first became a professional photographer in Brest, then (1852) set up a large portrait studio in Paris. In 1854 patented carte-de-visite photographs, which soon became immensely fashionable. Photographer to Napoleon III, Queen Victoria, Czar of Russia etc. Became Europe's richest photographer by 1861, but wasted away his fortune and ended his career as a Monaco beach photographer in the late 1880s. Page 39.

Marcel Duchamp (1887–1968) French. Painter and one of the original Dadaists. Early works (about 1911) include Cubo-Futurist 'Nude Descending a Staircase', influenced by motion analysis photography. Later shocked the establishment by his exhibitions (1914 and 1917) of ready-made objects–bottles, urinal etc–and apparently random constructions in wire and foil. Produced few paintings after 1930 and instead devoted his activities to chess.

George Eastman (1854–1932) American. Bank clerk and amateur photographer. In 1878 began making gelatin emulsion plates for his own use. Invented an emulsion coating machine and set up commercial production of plates in Rochester, NY as the Eastman Dry Plate Co. 1880. In 1888 marketed the enormously successful No. 1 Kodak, the first simple camera backed by a D & P service. Kodak products progressed from strength to strength–transparent roll-film, folding cameras, paper, movie films. After retirement Eastman died by his own hand, leaving much of his vast fortune to the University of Rochester.

Peter Emerson (1856–1936) English. Doctor of medicine and extremely influential amateur pictorial photographer. Abandoned his medical career for photography 1886. Published *Naturalistic Photography* promoting photography as an independent art (1889), then withdrew these opinions (1890). Produced several picture books of East Anglian landscapes 1886–1895. Much honoured by Royal Photographic Society in the 1890s. Ceased exhibiting and judging, and gradually became forgotten after the turn of the century. Page 104.

Frederick Evans (1852–1943) English. London bookseller and amateur photographer–mostly making portraits of literary friends. In 1898 devoted his full time to professional photography, including architectural studies of English cathedrals, French chateaux etc for the magazine *Country Life*. In 1901 became a member of the Linked Ring. First British photographer reproduced in *Camera Work*, 1903. Gave up photography when platinum paper was discontinued after World War I. Page 108.

Walker Evans (1903–) American. Documentary photographer, at first specializing in indigenous architecture, mostly for book illustration. With other members of FSA documented poverty-stricken US farmers 1935–1937. Illustrated *Now Let Us Praise Famous Men*, 1941. Several picture books of his objective style work published. Worked for *Time* and became associate editor *Fortune* magazine. Page 88.

Roger Fenton (1819–1869) English. Aristocratic background. Studied art and photography in Paris in the 1840s, then law-qualifying as a barrister. Paintings exhibited at the Royal Academy. In 1854, changed his profession from law to photography. Founded and was first secretary of the Photographic Society of London (later RPS) in 1853. Became famous for documenting the Crimean War and for his photographs of English architecture, landscapes, still lifes, royal portraits. Regularly photographed sculpture, documents, etc, for the British Museum. Gave up photography 1862 and returned to his legal career. Pages 29 and 51.

Francis Frith (1822–1898) English. Wholesale grocer who in 1850 became partner in a printing firm which mass produced photographic (albumen paper) prints. From 1855 he was fully occupied as a collodion photographer taking views of Britain and abroad. Travelled extensively in the Middle East 1856–1860. His firm marketed a range of several hundred thousand scenic views by 1890. Published his own books with pasted-in prints. Page 29.

Ernst Haas (1921–) Austrian. Originally a medical student, turning to professional documentary photography after World War II. Worked from New York all over the world for magazines such as *Life*. Became a member of Magnum and stills photographer for film companies, but his main interest–and the work for which he has become famous–is colour photography of urban and rural landscape, close-ups of natural forms etc. Page 142.

Bert Hardy (1913–) English. Self-taught photographer, while working as teenage messenger boy for a D & P laboratory. Ten years later became freelance press photographer for a Fleet Street press agency –one of the first using 35 mm equipment. Joined *Picture Post* 1940, and served with the Army Photographic Unit, returning to become the magazine's chief photographer until its closure. Page 97.

John Heartfield (1891–1968) German. Born Helmut Herzfelde but changed to a British name in 1916 as a political gesture. Painter and montagist of photographs, leader of Berlin Dadaism 1920s. A communist who used photomontages–reproduced as magazine covers, posters etc–to combat capitalism and militarism during the 1930s. Also chose this technique to design many book covers. Expelled from Germany in 1934, returning there 1950. Page 130.

David Hill (1802–1870) Scottish. Somewhat uninspired portrait and landscape painter. A founder, regular exhibitor, and secretary of the Scottish Royal Academy for forty years. Commissioned to paint 474 recognizable faces of ministers for a commemorative work in 1843, Hill set up a highly fruitful partnership with photographer and chemist Robert Adamson. Returned to painting after Adamson's early death in 1848. Page 21.

Lewis Hine (1874–1940) American. Sociologist and school teacher 1901–1907. Took up photography in 1905 to help publicly expose the lives of poor immigrants, Pittsburgh coal miners, etc. Became staff photographer to the National Child Labor Committee 1911, and produced photographs showing shocking exploitation of youngsters. American Red Cross photographer in World War I. Later (early 1950s) documented more positive workers' achievements–including the erection of the Empire State Building. Page 86.

Kurt Hutton (1893–1960) German. Born Jurt Hubschmann, and originally studied law but interrupted by World War I, learned photography instead and set up a Berlin portrait/advertising studio 1923. Turned to candid photoreportage for the new German illustrated magazines 1930. In 1934 emigrated to Britain (anglicizing his name), eventually becoming staff photographer for *Picture Post* 1938–1955. Page 98.

Dorothea Lange (1895–1965) American. Studied photography under Clarence White and opened a portrait studio in San Fransisco, 1919. Member of Group f64, 1934. Concerned for the depression unemployed, she acted as photographer in a research project on migrant labour, then produced her most famous work as a leading FSA photographer 1935. During World War II documented the internment of Japanese Americans. Later she travelled, producing numerous photoessays on American and foreign local communities, published in *Life* and similar magazines. Page 87.

Richard Maddox (1816–1902) English. Doctor of medicine and amateur photographer. Invented the first successful silver halide gelatin emulsion in 1871. Improved later by others, his discovery led directly to the manufacture of dry plates and films during the 1880s. Maddox, like Scott Archer twenty years earlier, never patented his discovery.

Angus McBean (1905–) Welsh shop assistant and amateur photographer who turned professional in 1934, working in a London society photographer's studio. Opened portrait studio in 1935 and quickly established himself as London's leading theatrical photographer–a position he held until the 1960s. Following World War II McBean delighted in adapting surreal ideas to create unusual studio portraits of actors and actresses. Page 130.

Rene Magritte (1898–1967) Belgian. Surrealist painter trained in Brussels but briefly in contact with French surrealists when living in Paris 1927–1930. His paintings have a dream-like clarity, evoking impossible events but featuring everyday subjects. They often use pale muted colouring. Working from Brussels he turned out a large volume of variable quality work between the 1920s and the early 60s. Page 130.

Felix Man (1893–1919) German. Born Hans Baumann. Studied art and drew illustrations of sports events for a Berlin magazine. Having used photography for reference material he became a professional photojournalist in 1928. Achieved inter-

national fame for his photo-interviews with important Europeans. Emigrated to Britain 1934 and changed his professional name. Helped to found *Weekly Illustrated*, worked for *Picture Post*, *Life* etc. Page 98.

Etienne Marey (1830–1904) French. Physiologist who, inspired by Muybridge's experiments, devised photographic equipment and techniques to record human movements. Apparatus included disc shutter cameras which gave a whole sequence of images on one photographic plate. Much of Marey's work, like Muybridge's, could be viewed in suitable equipment which 're-played' the original movements. Page 53.

Paul Martin (1864–1944) French, living in England. A newspaper illustration wood-engraver and successful amateur pictorial photographer. He also delighted in recording everyday life with a concealed 'parcel' camera. Gave up wood-engraving with the coming of half-tone blocks and in 1899 became a freelance photographer. Known today mostly for his (spare time) candid photographs of ordinary London street scenes, the seaside, etc (1895–1914), now of great historical interest. Page 84.

Baron De Meyer (1868–1949) French. Elegant fashionable man-about-town who married a relative of Edward VII and was created a German Baron in 1899. In following years photographed the fashionable rich of European society, Diaghilev's ballet company etc, as an amateur. Was elected to the Linked Ring and had pictures featured in *Camera Work*. Because of his German connections the Baron left Britain for America in 1914, where he turned professional and worked on contract from Condé Naste. His glittering, elegant portraits and fashion plates decorated *Vogue* 1914–1922, then *Harper's Bazaar* 1923–1935. Page 136.

Laszlo Moholy-Nagy (1895–1946) Hungarian. Studied law, interrupted by World War I. Began painting and drawing 1918. Moved to Berlin as an abstract painter, increasingly influenced by German expressionists. Joined the Bauhaus 1923, experimenting in photography and movies, and becoming head of the first-year course. Collaborated on stage design, light and colour experiments; produced various books on design education. Resigned 1928 and became stage/film designer in Berlin; then (1935) a photographer and designer London. In 1937 moved to America as director of the New Bauhaus, Chicago. Page 119.

Eadweard Muybridge (1830–1904) British eccentric, born Edward Muggeridge. Emigrated to America 1852. Became official scenic photographer to the government, also railway and steamer companies. From 1872 he was commissioned by a rich owner to record the exact motion of galloping horses. During 1884–1885 he produced a systematic analysis of animal and human locomotion of great significance to artists, published 1887. Designed 'replay' equipment which contributed to early movies. Retired to England in 1900. Page 52.

Felix Nadar (1820–1910) French. Born Gaspard Tournachon. Began career in Paris (1842) writing comic articles and drawing illustrations, aided by photography. Became a professional photographer 1853, first in partnership and then (1860) set up in large elegant portrait studio as 'Nadar'. Adventurous spirit – active in the political revolution of 1848; took the first photographs from a balloon 1858; created an aerial postal service during the siege of Paris; and made some of the first photographs taken by

electric light 1861. Supported the (much ridiculed) impressionist painters. Page 32.

Arnold Newman (1918–) American. Took up photography 1939 and opened a New York portrait studio 1946. However, specializes in showing eminent people in their own environment, often using dynamic but simple composition devices. Uses 4 × 5 in or larger stand cameras but still achieves a candid looking result. Work published frequently in *Life* and similar international magazines, particularly during the 1960s.

Nicéphore Niépce (1765–1833) French. Nobleman, landowner and amateur scientist. Interested in photo-etching and lithography. Experimented from 1816 on methods of photography using silver chloride, then bitumen on metal. Made successful copies of drawings by contact printing 1822 and later the world's first photograph from nature 1826. Entered into partnership with Daguerre in 1829 to devise a more practical camera system, but died four years later.

Tim O'Sullivan (1840–1882) American. Learned collodion photography while working at Brady's portrait studio New York, then Brady's Washington establishment. During the Civil War covered many Federal Army battlefronts, afterwards (1867) became a government photographer recording scenic views on pioneering survey expeditions to the West. In 1881 appointed Treasury Department chief photographer, Washington. Page 82.

Irving Penn (1917–) American. Trained at school as a designer, but began to take his own photographs while working as art director for *Vogue* in early 1940s. Following World War II became America's foremost fashion, portrait and advertising photographer. Penn photographs are austere and simple, using the minimum of setting. He published two outstanding books of portraits in the 1960s and early 1970s. Page 140.

William Lake Price (1810–1896) English. Successful watercolour artist of the 1830s and 1840s who became a collodion photographer in 1854. He pioneered artificial constructed compositions based on literary and historical subjects, and also photographed the Royal family. Both types of work were much exhibited and admired. Wrote a *Manual of Photographic Manipulation* in 1858. Gave up photography 1862. Page 103.

Man Ray (1890–1976) American. Worked as a draughtsman and studied painting in New York – a frequent visitor to Stieglitz's 291 gallery. Paintings exhibited in 1912 and 1915. One of America's first abstract artists, working with New York Dadaist group including Duchamp (1917). In 1920 began photography before moving to Paris, 1921. Invented abstract 'Rayographs' (photograms) 1922. Earned his living as a professional fashion/portrait photographer, continuing his experimental abstract work. Made several surrealist movies 1923–1929. Returned to America in 1936 and 1940 as painter/photographer, later (1951) returning to Paris and concentrating on painting. Page 118.

Oscar Rejlander (1813–1875) Swedish, resident in Britain. Portrait painter who used collodion photography as an aid. In 1855 became a professional portrait photographer, also providing figure study reference photographs for other artists. Exhibited art photographs in the style of popular allegoric paintings, using combination printing techniques. Also (1872) produced studies of facial expressions for Chalres Darwin's

The Expression of the Emotions in Man and Animals. Died in poverty. Page 31.

Albert Renger-Patzsch (1897–1966) German. Ex-chemistry student appointed (1922) head of the photo unit of an art book publisher. Began close-ups of natural and man-made objects. In 1925 opened his own photographic studio. Produced picture books of portraits, landscapes and every-day objects, pioneering the New Objectivity style. Taught photography briefly prior to World War II, later specialized in architecture, landscape and industrial photography. Page 126.

Jacob Riis (1849–1914) Danish, emigrated to America 1870. A carpenter who became police court reporter on *New York Tribune*. Shocked by the social conditions which led to crime, he began documenting New York slums (often using flashlight). Wrote and illustrated books crusading for reforms, with considerable success. Page 85.

Henry Peach Robinson (1830–1901) English. Bookshop assistant and amateur painter, who first learnt photography through the dagerreotype process. Operated a portrait studio in the midlands of England 1857–1862. From 1858 exhibited art photographs built around sentimental themes. An outspoken and influential member of the Royal Photographic Society. Moved into a studio partnership in southern England 1868–1888. Published many books and articles on photographic picture making. Founder member of the Linked Ring. Page 32.

Arthur Rothstein (1915–) American. Began reportage photography in 1934 and established his reputation working on the Farm Security Administration photographic project 1935–1936. Later a photographer for the US Army and the United Nations. Became technical director of photography for *Look* magazine. Wrote several books on photojournalism, colour photography etc. Page 87.

Erich Salomon (1886–1944) German. Doctor of Law. Worked for the publicity department of a leading magazine publishing house, becoming a freelance photoreporter 1928. Quickly became well-known for his existing light photography of social, political and musical events, mostly using the unobtrusive Ermanox camera. Throughout the 1930s his pictures sold to the new German picture magazines and to newspapers abroad. Being Jewish, Salomon and his family were persecuted, then murdered by the Nazis during World War II. Page 92.

Edward Steichen (1879–1973) Born Luxembourg but resident America. Lithographic apprentice, art student and amateur photographer. Elected a member of the Linked Ring 1901. Contributed pictorial photographs (and paintings) to major exhibitions from 1899. Founder member of Photo-Secession (1902) and its Gallery, 1905. During 1906–1914 settled in France, painting and sending work by modern European artists for showing in New York. He became Lt. Colonel in charge of aerial photography, US Expeditionary Forces, World War I. Giving up painting after the war, he set up an advertising photography studio in New York and worked as Condé Naste chief fashion/portrait photographer 1923–1937. Retired in 1938, but became Captain in charge US Naval Aviation Photographic Unit, World War II. Director, Department of Photography, Museum of Modern Art 1947–1962. Page 112.

Alfred Stieglitz (1864–1946) American. Student of engineering, then photo chemist Berlin 1882–1890. Won *Amateur Photo-*

grapher competition award 1887. 1890–1895 partner in New York photo-engraving business. An active amateur photographer, using a hand camera for pictorial studies of city. Member of the Linked Ring 1894. Editor of *American Amateur Photographer* 1893–1896, then *Camera Notes* 1897–1902. Organized breakaway exhibition of a group he named The Photo-Secession, 1902. Founded and edited *Camera Work* 1903–1917, opened and ran the 291 Gallery 1905–1917. (From 1908 hanging work of modern European artists as well as photography.) Numerous one-man shows and international honours 1932–1940. Ran gallery 'An American Place' New York 1929–1946. Page 109.

Paul Strand (1890–1919) American. Learned photography from Lewis Hine. Given a one-man show at 291 Gallery in 1916. Made his first semi-abstract photographs and closeups of man-made forms 1917. A US hospital technician during World War I. Movie cameraman 1919. Still photography of landscapes, portraits in New Mexico 1930. Spent 1933–1942 mostly making documentary films, reverting to still photography in 1943. From 1950 lived in France producing photo-books, profiling various European and African countries. Page 121.

Frank Meadow Sutcliffe (1859–1940) English. Set up a photographic portrait studio in Whitby, Yorkshire, 1875. Produced and exhibited many local landscapes, seascapes, fishing and country scenes around the town, becoming well-known for his naturalistic approach to pictorial photography. A founder member of the Linked Ring 1892. On retirement became curator of Whitby Museum.

William Fox Talbot (1800–1877) English. Landowner, scientist, Member of Parliament, inventor of negative/positive photography. Produced the first permanent photographic negative on paper 1835. In improved form this was patented as the calotype process, 1841. Published the first book illustrated with (pasted in) photographs 1844. Pioneered flash and photomechanical engraving in primitive forms. Talbot was also a visually talented photographer. Page 12.

John Thomson (1837–1921) Scottish. Explorer and early photographer. Travelled extensively in the Far East 1872–1874 and published books (with pasted in photographs) of his scenic views in various countries. Taught photography at The Royal Geographic Society (1870). Made a famous series of posed but authentic documentary collodion photographs of London's street life, 1876. Also ran his own professional portrait studio. Page 83.

Tom Wedgwood (1771–1805) English. Son of Josiah Wedgwood, the famous potter. Pioneer attempts about 1801 to photograph on paper or leather soaked in silver nitrate solution. He produced primitive silhouette photograms, but results were unfixed and so impermanent. Page 9.

Edward Weston (1886–1958) American. Student, Illinois College of Photography, 1908. In 1911 opened a portrait studio and (1914–1917) received many awards and honours for his diffused pictorial-style work. Spent 1923–1926 working in a Mexico City portrait studio – decided to redirect his exhibition work towards objective straight photography of natural forms. Made first use of a 8×10 in view camera. 1928 opened a San Fransisco portrait studio with son Brett. Founder member of Group *f*64, 1932. A Guggenheim Award allowed him to give up commercial portraiture so that he could travel and photograph extensively in the Western US 1937–1938. Southern and Eastern states trip 1939. Major exhibitions New York (1946) and Paris (1950). Ceased taking photographs 1947 when stricken with Parkinson's disease. Page 122.

Minor White (1908–1976) American. University graduate in botany 1933. Poet. Learnt photography through recording microscope slides. 1938 WPA Project photographer. Director of an Art Center 1940, where he began teaching photography. After World War II studied art history, worked under Beaumont Newhall (Director of Photography Department, Museum of Modern Art), taught at the School of Fine Arts, California. Made frequent visits to work with Weston during the late 1940s. Produced 'sequences' – portfolio sets of original photographs, mostly landscapes and close-ups of natural forms. Editor and publisher of *Aperture* magazine from 1952. Taught at Rochester Institute of Technology 1955–1964 and Massachusetts Institute of Technology 1965–1973. Produced books on technical aspects of photography and collections of his own mystic style of work, including 'equivalents'. A believer in visual analysis and meditation as a central core of photography. Page 131.

PICTURE CREDITS

Photographs were reproduced by kind permission of the following:

Chapter 1: 5 & 6–Kodak Museum, Harrow; 8–Fox Talbot Museum, Lacock; 10–International Museum of Photography, George Eastman House, Rochester, USA.

Chapter 2: 1–British Library, London; 3, 4, 7, 8, 9, 10 & 16–Science Museum, London; 11 & 14–International Museum of Photography, George Eastman House, Rochester, USA; 12 & 13–Scottish Arts Council; 15–Victoria & Albert Museum, London.

Chapter 3: 2, 3 & 28–Science Museum, London; 5 & 17–Victoria & Albert Museum, London; 6–Greater London Council; 7, 8, 10, 11, 12, 23, 27, 31, 33 & 34–Royal Photographic Society, London; 9–Royal College of Art Library, London; 13 & 14–Nadar/© Arch. Phot. Paris/S.P.A.D.E.M.; 16, 24, 25 & 32–International Museum of Photography, George Eastman House, Rochester, USA; 18–Christies, South Kensington, London; 30–Mander & Mitcheson Theatre Collection; 35–Notman Photographic Collection, McGill University, Canada.

Chapter 4: 2, 3, 4 & 14–Kodak Museum, Harrow; 5 & 13–International Museum of Photography, George Eastman House, Rochester, USA; 6–Nadar/© Arch. Phot. Paris/S.P.A.D.E.M.; 7–Royal Photographic Society, London; 9 & 19–Science Museum, London; 21–Victoria & Albert Museum, London; 22–Musee des Beax Arts, Pau, France; 23–Museum of Modern Art, New York, William B Jaffe & Evelyn A J Hall Collection; 24–The Stewards of the Jockey Club; 25–Forbes Magazine Collection, New York.

Chapter 5: 3–Science Museum, London; 4 & 6–Kodak Museum, Harrow; 7 & 8–Polaroid Corporation, USA.

Page 78: International Museum of Photography, George Eastman House, Rochester, USA.

Chapter 6: 1–Mansell Collection, London; 2–Royal Geographical Society; 3, 4, 10, 11, 12, 13, 14 & 15–Library of Congress, Washington DC; 5–From Ralph Andrews 'Picture Gallery Pioneers'; 6–Dr. Barnardo Library; 7 & 8–Gernsheim Collection, Humanities Research Center, The University of Texas at Austin, USA: 9–Museum of the City of New York, USA; 16–British Library; 17–Thomas Grant, from John Hillelson Agency, London; 18–USSR Reconstructs; 19–Associated Newspapers Limited, London; 20, 21–Erich Salomon, from John Hillelson Agency, London; 22–Henri Cartier Bresson, from John Hillelson Agency, London; 23–Bill Brandt, London; 24–Radio Times–Hulton Picture Library, London; 25–Associated Press Limited, London.

Chapter 7: 1–Private Collection, England; 2, 4, 5, 6, 7, 8, 9 & 12–Royal Photographic Society, London; 3–Victoria & Albert Museum, London; 10–Copyright © 1960, 1773 by Dorothy Norman; 11 Collection of the Art Institute of Chicago, USA.

Chapter 8: 1 & 3–Royal Photographic Society, London; 2–British Council, London; 4–The Louise and Walter Arensberg Collection, Philadelphia Museum of Art, USA; 5–Mrs Juliet

159

Chapter 8, *contd:*

Man Ray and Kimmel/Cohn, New York, USA; 6 & 7–Miss Hattula Moholy Nagy; 8–Kodak Limited, Harrow; 9–Professor Harold Edgerton, MIT; 10 & 11–ⓒ 1971 by the Estate of Paul Strand and Hazel Strand: A Retrospective Monograph; 12–ⓒ Edward Weston, 1931; 13–ⓒ Edward Weston 1934; 14–Ansel Adams; 15, 16 & 17–Galerie Wilde, Cologne, West Germany; 19–Bill Brandt, London; 20–Light Gallery, NYC, USA; 21–Frau Gertrud Heartfield, Berlin; 22–Theatre Collection, Harvard University, USA; 23–Museum Boymans-van Beunignen, Rotterdam, Holland, ⓒ ADAGP, Paris; 24– ⓒ 1969 by Aperture Inc., USA.

Chapter 9: 1–USSR Reconstructs; 2 & 7–National Portrait Gallery, London; 3–Humphrey Spender; 5–Vogue, Copyright ⓒ 1979 by The Conde Nast Publications Inc., USA: 6–Sothebys, London; 8–Imperial War Museum and IPC Magazines Ltd., London; 9–Signal Magazine; 10–Photograph by Penn ⓒ The Conde Nast Publications Ltd. London; 11–ⓒ Arnold Newman; 12–Walter Nurnberg; 13–Associated Press Ltd, London; 14–Hasselblad; 15–ⓒ Andy Warhol 1979.

INDEX